D0962319

In the
Footsteps
of Popes

⚷

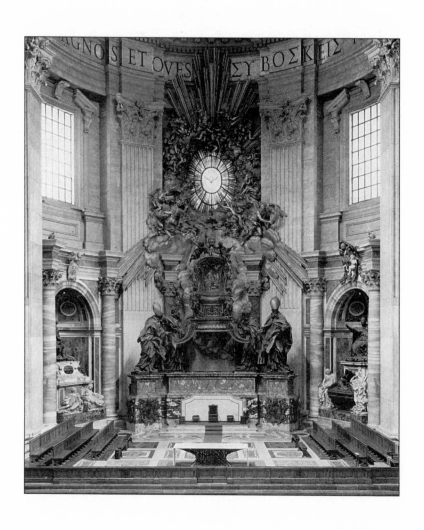

In the Footsteps of Popes

A SPIRITED GUIDE TO THE TREASURES OF THE VATICAN

ENRICO BRUSCHINI

WILLIAM MORROW
75 YEARS OF PUBLISHING
An Imprint of HarperCollins*Publishers*

IN THE FOOTSTEPS OF POPES.
Copyright © 2001 by Enrico Bruschini.
All rights reserved. Printed in the United States of America.
No part of this book may be used or reproduced in any manner whatsoever without written permission except in the case of brief quotations embodied in critical articles and reviews.
For information address HarperCollins Publishers Inc.,
10 East 53rd Street, New York, NY 10022.

HarperCollins books may be purchased for educational, business, or sales promotional use. For information please write: Special Markets Department, HarperCollins Publishers Inc., 10 East 53rd Street, New York, NY 10022.

FIRST EDITION

Designed by Fearn Cutler de Vicq

Printed on acid-free paper

Library of Congress Cataloging-in-Publication Data has been applied for.

ISBN 0-688-17756-5

01 02 03 04 05 QW 10 9 8 7 6 5 4 3 2 1

This book is dedicated to all the friends with whom I have visited the Vatican. It is the response to the many interesting questions that were posed spontaneously as we admired the masterpieces of Michelangelo, Raphael, and Bernini. Through conversation with these many friends this book was born, and so with gratitude I consider them all coauthors.

Thanks for the collaboration to:

Jennifer Dudley
Erick Wilberding
Ilaria Marra

FOREWORD

BY COKIE ROBERTS

If you were walking through the Vatican with Enrico Bruschini he'd stop at some random, seemingly insignificant, spot along a hallway. "Allora," he'd begin, and proceed to tell you a spellbinding story about your surroundings—the walls, the floor, the ceiling, the windows even. You'd watch his eyes twinkle with enjoyment, his smile spread under his maestro mustache as he regaled you with the adventures, or misadventures, of the artists we think of only, and simplistically, as "great."

This book provides you with a written version of those delightful discourses. Immediately on meeting this distinguished art historian—Bruschini has written several books on Roman art, excavated ancient Roman sites, and directed the restoration of antique frescoes—he becomes just Enrico, your friend. Meeting him through the pages of this book, you might not be able to hear Enrico's enthusiasm when greeting a colleague; or admire his patience as he answers the question of a stranger who's horned in on his tour; but you will be able to read and refer back to the wealth of information that even the eager ear might not remember.

The book takes you step by step through the buildings and

courtyards of the Vatican. When Enrico asks you to trust his many years of experience as a guide, "combined with a great personal passion for art, to select the works of major interest," be grateful. He is giving you good advice on what to skip as well as what to see. And he tells you how to make the most of your visit. For instance, while viewing the three altarpieces of Raphael, Enrico recommends that, "after admiring them from the best standing vantage point, you sit on the comfortable antique chairs facing them to admire these works as a group. It is something unforgettable!"

It's not just as an artistic student and critic that Enrico leads you through the Vatican, it's also as an historian who can tell you the sometimes juicy stories of the people depicted in the sculptures and paintings. The Roman work of the Venus Felix, for example, shows the goddess of love preparing for her bath with her son, Cupid. Venus' face, in the eye of the keen observer Enrico Bruschini, resembles closely portraits of Second Century Roman Faustina Minor, wife of the emperor Marcus Aurelius. According to our guide, she was "well known in Rome for her dissolute ways and for her subsequent scandals which the emperor desperately tried to cover up. If the statue really represents Faustina, she is properly represented with the body of Venus, the goddess of love!" Good stuff!

Since Enrico talks about Michelangelo, Raphael, Leonardo, and Caravaggio in such familiar terms, it's hard to believe he didn't know them personally; but he also appreciates modern works. He passionately describes the Sphere within a Sphere sculpture placed in the Courtyard of the Pine Cone in 1990, concluding, "A work of art is a true work of art only if it moves your soul." And remarkably, Enrico Bruschini finds himself moved by the masterpieces of the Vatican even after what must be the millionth time he's seen them.

In introducing the Sistine Chapel, Enrico says simply, "No description can equal the powerful impact of seeing Michelangelo's frescoes in person." Its impact gets him every time, causing him to tear up with emotion as he beholds them once again. Lucky for you, that passion comes through in this book

along with the useful and interesting information. In my tours through Rome with Enrico, I've learned from his breadth of knowledge, his intellect, and his fine artistic eye. I have great admiration for him as a teacher. But it's his love for these works that makes them come alive. Partly because of that contagious sense of joy, I also have great affection for Enrico Bruschini as a friend.

GENESIS OF THE VATICAN

The story of the Vatican started in Rome about two thousand years ago, during the cruel reign of the Emperor Nero.

In the year A.D. 64 a terrible fire devastated the city. The Romans were quick to accuse their emperor of having deliberately set the fire in order to acquire more land to build his new, immense palace, the Domus Aurea (Golden House). Today we know that this accusation was almost certainly untrue.

Rome was already renowned for its splendid edifices in marble thanks in great part to Emperor Augustus, although the poorest part of the city, the *suburra* (slums), was comprised mainly of wooden abodes. It was therefore common for a spark, especially during the preparation of meals, to set afire any nearby furnishings, often engulfing entire structures. The narrowness of the roads, as well as the closeness of the houses to one another, most likely contributed to the rapid spread of "Nero's Fire."

Nero, however, could not afford the harsh criticism of the populace, because his extravagances had already greatly irritated the Romans. Another mistake would have made his survival

even more precarious. As a result, the emperor was quick to find a scapegoat for the fire: the Christians! With this accusation, he initiated one of the most absurd and cruel persecutions in history.

During the same period the Apostles Peter and Paul were both in Rome.

Saul, or Paul as he was subsequently called after the Latin word *paulus* or "small," was born at Tarsus in Anatolia, today's Turkey, between 15 B.C. and 5 B.C. His father, who had acquired Roman citizenship, was able to pass it on to his son.

Paul, at the beginning, did not share the beliefs of the early Christians. He was a witness in Jerusalem at the stoning of Saint Stephen (called the "protomartyr" because he was the first martyr in the name of Jesus).

As written in the Acts of the Apostles (9:3–19), Paul was on his way to Damascus to participate in the persecution of the local Christian community when a supernatural force flung him from his horse and Jesus appeared, addressing him with the famous words: "Saul, Saul, why do you persecute me?" Struck by divine grace, Paul embraced the Christian faith and dedicated himself to the conversion of pagans, traveling to Cyprus, Asia Minor, and Greece.

On his return to Jerusalem he was arrested and brought to Caesarea, in Palestine, to face Felix, the Roman prosecutor. He was imprisoned for two years, until he appealed to the Roman emperor with the famous phrase: "Civis Romanus sum" (I am a Roman citizen) and thus was released.

In the year A.D. 60 he arrived in Rome, where he was kept under the surveillance of Roman authorities. According to tradition, Paul made a trip to Spain as well as a trip to the Orient, and in the year A.D. 66 was again arrested and, most likely in the year A.D. 67, was condemned to death.

As a Roman citizen, however, he did not undergo the disgraceful penalty of crucifixion and was, instead, sentenced to be decapitated. His body was placed in a sepulcher on the Via Ostiense, south of Rome.

In the fourth century A.D., the emperor Constantine built a

basilica over his tomb. Part of this magnificent church still exists today, and is called Saint Paul Outside the Walls.

Simon, as we know, was born in Galilee. The symbolic nickname of *Kephas* ("rock" in Hebrew), or *petrus* in Latin, was given to him directly by Jesus with the noted words: "You are 'Peter' and on this Rock I will build my Church." He lived in Capernaum and was a fisherman, as was his brother Andrew. Christ chose both of them as apostles. After Jesus' death, Peter was arrested and according to tradition, an angel sent by God set him free. Peter left Jerusalem and journeyed to Antioch. He then went to Rome, where he stayed for about twenty-five years and became the first pope of the Christians.

————

When the first accusations were made by Nero against the Roman Christians, the community prevailed on Peter to leave the city to save himself. According to tradition we know that just outside the city Peter encountered Christ. In astonishment, he asked, "Quo Vadis, Domine?"—"Where are you going, O Lord?" and Jesus replied, "I am going to Rome to be crucified again." At this point, the old apostle understood that his duty was to give evidence of his faith by returning to Rome, and thus not escape his destiny.

On the Via Appia Antica it is still possible to visit the small church of the "Quo Vadis" which recalls the place of the encounter.

Nero's anger immediately fell upon the leader of the Christians. Peter, not being a Roman citizen, was condemned to be crucified.

○—➤ The realistic depiction of the crucifixion is powerful. Notice that the third executioner is ready to insert the long nail into Peter's feet.

The capital punishment of the leader of the Christians was to be a public spectacle. The Christians were considered by the

————

In the Footsteps of Popes

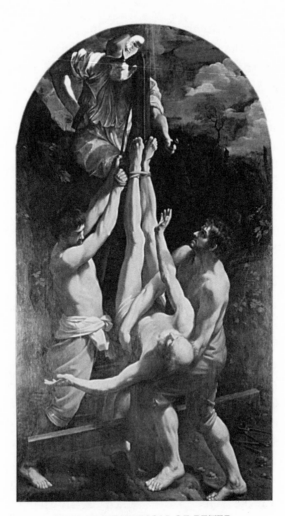

1. THE CRUCIFIXION OF PETER

Guido Reni, 1575–1642

Romans to be strange and dangerous, as they insisted on worshipping only one God, and in the name of that God were even ready and willing to die.

It was probably in the year A.D. 67 that Nero ordered Peter's death to be carried out in the imposing Circus that he had just completed beyond the Tiber River in the Ager Vaticanus (Vatican Plain). This name most likely came from the Latin word *vaticinium* (prophecy), because it had been, for a

Enrico Bruschini

time, the place used by the Etruscans, the populace which preceded the Romans, to gather vaticinations, or prophecies.

On being notified of his impending execution, the old apostle said: "I am not worthy of dying like Our Lord," and at his own request was crucified upside-down.

The Roman officer who accompanied Peter to martyrdom on that day could never have imagined that he would be helping to make history by laying the foundation stone for a place unique in the world, a concentration of religion, history, and art that is visited every year by more than ten million people: the Vatican!

The apostle faced his terrible death with bravery, for the love of Christ and humanity. Next to the Circus there was a street, Via Cornelia, and beyond that a cemetery where Peter was buried in a simple grave covered with terra-cotta tiles.

After more than two and a half centuries, around the year 324, after having granted liberty to the Christians, the emperor Constantine began building the first Christian basilica over Peter's burial site. The heart of the Vatican began to beat at that moment!

THE VATICAN TODAY

Today, the Vatican is the religious and artistic center of the Eternal City. It is certainly not easy to orient oneself, surrounded by more than 2,750 years of history and the tens of thousands of artistic masterpieces preserved here.

The scope of this guidebook is to help you to choose the best route and, depending on the amount of time you have available, to get the most out of your visit in the most efficient way. You will be able to discover and admire the important masterpieces without disregarding the curiosities and the anecdotes that will render them more vivid, making this trip into art and history more comprehensible.

Undoubtedly, there are three principal destinations in Rome, particularly during and after the Jubilee:

In the Footsteps of Popes

* From a cultural point of view: The Vatican museums
* From an artistic point of view: The Sistine Chapel
* From a religious point of view: St. Peter's Basilica

An ancient proverb states: "To know Rome, a lifetime is not enough." The same can be said for the Vatican. However, in just those few days that you have available, we hope to enable you to gain a better understanding of some of the most important treasures of this unique place.

Enrico Bruschini

THE VATICAN MUSEUMS

0—⚷ In order to plan in advance the visit to the Vatican museums, you will find at the end of the book the information on the opening time and useful suggestions to avoid the line at the entrance.

The Vatican museums have the greatest concentration of masterpieces in the world. The works displayed cover more than four thousand years of civilization. You can begin with the Egyptians and continue with the Romans and the Renaissance, arriving at contemporary art. To see everything, it would take approximately seven hours of visiting time, perhaps a bit much for those who do not have the time or who lack the desire to visit certain parts of the museums.

From experience, it is suggested that you concentrate on the true masterpieces and—why not—on the curiosities that make the artworks more vivid and memorable to the spectator. To reach the objective mentioned above, only the most important artworks will be presented in this book. Among the artworks named, the most important masterpieces will be identified by a star (★).

Descriptions of the hundreds of other artworks displayed

have been intentionally left out to avoid what is known as the "Stendhal Syndrome," that is, a heavy indigestion of works of art that could result in something truly dangerous.

I ask that our readers trust my many years of experience as a guide, combined with a great personal passion for art, to select the works of major interest.

I am, however, convinced that comments, historical descriptions, and artistic curiosities that can help you to enjoy further the beauty of the displayed works cannot be avoided. These comments are indicated by a small key.

ENTRANCE TO
THE VATICAN MUSEUMS

The entrance to the museums is in the Viale Vaticano. A large and modern entrance has been inaugurated for the Jubilee of the year 2000. The huge bronze door, entitled *Waiting 2000*, is by Cecco Bonanotte.

○━━ A political historical curiosity: The threshold of the entrance door you are passing through represents the northern boundary between Italy and Vatican State!

Before entering take a look at the large portal on your right, opened in the sixteenth-century walls built to defend Vatican City. Until February 2000 this portal was the old entrance to the Vatican museums. It is surmounted by two large statues by Pietro Melandri (1932) that portray the principal artists whose works will be seen and enjoyed inside the museums: Michelangelo with chisel and mallet, and the young Raphael with palette and paintbrushes. In the center of the two statues you will find the coat of arms of Pius XI, the pope who opened this entrance in 1932 so that the city of Rome might have direct access to the top of the Vatican hill.

In the center of the vast entrance hall there is a very modern statue by Giuliano Vangi (1999), *Crossing the Threshold*. It

shows Pope John Paul II pushing a young man into the world, encouraging him to become involved.

Some advice before starting: It is common, at the end of a visit to the Vatican museums, to visit also St. Peter's Square and Basilica. From the Sistine Chapel a convenient passageway brings you directly to nearby St. Peter's Square. This passageway, however, is not always open due to the necessities of a public audience, or for some other official reason.

It is easy to see if the passageway is open. Almost in the center of the large atrium, slightly off to the right, you will find the Information Desk where four big monitors indicate which areas of the museum are open to the public and which are temporarily closed. A silhouette of St. Peter's Square illuminated *in green* indicates that the passageway is open; *a red* illumination indicates that the passageway is closed. If the monitors indicate it is closed, it is a good idea to ask at the desk if it will reopen later in the day.

If the passageway is closed you cannot reach St. Peter's Basilica directly from the chapel. You will need to return to the entrance of the museums and, after a long walk around the outside following the Vatican Walls, you will arrive at the Square and the Basilica.

If the passageway is open, on the other hand, be sure not to leave any personal articles at the coat check at the entrance, otherwise you will be required to return to the front entrance of the museums to retrieve the items you checked!

In case of rain, you are advised to carry only a folding umbrella into the museums. It is Vatican policy that, for security reasons, large umbrellas must be checked at the entrance.

We are finally inside the Vatican City State—the smallest state in the world, but surely among the most unique. The surface area is small, 109 acres (44 hectares), with about 900 inhabitants, but its religious and political importance reaches way beyond its size and borders. It maintains a diplomatic corps, and many states also have an embassy to the Holy See. The Vatican also has permanent representatives to the United Nations. It has its own monetary and postal system, a train

9

system, and automobile license plates, CV or Città del Vaticano (Vatican City); it has its own army, the Swiss Guard, with around 100 soldiers, hired to protect the person of the Pope.

The Holy Pontiff is simultaneously the head of the Catholic Church and the sovereign of the Vatican City State.

VATICAN MUSEUMS

THREE POINTS TO KEEP IN MIND

For a few years now a one-way itinerary of the visit to the museums has been implemented because of the large number of visitors. For this reason, all sections of the museums will be described in this guide, as you will encounter them on the one-way itinerary. This way it will be easier for you to decide in which sections you will stay a longer or shorter time.

Before starting your visit, keep in mind that the Sistine Chapel houses without a doubt the most important concentration of art existing in Italy, and perhaps the world. Therefore, if you only have one hour or a little more than one hour available, it is a good idea to go directly to the Sistine Chapel (Letter M on the map), which you will find almost half a mile from the entrance point.

To do this it is necessary to follow with great attention the arrows that indicate the direct route: CAPPELLA SISTINA (Sistine Chapel). At the glass covered courtyard (letter A on the map) go up the first flight of the stairway, pass through the Gallery of the Candelabra (H1) on the upper floor, and then proceed directly to the Sistine Chapel, avoiding the Borgia Apartments (L).

It will not be easy to pass by beautiful works of art without observing them closely, but it is the only way, with just one hour or so available, to get to the masterpiece of masterpieces. Too many times tourists have arrived at the chapel just when the museums have already begun to close and custodians are ushering people out. There are no exceptions!

Enrico Bruschini

LOWER FLOOR

ESCALATOR

E5
E4
E6
F
E2
E3
E1
E
O

P
B
PINACOTECA

C
COURTYARD
OF THE
PINE CONE

D
*
D1

O2

LARGE
COURTYARD
OF
BELVEDERE

O1
O
L
M SISTINE
CHAPEL
N

EXIT TO
ST. PETER'S BASILICA

UPPER FLOOR

G
H
H1

H2

H3

I
I2
K2 K1 K J
J2
J1

ROOMS
OF RAPHAEL

VATICAN MUSEUMS

The capital letters A,B,C, etc., identify the various sections of the museums that visitors will encounter during the one-way itinerary.

If you have at least two, or better, three hours available, you should plan your visit to take advantage of the best of the Italian art in the proper way (The Ideal Itinerary). This means:

★ First visit the Pinacoteca, or Picture Gallery (B), above all to admire the artworks of Raphael, Leonardo da Vinci, and Caravaggio.

★ Then you can travel across the Courtyard of the Pine Cone (C) and visit part of the Pio-Clementine Museum (E) to enjoy the classical ancient sculptural masterpieces like the *Apollo,* the *Laocoön,* and the Belvedere Torso. These works were admired by Michelangelo and strongly influenced his work in the Sistine Chapel.

★ To reach the Sistine Chapel you will pass through the long corridors of the Candelabra (H1), of the Tapestries (H2), and of the Maps (H3).

★ Arriving near the chapel, if you still have at least an hour to spare, you might visit the famous Raphael Rooms (K, K1, K2) and compare the styles of two great artists of the Renaissance when you finally reach the Sistine Chapel (M).

<div style="border:1px solid;">

THE IDEAL ITINERARY

To enjoy the best without getting tired, the Ideal Itinerary will be identified by the underlined sections.

★

For each part of the museums the most famous masterpieces will be identified by a star (★).

</div>

The different parts of the museums will be illustrated following the one-way itinerary of the visit.

Enrico Bruschini

Through the new entrance, you will reach the starting point of the visit:

A—Glass-Covered Courtyard

(See the map) from which you can:

Turn right to reach "B," the Pinacoteca, through the hallway
Turn left and go straight ahead to reach "C," the Courtyard of the Pine Cone
Turn left and climb the steps and go directly to the Sistine Chapel

B—Pinacoteca (Picture Gallery)

At the entrance of the Pinacoteca, to the right, we find a 1975 copy of Michelangelo's famous *Pietà*.

Obviously a copy doesn't give us the same feeling that one finds standing in front of the original (which we will see inside St. Peter's Basilica; it will be described in detail in that section), but here we have the possibility to enjoy this masterpiece up close and to note several details.

Remember that Michelangelo was only twenty-three years old when he was commissioned by a French cardinal to carve the *Pietà*. According to Vasari, who wrote an early biography of the great artist, Michelangelo discreetly joined the crowd that was admiring his recently completed masterpiece. While overhearing laudatory comments, however, Michelangelo became furious when he realized that someone in the crowd was attributing his work to another sculptor. That night Michelangelo returned to St. Peter's Basilica and carved his name in abbreviated Latin on the sash across the chest of the Virgin: MICHAEL AGELVS BONAROTVS FLOREN FACIEBAT (Michelangelo Buonarroti the Florentine did this).

0—𝓇 The signature can only be seen clearly on this copy, as the original has been placed notably far from the public. It is the only sculpture signed by Michelangelo!

ROOM I: PRIMITIVES

The Primitives Room is called as such for the painters who worked from the eleventh to the fourteenth century.

Remarkable on your left are *The Madonna of the Flagellants* (inventory number on the painting: No. 40017), by Vitale da Bologna; *Saint Francis of Assisi* (No. 40002), by Margaritone d'Arezzo; and *The Last Judgment* (No. 40526), by Nicolò and Giovanni; from the twelfth century, this last is the oldest painting in the gallery.

If you have sufficient time, enjoy this early medieval work; otherwise pass through—the masterpieces are awaiting.

ROOM II: GIOTTO

We advise a short stay in this room to see the ★*Stefaneschi Polyptych* (No. 40120), a work by the great Italian painter Giotto di Bondone (1267–1337).

A polyptych is a work made up of several paintings; in this case there are six. This work was hung over the major altar of the Old St. Peter's Basilica around 1315. The altarpiece is painted on both the front and back in order to be seen by the faithful in the nave as well as by the pope seated on his throne in the apse. Typical of this period is the golden background that recalls the Byzantine style. Characteristic of Giotto—and new for those times—however, is the method of suggesting more real and soft figures in a more rational space.

On the front of the painting, in the center, is Saint Peter, the first pope, enthroned with apostles and saints at his sides. Cardinal Stefaneschi, who commissioned the piece, appears at the feet of Saint Peter showing a scale model of the same altarpiece. Note all the details of the large panel are reproduced in miniature in the scale model. This is a detail that is particularly enjoyed by children, but it is important in art history because in it you can also see the large gold Gothic frame that has since been lost. This polyptych allows us to grasp the impressive nature of the altar of the Old St. Peter's Basilica.

Enrico Bruschini

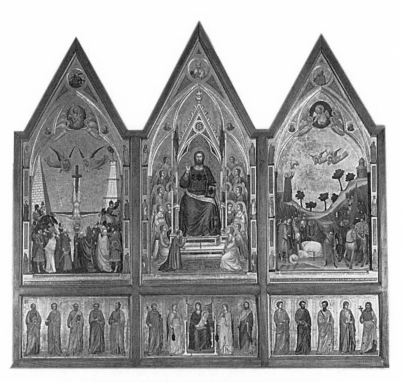

2. STEFANESCHI POLYPTYCH (BACK SIDE)
Giotto di Bordone, 1267-1337

In the center back panel is the figure of Christ enthroned.
Cardinal Stefaneschi is also portrayed, on the bottom left, kiss-
ing the foot of Christ with great devotion. On the left side the
crucifixion of Peter is depicted and on the right is the behead-
ing of Saint Paul.

The work was done in tempera on wood panels. It is interest-
ing to remember that in the 1300s the technique of oil on can-
vas was not yet in use. With tempera, the colors, instead of
being dissolved in oil, were dissolved in a natural adhesive such
as milk, egg yolk, and the like, and applied to oak or poplar
panels. We must wait until the 1400s, with the arrival of the
Flemish school, to see the first paintings in oil on panel.

In the Footsteps of Popes

ROOM III: FRA ANGELICO AND FILIPPO LIPPI

Interesting are, on the left, the *Scenes from the Legend of Saint Nicolas of Bari* (Nos. 40251–40252), and the small but delightful ★*The Virgin and Child Between Saints Dominic and Catherine of Alexandria* (No. 40253), by Fra Angelico; also the triptych (triple painting) ★*The Coronation of the Virgin, with Angels, Saints, and Donors* (No. 40243), by Filippo Lippi.

ROOM IV: MELOZZO DA FORLÌ

In this room, two notable works by Melozzo da Forlì (1438–1494) are preserved. On the wall in front is the *Sixtus IV Names Bartolomeo Platina Prefect of the Vatican Library* (No. 40270), painted in the year 1477, a portrait of the pope who commissioned the building of the Sistine Chapel and from whom it takes its name. Note the perfect perspective of the elegant hallway.

Sixtus IV is seated on a throne; standing in front of him in cardinal dress is his nephew, Giuliano Della Rovere—the future Julius II who will commission Michelangelo to paint the ceiling of the Sistine Chapel. The work is a fresco that has been removed from the wall and transferred to canvas.

In the same room you will find several ★ fragments of detached frescoes (No. 40269), dated 1480. They are part of a larger fresco detached in 1711 from the destroyed apse of the Roman church of the Saint Apostles.

○━ᴋ The technique of fresco is very unusual. It was already known by the ancient Greeks, and perfected by the Romans. It consists of applying a layer of fresh plaster to the wall to be decorated and while the plaster is still wet painting directly onto it. The colors are absorbed and penetrate into the plaster for about 2 millimeters (one eighth of an inch). The oxygen present in the air hardens the surface and forms a colored layer of calcium carbonate that forever contains the colors.

If, for instance, you have had the opportunity to visit the

Enrico Bruschini

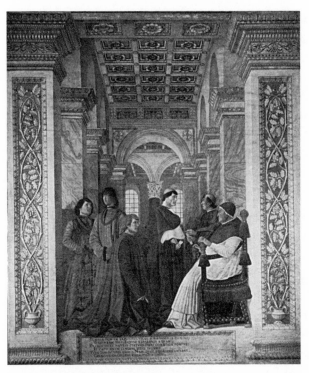

3. SIXTUS IV NAMES BARTOLOMEO PLATINA PREFECT OF
THE VATICAN LIBRARY

Melozzo da Forlì, 1438-1494

elegant frescoed rooms of the ancient Roman town of Pompeii, destroyed by the eruption of the year A.D. 79, you may have noticed that they seem to have been painted just yesterday!

The enormous problem of the fresco technique is that errors cannot be corrected, and you cannot paint over it, as can be done with oil on canvas. A fresco, once painted, is untouchable and not correctable.

Keep all this in mind when you see the Sistine Chapel, and you will better appreciate the greatness of Michelangelo's work.

ROOM V: FIFTEENTH-CENTURY PAINTERS

On the left is the ★ *Miracles of Saint Vincenzo Ferreri* (No. 40286) by Ercole de Roberti, followed by the *Pietà* (No. 40275) by Lucas Cranach the Elder.

ROOM VI: POLYPTYCHS

This room contains the ★ *Pietà* by Carlo Crivelli (No. 40300), and ★ *Madonna and Child* (No. 40297), by the same artist, signed OPUS CAROLI CRIVELLI VENETI, and dated 1482.

ROOM VII: UMBRIAN SCHOOL

In the center of the left wall we find another interesting work, a ★ *Madonna with Child and Saints* (No. 40317), a tempera on panel finished around 1495 by Pietro Vannucci, known as "Perugino," from his town of origin, Perugia. He was the young Raphael's teacher. It is interesting to see Perugino's influence on Raphael in the softness of the figures, the richness of the colors, and the correct placement of the figures in space.

○━━┱ Look at the panel in the lower part of the painting containing smaller figures and observe the faces of the saints that are looking up. The faces are painted using a difficult perspective, "from bottom to top" and slightly turned to an angle (three-fourths). The same poses can be noted in Raphael's first paintings.

Notice, on the opposite wall, close to the corner, a pleasant work of art that only recently has been added to this room. It is a detached small fresco by Pinturicchio, ★ *The Madonna of the Window-Sill* (No. 40324).

ROOM VIII: RAPHAEL

This is the room dedicated to Raphael's artwork.

In the showcases all around the room are preserved the famous ★ tapestries executed in Brussels by Peter van Aelst, using the cartoons drawn by Raphael (note that cartoons are preparatory drawings for tapestries and frescoes, done on thick paper). These tapestries, commissioned in 1515 by Pope Leo X, were hung in the Sistine Chapel during solemn celebrations. Copies of these tapestries contributed to spreading Raphael's style throughout Europe.

Enrico Bruschini

The first tapestry to the right when you enter the room is ★ *The Donation of the Keys.* The brightness of the silk is admirable (note the resplendent figure of Jesus dressed in a white garment covered with stars). Noteworthy, especially on the lower part, is the use of real gold thread. Because of the enormous cost involved, it was one of the first times that such an abundance of gold was used in a tapestry.

Three of Raphael's great altarpieces are on the long wall in front of the entrance, and are lined up magnificently. It is impressive to see them after their recent restoration, rescued from the ravages of time and dazzling in their full splendor. For years one of the three was missing due to the laborious restoration process; finally all three have been returned to their original places to be admired together.

It is impossible to describe adequately the beauty of these large paintings. I suggest that, after admiring them from the best standing vantage point, you sit on the comfortable antique chairs, facing them, to admire these works as a group. It is something unforgettable!

Let us begin in chronological order. The first work to the right is ★ *The Coronation of the Virgin* (No. 40334), painted by Raphael in 1502–1503, when the artist was only nineteen or twenty years old.

At the bottom, the tomb of the Virgin is empty, as she has already ascended to Heaven. The apostles in the lower part are watching Christ in the act of crowning the Holy Mother. Perugino's influence is evident in the perspective of the faces looking up.

In the glass display case there is the lower part of the same painting, the so-called predella (No. 40335), which displays *The Annunciation, The Adoration of the Magi,* and *The Presentation in the Temple.* These are three delightful miniatures.

The painting to the left, entitled ★ *The Madonna of Foligno* (No. 40329), was commissioned c. 1511 by Sigismondo de Conti of Foligno, secretary to Pope Julius II. The work was requested to show gratitude to the Virgin for having saved Sigismondo's house, which had been struck by lightning or a

ball of fire. Looking closely at the center of the painting, one can clearly see a sphere of fire. The artist was perhaps trying to represent a meteorite falling to the earth. We should remember that the first recorded sighting of a meteorite was by the Chinese six thousand years ago and later by the Hebrews and then the Romans. This phenomenon continued to fascinate scientists and philosophers, especially during the Renaissance. Raphael's painting could possibly reveal this renewed interest.

The patron is pictured on his knees on the right, as he is presented to the Virgin by Saint Jerome. To the left we see Saint Francis and Saint John the Baptist.

The central landscape is rich in color, clearly of Venetian inspiration, in which one recognizes Sigismondo's threatened house under a rainbow that announces the end of the storm. The Madonna is pictured surrounded by blue clouds, but look closely and you will realize that what appear to be clouds are instead the faces of smiling cherubs. The cartouche that is lifted up by a little angel was to contain the dedication to the Virgin, but it remained empty.

In the glass display case there is the predella (No. 40332) of another famous painting by Raphael not displayed here, the famous *Deposition* in the Borghese Gallery in Rome. The theological virtues of Faith, Hope, and Charity are depicted in chiaroscuro.

o—⚓ The two great paintings were confiscated by Napoleon's troops and moved to Paris in 1797 where they remained until 1816 when, after Napoleon's abdication, they were returned to Rome. In Paris the works were detached from their wooden supports and transferred to canvas.

The painting in the center is Raphael's masterpiece, the very famous ★ *Transfiguration* (No. 40333).

o—⚓ This superlative work was also taken by French troops, and remained in Paris from 1797 to 1816.

Enrico Bruschini

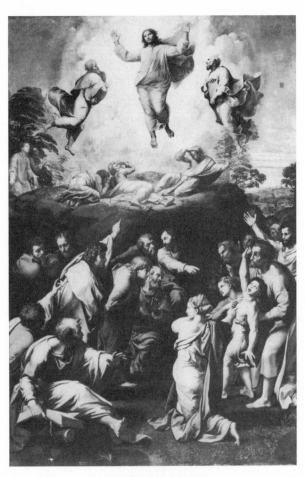

4. TRANSFIGURATION

Raphael, 1483–1520

The upper part of the painting depicts the moment in which Jesus, to encourage the disciples before his death, led three of them, Peter, James, and John, to a mountain (traditionally thought to be Mount Tabor) and was transfigured in front of them. The Gospel reminds us that the face of Jesus became "bright like the sun and his clothes white like the light." The prophets Elijah and Moses are depicted in conversation with him.

In the Footsteps of Popes

In the lower part Raphael painted another passage of the Gospel: the young boy possessed by a demon. On the right you can see the young boy overtaken by demonic spirits. While the parents of the child ask for help from the apostles, they are shown indicating that only Christ can save their son.

Just a note on the young boy: His arms appear too muscular for a young man and his eyes and mouth are distorted. To comprehend this apparent deformation, we must remember that the devil has entered the boy's body and has incredible strength. It may be that Raphael wanted to emphasize the fiendish shriek and anger of the demon who must acknowledge his defeat in the presence of the Lord.

The kneeling figure in the foreground almost surely represents Faith, who is inviting the apostles to help the young boy. Notice the powerful foreshortened right arm of Faith; it is a sure sign of the influence that the frescoes by Michelangelo exerted on Raphael. It is quite similar in style to the arm of one of the powerful Sibyl we will admire later in the Sistine Chapel.

Begun in 1518, the painting of this oil on panel was interrupted in 1520 by Raphael's sudden death at the early age of thirty-seven.

0—⚷ There has been a long-standing controversy about how much of this painting was actually done by Raphael himself. A recent restoration brought back to its original state the exquisite tonality of the colors of the lower part of the painting. The perfection of the forms, as well as the evident connection and chromatic balance between the lower and upper parts, confirm that the painting was almost completely done by Raphael. This would indicate that the contribution by his pupils, in particular by Giulio Romano, was very limited.

So, why is there so much contrast between the two parts of the painting? This was done on purpose! The great Raphael wanted to invite us first to admire the serene upper scene while very deftly involving us in the crowded lower scene. We tend, by some interior need, to raise our sight on high automatically,

Enrico Bruschini

almost as if trying to rise above the chaos to reach once again the vision of peace and joy, in a crescendo of sensations that make the heart beat a little faster. This magnificent painting can be considered Raphael's spiritual and artistic testament.

During the artist's funeral ceremony, his faithful students hung the painting of the *Transfiguration* above his body laid out for public viewing. Giorgio Vasari, a Tuscan painter, architect, and writer who described the life and works of the most important artists of his time, so describes the vision: "Seeing his body dead, and his work so alive, it felt as if our heart would break in two." Let us try to imagine this sad but moving scene!

If you are not in a hurry, I advise you again to sit for a few moments on the old-fashioned and elegant benches to admire one of the most moving works of all time!

ROOM IX: LEONARDO

At the center of the left wall there is an unfinished work by Leonardo da Vinci, ★ *Saint Jerome* (No. 40337). Saint Jerome, the translator of the Bible, is caught in a moment of penance as he is beating his chest with a stone.

Painted before 1482, the work is a monochrome of brown colors on top of darker colors. Knowing this helps us to understand better the effort made by Leonardo to obtain the intense expression of the head of the saint in the desert, with hollow cheeks and eye sockets, and the painful, dark line of the mouth.

The drawing of the powerful lion, barely sketched, is wonderfully done. (The lion remained forever faithful to him because the saint, discovering this wounded beast in the desert, had the courage to remove a thorn from its paw.)

The colored landscape in the upper left portion of the panel reminds us of the landscapes in *The Virgin of the Rocks* and *Mona Lisa*. In the right portion there is an architectural study of a church façade in Leonardo's distinctive style.

o—ᴛ Done in tempera on wood, this work was probably begun in Florence and remained as a sketch when in 1482 Leonardo

went to the court of Ludovico il Moro in Milan. (The *Last Supper*, which was recently restored, was painted for Ludovico.) The sketch became the property of Angelica Kauffmann, a Swiss painter, and was lost at the beginning of the nineteenth century when she died. It was rediscovered by an art connoisseur, the famous Cardinal Joseph Fesch, uncle of Emperor Napoleon, cut into two parts and being used as household scrap wood. The cardinal found part of the painting, from which the head of Saint Jerome had been cut off, in a second-hand shop. This mutilated piece of wood was being used as a cover for a chest. The wonderfully painted head was located only five years later by the same cardinal in a cobbler's shop, where it had become a stool! You can still discern how the two pieces were pasted together.

It is amazing to think about how many priceless works of art may still be scattered around the world.

ROOM X: VENETIANS
On the left wall is the big work by Titian, ★ *Madonna with Saints* (No. 40351). On the right wall is ★ *Saint George and the Dragon* (No. 40354), by Paris Bordon.

ROOM XI: LATE SIXTEENTH CENTURY
In the center of the right wall we find a pleasant ★ *Rest on the Flight into Egypt* (No. 40377), by Federico Barocci. The painting is known as *The Madonna of the Cherries* for the happy expression on the face of the Child Jesus receiving a branch of cherries from Joseph.

ROOM XII: BAROQUE
o—⚓ Before dedicating yourself to the paintings, take a moment to peek out of the window to enjoy one of the most beautiful views of the great dome of St. Peter's. Behind a large cedar of Lebanon, the dome appears to be almost suspended above the intense greenery of the Vatican gardens. Note that Michelangelo was seventy-two years old when he was appointed to supervise the work on St. Peter's Basilica and when he made his

Enrico Bruschini

calculations for the construction of the colossal dome. He worked on the dome until he was eighty-nine years old, reminding us once more that genius is ageless!

In front of the window is an interesting work, ★ *The Communion of Saint Jerome* (No. 40384)—oil on canvas—a very good work by Domenico Zampieri, known as "Domenichino," painted in 1614. It shows the old Saint Jerome (the saint already seen in the paintings of Leonardo and Raphael, a saint who struck the interest of many artists of the period), who had reached the age of ninety. Depicted almost at the point of death, he is asking to receive Communion, helped by his disciples, who are holding him up. At his feet we find the faithful lion that Saint Jerome had once aided in the desert.

To the right of the preceding painting, there is another very famous work of the Vatican Pinacoteca, ★ *The Deposition* (No. 40386), by Caravaggio—or perhaps it would be better to call this *The Entombment of Christ.*

☞ Michelangelo Merisi, known as "Caravaggio" (from the name of his home town in Lombardy), brought a new style to painting. At the death of Raphael, almost all of the other artists of the time continued to follow Raphael's style, or the "manner" of the master, giving birth in a certain sense to mannerism.

Almost half a century later, Caravaggio asked, "Why follow the manner of other artists when you can follow nature itself?" *The Deposition* is one of the most classic examples of this new realistic style.

Painted in 1604, this oil on canvas is a typical Caravaggio, with a completely black background from which the characters of the scene emerge, illuminated from top to bottom by a flash of radiant light. See *The Deposition* in the color insert.

☞ The figure of the dead Christ is very powerful. His arm barely touches the great sharp stone of his tomb, which almost punctures the picture plane, invading the space of the spectators.

In the Footsteps of Popes

Caravaggio loved using this invitation, which allows us to enter the painting and participate in the action.

John, the favorite apostle, with his face veiled by the dim light, holds up the lifeless body of the beloved Master. The face of the Virgin Mary is greatly contorted by her suffering while Mary Magdalene weeps. All of the characters are filled with great pain. Only Mary Cleophas shows an expression of desperation. On the right is Nicodemus, the Pharisee and friend of Jesus, participating in the action. His legs and feet are naked, which in Caravaggio's time caused quite a scandal, but they cannot be considered irreverent. On the contrary, these details impart a tone of reality and simplicity to the terrible and moving scene.

Beyond using deep blacks from which the figures detach themselves very forcefully, Caravaggio was able to obtain an intense white, in the draperies, never before obtained by other painters. Just look around at the works of his contemporaries to confirm this! The powerful white was obtained using a pure ceruse, or white lead, which was highly toxic but intensely bright. In examining paintings with X-rays, this white stands out powerfully because the lead halts the rays.

Let us end our visit to the Pinacoteca with the painting to the right: the ★ *Crucifixion of Saint Peter* (No. 40387), by Guido Reni. (A reprint of the painting can be seen in the introductory pages.)

The Bolognese painter Guido Reni was a student of ancient art and later a follower of the style of Raphael. Soon after arriving in Rome, he was greatly influenced by the art of Caravaggio. The *Crucifixion of Saint Peter* is clearly done in the style of Caravaggio for both the liveliness of the scene and the particular use of light.

o—⚷ Almost all of the painters of the day, and those who followed, were strongly influenced by Caravaggio's use of new colors as well as by his new and powerful naturalism. No one has ever been able to imitate him completely, however.

Enrico Bruschini

Speaking of imitators, it is interesting to remember what Michelangelo once said: "He who follows the footsteps of another will never be able to overtake him, as he would no longer have a trace to follow and would lose his way."

Passing through rooms XIII, XIV, and XV (it is surely difficult not to stop and to look at many of the other great works) you will reach the exit.

Exiting from the Pinacoteca you will find a self-service restaurant, a restroom, a post office, and a small souvenir shop.

Now turn left and then right. You will return to the hallway and go to the Courtyard of the Pine Cone.

C–Courtyard of the Pine Cone

To be able to appreciate the courtyard better, move a little further toward its center.

All art experts have a favorite spot where they like to pause with their guests. I prefer to stop close to the door facing the entrance (look at the star on the map), exactly at the point where it is possible to frame, almost one on top of the other, the modern great bronze sphere placed exactly in the center of the courtyard and the enormous dome of Michelangelo. The contrast is superb!

Looking at the wonderful profile of the dome one can note that on the top there is a round balcony that appears to be almost hung from the sky. This is crowded with people, who form a kind of "human crown" at the top of the dome. The visitors are looking at the most spectacular panoramic view of Rome. The climb to the dome is long and difficult, but the view that one can see and enjoy at the top is worth this great effort.

The Courtyard of the Pine Cone takes its name from the large ★ bronze pine cone located in the center of the apse. It was a fountain that during the time of ancient Rome spouted water from the many holes all around. Donato Bramante, the

27

great architect who built the New St. Peter's Basilica, also designed the courtyard.

○━━ Warning! The word "new" has a meaning that is particular in Rome. In this case we consider new a basilica that is a good five hundred years old. In effect, this is new with respect to the first basilica, built by Constantine more than 1,600 years ago above the tomb of Saint Peter.

At the beginning of the sixteenth century, Bramante built two long corridors, through which we will pass. These linked the palace of Pope Innocent VIII, built in 1490 (the palace on which there is the large niche), with the Vatican buildings, the Sistine Chapel, and St. Peter's Basilica.

In this courtyard one can really understand the meaning of the word *renaissance,* which we know means "rebirth."

If you look inside the courtyard at the pillars, with their beautiful Corinthian capitals, at the perfect proportions of the ★ large niche, or at the two small Doric temples above the same niche, you realize that everything "breathes" classicism. The styles and proportions of ancient Rome and Greece were reborn in the Renaissance. After the Gothic period of pointed arches, artists felt the need to return to the classical period and, with the study and measurements of ancient buildings still extant, the new classical style evolved.

A beautiful ★ Corinthian capital from the third century A.D. supports the pine cone. In the center of the capital, one can note the well-defined body of a winning athlete who is surrounded by the judges of the competition. On the sides of the pine cone you will see two bronze peacocks, symbols of immortality. These are modern copies. The original peacocks you will see later in the New Wing of the museums. They were found in Hadrian's mausoleum, which was later transformed into Castel Sant'Angelo. Under the peacocks there are two Egyptian lions. If you understand ancient hieroglyphs you can amuse yourself by recognizing in the cartouches at the base of the lions the

Enrico Bruschini

name of Nectanebo I, the pharaoh who reigned around four hundred years before Christ.

In 1990, a ★ *Sphere within Sphere,* a large modern piece of art by the sculptor Arnaldo Pomodoro, was placed at the center of the courtyard.

⊶ If you stop in the place indicated above, you will note that the contrast between the classic profile of Michelangelo's dome and the great modern bronze sphere creates a feeling of amazement. Surely it is not easy to comprehend modern art and its significance. Personally I see in the sphere the torment that afflicts our world today through war, hunger, and disease. But from the larger sphere a new sphere is about to break off; a new life, a new world is emerging. . . . A work of art is a true work of art only if it moves your soul!

Halfway up the great wall to the left of the sphere is a large head of Emperor Augustus, found on the Aventine Hill around five hundred years ago. If this is only the head, try to imagine the rest of the statue!

Leaving the courtyard through the large door opposite the one we entered, you can:

★ Turn left and climb the steps to reach the Pio-Clementine Museum and the Sistine Chapel.
★ Turn right and, if you have time and are interested in classical Roman art, you can visit the *Chiaramonti Museum.*

D–Chiaramonti Museum

This museum was arranged by the great sculptor Antonio Canova for Pope Pius VII Chiaramonti, who reigned from 1800 to 1823. It contains more than one thousand ancient Roman statues and reliefs. A visit to this museum requires at least thirty minutes. If you don't have the time, just quickly look at "The Marble People," as this large collection of busts

and statues is called, then climb the stairs on the left to the Square Vestibule of the Pio-Clementine Museum.

The Chiaramonti Museum is divided into fifty-nine compartments to the right and left. In the first compartments to the left we can observe busts of numerous Roman emperors and citizens and admire their true likeness. Notice how the Romans did not beautify their images as the Greeks did! The Romans preferred to depict the personal characteristics of their subjects, rather than idealizing them. If a person had wrinkles—or close-set eyes, a wide bulbous nose, or thin lips—the Roman sculptor would include these features in his work because they were the real qualities of the subject.

COMPARTMENT VII

The relief that merits more attention than the others is in Compartment VII to the left, identified by Roman numerals (check above, in the center of the arch).

One sees up above a ★ relief depicting Aglaurids (No. 2), the three sisters who donated the night dew to the fields. This is a beautiful Roman copy from the time of the emperor Hadrian (second century A.D.), derived from a Greek original of the fourth century B.C. (The different meanings of the expression "Roman copies" will be explained later while admiring the statue *The Discus Thrower* in the Room of the Biga. The first figure to the left has made a strong impression on more than one writer.

Note the grace with which the young girl slightly lifts up her ample clothing, allowing us to discover her moving feet. The left foot rests on the ground and the right foot rests only on one point. Her beautiful head is leaning slightly forward.

○━╼ This figure moved the German writer Wilhelm Jensen so much so that in 1903 he immortalized it as the main character of his novel *Gradiva, a Pompeiian Fantasy.* In 1906, at the invitation of the eminent Swiss psychiatrist Carl Gustav Jung, Sigmund Freud described "the delirium and desires of the novel by Jensen" and called this charming figure "Gradiva, the girl mov-

Enrico Bruschini

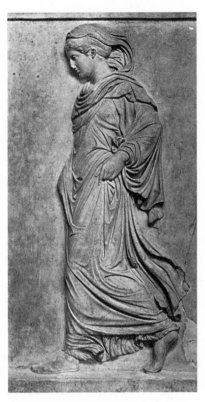

5. ONE OF THE AGLAURIDS

ing forward." Even Freud fell in love with Gradiva. After
numerous requests, he obtained a cast of this ancient relief
that is still preserved in his house in Vienna.

When Sigmund Freud saw the original relief in Rome in
September 1907, he wrote to his wife, Martha: "Imagine my
joy today when, after much solitude, I saw in the Vatican a dear
and familiar face, the Gradiva, . . . but almost surely she didn't
recognize me!"

Under the relief there is a series of good portraits, among
which one stands out for its true-to-life form, a portrait of a
woman (No. 13) of the second century A.D., which shows a

Roman matron, still beautiful, but with deep circles under her eyes.

COMPARTMENT IX

A beautiful Roman statue from a Greek original of the fourth century B.C. This statue of *Hercules with his son Telephos* (No. 3) was discovered in 1507 and acquired by Julius II for his collection of antiquities. Notwithstanding the lion's pelt, the powerful Hercules appears to be tender as any father.

COMPARTMENT XI

This compartment contains a statue of the head of Marcus Tullius Cicero (No. 12), writer, orator, counselor, and friend of Caesar. This interesting portrait was found at the Villa dei Quintili, a noble residence on the Old Appian Way.

COMPARTMENT XIX

Head of the so-called ★ Caius Marius (No. 13). Portrait of a man of the Roman Republic, end of the first century B.C.

COMPARTMENT XLIII

Resting on the ground, there is a small statue of *Ulysses* (No. 18), who is offering a cup of wine to the giant Polyphemus. It is a Roman work of the first century A.D. The pose of Ulysses is astonishing, demonstrating courage and terror at the same time. He is offering the wine—however at the same moment he is also readying himself to flee!

Proceed to the end of the gallery, where you may turn to the right to see the most interesting part of the collection: the New Wing.

D I—New Wing

This lighted gallery was inaugurated in 1822 and is supported by elegant columns made of ancient marble and granite. The floor is formed by elegant Roman mosaics of the second century A.D. with black and white tesserae.

In the third niche on the right there is a beautiful statue of

★ *Silenus Cradling the Child Dionysus* in his arms (No. 11). It is a Roman copy of an original by the great sculptor Lysippus of the fourth century B.C. The expression of the old wise Silenus, who is leaning on a tree trunk and rocking in his strong arms the young tender boy Dionysus (or Bacchus for the Romans), the god of wine and pleasures of nature, is very sweet. The meeting of their glances and the natural enthusiasm of the embrace of the child are notable. The works of the Renaissance and Baroque periods are indebted to these works of antiquity.

⚬━🔑 Note the considerable traces of color in Silenus's hair and beard, and on the tree used as support. This means, even if it appears baffling to us, that almost all ancient marble statues were painted! (We will further explain this fact in front of another sculpture where the color is more evident.)

Continuing on, in the fourth niche one can admire one of the most interesting pieces in the New Wing: the beautiful statue ★ *Augustus of "Prima Porta"* (No. 14). It was found in 1863 near Prima Porta, located on Via Flamina, to the north of Rome, where the summer residence of his wife Livia was sited.

The emperor is depicted as a supreme commander of the army in the act of talking to his soldiers with great pride. Near his right leg there is Cupid riding a dolphin; both are symbols of the goddess Venus, the progenitor of the *Gens Julia,* or the Julian Clan, the family of Augustus. Filled with strength and intelligence, his face is captivating and makes us easily understand why not only Livia, but also all of the women and men in Rome admired the emperor who had made Rome into a great and powerful empire!

⚬━🔑 It is thought that Livia, Augustus's wife, requested this statue after the emperor's death in A.D. 14. It is believed to be a copy of a described statue in bronze officially sculpted in his honor when the emperor was about forty years old (the original bronze statue no longer exists). It is still possible to see traces of color on the relief in the center of the armor.

In the Footsteps of Popes

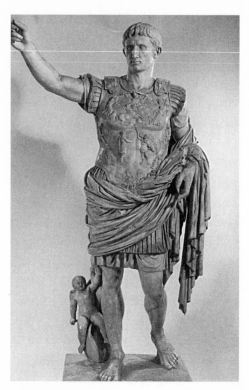

6. AUGUSTUS OF "PRIMA PORTA"

On the wall behind you, right in front of *Silenus*, there is another famous statue: ★ *The Doryphorus* (*The Spear Bearer*) (No. 123), a beautiful Roman copy of a celebrated bronze original by Polycletus, 440 B.C., that no longer exists.

We know that Polycletus, the celebrated Greek sculptor of the fifth century B.C., in his theoretical work the *Canon*, established the proportions of the human body and the principles that action and inaction must alternate in a figure. For example, one leg carries the weight of the body, while the other is relaxed; the arm opposite to the leg in action is also in action, that is, it carries something like a weapon and the other arm is at rest. Polycletus created a model statue to exemplify these principles. The statue in front of us could be the copy of the

lost original by Polycletus! The *Canon* greatly influenced
Greek and Roman art. The wonderful statue of Augustus,
which we have already seen, shows identical principles!

Continuing on the same side, in the niche before the large
apse in the center of the hallway, we will see the beautiful
statue of the ★ *Giustiniani Athena* (No. 111), so named from
the noble Roman family who were its former owners. This
work has been sculpted in Parian marble (from the Greek
island of Paros, famed for the most beautiful and precious white
marbles). It is a wonderful Roman copy of the second century
A.D. from a Greek bronze original of the fourth century B.C.

○━☞ Johann Wolfgang von Goethe, the great German writer,
described this statue in his *Trip to Italy* of January 1817, when
the statue of Athena was still at the Giustiniani Palace in
Rome. He wrote that, since he had remained for such a long
time to admire the statue and did not tire of staring at it, the
female guardian of the building asked him if perhaps the
statue resembled one of his lovers. Goethe thought to himself:
"That lady, with very simple tastes, could comprehend human
love, but she couldn't imagine the pure admiration of a noble
artwork!"

Athena was the Greek goddess of the arts, justice, and the
sciences, and was considered the embodiment, or symbol, of
knowledge. She was born from the head of Zeus (Jupiter for the
Romans) already wearing a helmet and holding a lance. Greek
mythology records that Zeus, plagued by a bad headache,
asked Hephaestus (Vulcan for the Romans) to break his head
with a blow from an axe, and when he did this, Athena sprang
out from the head of the father of the gods! She was the protec-
tress of war, or, better yet, a protectress of one of the aspects of
war: strategy. Mars attended to the other aspects of war, the
bloody part.

Athena was especially venerated in the city of Athens,
which took her name. Her attributes were the lance, helmet,

In the Footsteps of Popes

and armor on which the head of the Medusa was placed in order to turn Athena's enemies to stone when they had the audacity to look at it.

0—🗝 Three animals were sacred to Athena: the owl, the rooster, and especially the serpent, as you can see from this sculpture. We must remember from Greek mythology that the serpent was celebrated as a positive animal. Since the serpent lived primarily underground, it was associated with the formative phase of the earth, and because of its ability to change its skin, it became a symbol of continual renewal.

In a few minutes, we will come upon the magnificent statue of the *Laocoön* and we will note that the two very large snakes sent by Athena contributed to the fall of Troy.

In the ample central apse, an enormous figure lying down in front of us captures our attention. This is the statue of ★ *The God Nile* (No. 106), which was recently restored thanks to the generosity of the Pennsylvanian Patrons of the Arts in the Vatican Museums.

The god Nile holds in his left hand a cornucopia full of fruit, a symbol of abundance, and in the right hand, ears of wheat, and he is lying in the typical position that the ancients used to depict river divinities. It is therefore easy to recognize him as the god of the River Nile because he has a sphinx supporting his left arm, and at his feet there is a crocodile cheerfully playing with two putti (children).

0—🗝 The sixteen children that are playing and almost climbing on top of the large body of the god Nile are likable symbols of abundance. To understand their significance we must remember that every year around the end of September the Nile River flooded. As a result, the river deposited on the nearby lands a thick layer of fertile mud and bountiful water for irrigation. How much did the Nile have to grow to give an abundant harvest? Sixteen cubits, or arms, about 26 feet (7.9 meters). If you imagine placing all the little putti one on top

Enrico Bruschini

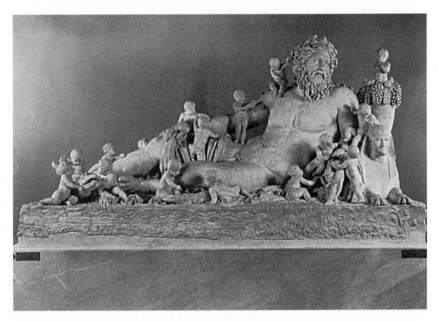

7. THE GOD NILE

of the other, you can visualize the actual height of the water needed to obtain the overflow of the river!

The statue was rediscovered at the beginning of the sixteenth century near the Pantheon, where there was a monumental temple dedicated to the goddess Isis, together with another large sculpture representing the god Tiber. The two statues were immediately brought to the Vatican, only to be confiscated by Napoleon in 1797. Along with many other Vatican and Italian artworks they were sent to Paris to give to the capital of the new Napoleonic Empire the same grandeur that had characterized from ancient times the universal preeminence of Rome. Fortunately, after the fall of Napoleon, with thanks to a great diplomatic effort by Antonio Canova, almost all of the artworks were recovered.

Unluckily, the impressive statue of the god Tiber is still at the Louvre. It remained in Paris as a "donation" from Vatican

In the Footsteps of Popes

diplomacy to the restored French monarchy that had contributed to Napoleon's final defeat.

Just in front of the statue of *The God Nile* is a *Portrait of Julius Caesar* (No. 301) (assassinated on March 15 of the year 44 B.C.). Regrettably, as the surface of the marble was in poor condition, the portrait has been extensively reworked and has lost much of its initial beauty.

The splendid originals of the two ★ Roman bronze peacocks (Nos. 30C and 30D) found in Hadrian's mausoleum were recently placed on either side of the bust. Note the perfection reached by Roman artists in the reproduction of animals. For the ancient Romans, the peacocks were a symbol of immortality due to an ancient legend saying their meat was imperishable; therefore, for the first Christians, they became symbols of the resurrection.

At the end of your visit to the New Wing it is advisable that you return to the entrance of the Chiaramonti Museum to follow through to the *Pio-Clementine Museum.*

While returning toward the entrance, notice to the right the lunette in Compartment XXI. An important historical event was painted there. Antonio Canova, the great Italian sculptor who contributed to the recovery of the works of art pillaged by Napoleon, and who had been commissioned to prepare and beautify this part of the museum, asked the Italian painter Francesco Hayez to illustrate in this lunette the return of the artworks to Rome. Note, to the left, the wagons returning to Rome with the ancient works of art, as they are passing under the little hill of Monte Mario, very near the Vatican. On the right of the lunette is *The God Tiber.* You will remember that this is the statue which was left in Paris as a donation by Pius VII to the new French king. It also represents the Tiber River in Rome, which flows near the street where the wagons are traveling. He watches with pleasure the return of the confiscated works.

The painted bust in the left foreground is a portrait of Sir

William Hamilton, then the English Undersecretary for Foreign Affairs, who took a personal interest in the restitution of the artworks to the Vatican.

COMPARTMENT XVI

There is a huge head of Athena (No. 3). It is a Roman copy of a work by Phidias in the fifth century B.C. The big eyes made of glass are impressive.

E–Pio-Clementine Museum

This museum is named after popes Clement XIV (1769–1774) and Pius VI (1775–1799), who collected primarily Roman marble statuary.

As you climb the steps, look up at the ceiling and the walls. You will see light figures on a white background. This is one of the best examples of the grotesque style.

○──➤ To understand this style, we must go back to the time of the Emperor Nero. He was cruel, but he had wonderful taste. After the fire of A.D. 64 he wanted to reconstruct his house, the Domus Aurea (Golden House), more beautiful than anything Rome had ever seen. Nero chose the best painter of the time, Fabullus, who invented a new style: light fantasy figures, half animal and half flower, painted with geometric symmetry on a white background.

During that time, in other important cities such as Pompeii and Herculaneum, very vivid colors such as yellow or black, or even the well-known Pompeiian red were the preferred colors for background painting. In Rome, Fabullus preferred the more classical white for Nero's house.

Consider that when Fabullus climbed the scaffolding of the Domus Aurea, he wore his most elegant white togas (remember that for ordinary Roman citizens togas were only white in color; only the emperors used the purple toga), as recounted by Pliny the Elder, the great Roman historian. This might be considered a crazy idea, to wear a white toga when

painting with colors! But Fabullus wished to be elegant because he was sure that he was doing a very special thing, he was painting for future generations!

Only today do we realize how farsighted Fabullus was.

After Nero's death the house was slowly stripped of its works of art (later we will see the most beautiful of them, the magnificent *Laocoön*). Finally in the year A.D. 104 the emperor Trajan covered Nero's house completely with his large new thermal baths.

The Golden House remained underground, forgotten, but miraculously preserved. Only at the end of the fifteenth century, through holes dug in the gardens of a small hill in front of the Colosseum, did artists discover the wonderful frescoed ceilings of the old residence. After the discovery, most of the best artists present in Rome to paint the walls of the Sistine Chapel rushed to the site to admire the frescoes. Visits by Ghirlandaio, Pinturicchio, Perugino, and Filippino Lippi are certain. Later painters, such as Giovanni da Udine and Raphael, also entered to see the frescoes and to admire the perfection of Roman art. These artists did not realize that the ruins that had been discovered were actually rooms from Nero's house. The frescoes seemed to be painted on the ceilings of long tunnels or natural "grottoes," as the rooms were almost completely filled with dirt.

These magnificent frescoes came to be called "grotesques," which initially meant "in the style of the frescoes discovered in the grottoes in front of the Colosseum."

As a result of his visit to Nero's house, Raphael decorated the famous Loggia of the Vatican in grotesque style. This style was admired as long as the figures of the grotesque remained light, as in the works of Raphael and his followers, and were not overdecorated. Later on, less able painters depicted the figures much heavier and mixed together with too many ornamental motifs, resulting in bizarre, ridiculous, almost "grotesque" scenes, so that, in the end, the word changed its meaning as we know it today.

It is only in this hallway of the Vatican buildings that we can see both forms of the grotesque style. The walls and ceiling

Enrico Bruschini

of the staircase were painted by pupils of Raphael, who almost certainly had entered the Domus Aurea with their master. The style is light and pleasing. The room at the top of the stairs, on the other hand, was painted by Daniele da Volterra. He is the same painter who, in 1564, as it will be described later, was ordered by Pope Pius IV to partially cover the "scandalous" nudes of Michelangelo in *The Last Judgment* in the Sistine Chapel. The difference is evident.

Halfway up the stairs, there is a small bathroom with cool drinkable water.

SQUARE VESTIBULE

To the left, in the niche, there is the large ★ *Sarcophagus of Scipio Barbatus* (Scipio the Bearded). He was consul in 298 B.C., ancestor of Publius Cornelius Scipio, called the "African," because he was the conqueror of Carthage. The beautiful sarcophagus is done in gray tufa, a soft volcanic rock (at that time, marble was not yet used in Rome). The elegant ornamental motif shows a clear Greek influence. The long funeral eulogy engraved on the sarcophagus is one of the most important texts in ancient Latin. It explains that Scipio was a man of great virtue who had strengthened and enlarged the Roman Republic by conquering neighboring regions, including the Sanniti and Lucani populations.

0—➤ Because of the importance of the person and especially the beauty of the sarcophagus, this work was moved to the Vatican from the still extant sepulcher of the Scipio family on the Appian Way. Till last century, at the time of the Papal States, works of art were often moved to the Vatican, especially those lying outside churches or other buildings, to protect them from being stolen or destroyed.

BALCONY ROOM

Let us continue with the Balcony Room. If the balcony is open, we can understand why this palace, built for Pope Innocent VIII at the end of the fifteenth century on the highest part

of the Vatican Hill, was called Palazzo del Belvedere, that is, the palace with the great view. The ★ panorama from the balcony (or from the window on winter or on rainy days) is really spectacular. From right to left, there is a succession of palaces and domes—small and large—which make the skyline of the Eternal City unique in the world!

○━┳ We could stay and admire this panorama for a long time while recognizing the most interesting buildings of Rome, but this pleasurable activity would greatly distract us from our visit. We have to limit ourselves to that which is strictly connected to our tour.

On the right, at the end of the long wall of the Bramante hallway, the Papal Residence is truly impressive. In front of us we see a dark round building that looks like a fortress, with a statue of an angel with open wings topping it. This is Castel Sant'Angelo, which was the mausoleum that the emperor Hadrian had constructed for himself on this side of the Tiber River. The mausoleum was transformed by the popes into a strong fortress, and a series of arches make up an ancient passageway that still connects the Papal Palace with the castle. In case of emergency, the popes could reach the castle and secure themselves inside. This happened in 1527, when the German troops of the emperor of Germany and Spain, Charles V, besieged Rome, and Pope Clement VII escaped to the castle just in time to avoid capture.

For those who love opera, remember that this is the castle in the opera *Tosca*. Puccini, the composer, imagined that the execution of Cavaradossi, Tosca's lover, would take place on the terrace of Castel Sant'Angelo, and that from the terrace Tosca would throw herself into the Tiber.

Before leaving the balcony, lean over, if it is open, to look below at a small, unknown treasure, a small Lead Galley of the seventeenth century that seems to float in the center of a basin. As a symbol of peace, water shoots out of the numerous cannons.

Enrico Bruschini

In passing to the next room a large Latin inscription on the wall records that the great Leonardo da Vinci was invited by the Florentine Pope Leo X to use these and other rooms of the Belvedere Palace (of course not yet a museum) as his workshop and residence. Leonardo lived here from 1513 to 1516.

0—⚷ We can imagine the great artist and scientist, then in his sixties and very famous, absorbed in his studies. The writer Vasari described the surprising and even frightening inventions he made here such as inflatable animals from a paste of his invention, new oils and varnishes, and tricks with mirrors. He also fashioned wings, a horn, and a beard for a lizard found in the Belvedere garden and this changed creature frightened many visitors.

How many times did Leonardo stand on the nearby balcony and gaze out into the countryside, resting from his many and diverse studies? The view was certainly different from that of today. From the hundreds of domes that form the skyline of the Eternal City, Leonardo in his time could have seen only three: the ancient dome of the Pantheon (it is still possible to admire it from the balcony; it is the large, quite flat dome to the right of the Castel Sant'Angelo) and the two smaller domes of Santa Maria del Popolo and Sant'Agostino.

Who knows how many times Pope Leo X, the son of the Florentine Lorenzo the Magnificent, would have conversed with his celebrated guest in these rooms?

In the center of the Vestibule, there is a paonazzetto basin, made of a special white-and-purple marble.

ROOM OF THE APOXYOMENOS
In the small room to the left of the balcony, there is another masterpiece of the Vatican museums: ★ *The Apoxyomenos.*

The title in Greek means "the man wiping himself off." It is a wonderful Roman copy of a bronze statue representing an athlete by Lysippus, one of the greatest Greek sculptors of the fourth century B.C. The artist makes us understand that this athlete was a runner—observe his long legs. If Lysippus had

wanted to depict a boxer he would have sculpted an athlete with a powerful chest and arms.

This runner is not depicted during the competition but rather during the cooling-down period after the race. He is wiping off his right arm with a particular tool, a *strigil,* a sort of curved spatula.

○━ The ancient Greeks knew about soap. However, knowing it was too caustic, they limited its use to washing clothes. To cleanse their bodies, especially in the gyms, both ancient Greeks and Romans used to rub their skin with oil and pulverized pumice stone, and then remove it using a strigil. This is exactly what Apoxyomenos is doing!

Note how his face is completely relaxed. This is also an invention of the great Lysippus: In sculpting, he would puff up the part between the eyebrows and eyes. This little trick sufficed, as can be noted, to give an expression of complete relaxation to the face.

The Roman writer of the first century A.D. Pliny the Elder described in his book *Naturalis Historia* this marvelous statue, saying that it was copied in marble in Rome during his time. Agrippa, the son-in-law of Augustus, transported the original from Greece to Rome. Unfortunately, the bronze original has disappeared, perhaps melted down in some past century. Luckily the Romans had the good taste and the time to carve this copy in marble, and it is the only one in existence. Even this beautiful copy had disappeared and was only rediscovered in 1849 in Trastevere, a Rome neighborhood, buried under a narrow street renamed Vicolo dell'Atleta (Lane of the Athlete).

○━ It is easy to recognize *The Apoxyomenos* as a marble copy of a bronze original, as statues made in bronze are empty inside. The thickness of the bronze is around 4 or 5 millimeters and the weight of the statue can easily be supported by the legs and in particular by the ankles. It is only necessary to secure the feet of the statue to the base. However, when the same statue is

Enrico Bruschini

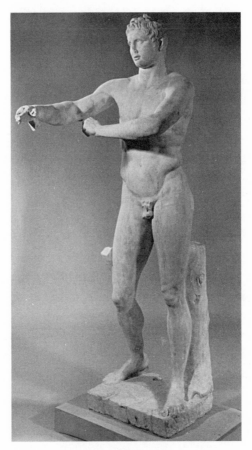

8. THE APOXYOMENOS

Lysippus

copied into marble, it becomes very heavy and the ankles are too fragile to support it. The Roman copyists of Greek originals were thus obligated to add a third support connected to the statue—such as a tree trunk, as in this case, or an animal (as the dolphin supporting the statue of Augustus seen in the New Wing). For women, the support could be an amphora or some article of clothing.

If you look closely you will notice that even the right arm at one time had a support. Today it has been removed, and instead a steel pin has been set inside the arm to add strength. The left arm is also connected to the body by a support.

Surely the original in bronze did not have a need for all of these nonaesthetic supports.

VESTIBULE OF THE STAIRWAY

Facing the door of the little Vestibule of the Stairway behind *Apoxyomenos,* it is possible to see Bramante's beautiful spiral stairway, the first of numerous spiral stairways built in Rome. It was built at the beginning of the sixteenth century for Julius II, the great pope of the Renaissance, to provide an entrance which could give access on horseback to the upper floors of the palace from the lower external garden of the Vatican.

In accordance with the principles of Vitruvius, the Roman architect of the first century B.C., the columns are of three types: Tuscan (Doric with a base) in the lower section, Ionic in the middle, and Corinthian in the top section. It would be hard to find a more elegant "elevator"!

Returning to the Balcony Room and turning to the right we enter the Octagonal Courtyard.

El–Octagonal Courtyard

This courtyard, once called the Little Courtyard of the Belvedere, is adorned with beautiful Greek and Roman statues. Its significance goes beyond its function as an appendage to the main building, because it contributed in an essential way to the Renaissance!

☞ In 1503 Giuliano Della Rovere, immediately after being elected pope with the name of Julius II, brought his personal collection of ancient statues to this courtyard and invited the artists of the time to view them (in those days it was not easy for an artist to find a large collection of important artworks in one place).

Artists who came to the Little Belvedere began to admire, draw, and copy the classical statues. They rediscovered the ancient styles and appreciated the perfection of the proportions, the softness of the feminine bodies, and the vigor of

Enrico Bruschini

9. OCTAGONAL COURTYARD

the masculine ones. It is certain that Julius II, thanks to his generous exhibition of artworks, contributed to reviving classical art.

We can say that the year 1503, with the opening to the public of this courtyard, constitutes the official founding year of the Vatican museums.

APOLLO ALCOVE

Let's begin with the magnificent statue in the left corner, the famous ★ *Apollo Belvedere* (No. 2). It was the most beautiful statue of the private collection of Julius II. A Roman copy in marble from the second century A.D., the original was almost surely the celebrated bronze statue by the Greek sculptor Leochares (fourth century B.C.). The Greek writer Pausanias reminds us that this beautiful statue was one of the principal ornaments of the Agora, Athens' main square.

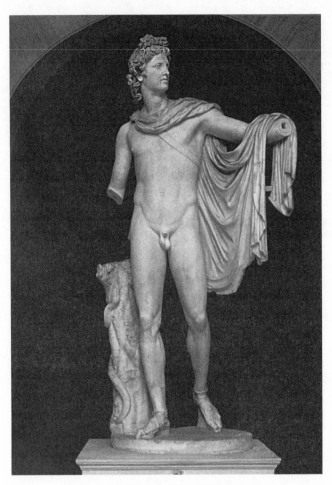

10. APOLLO BELVEDERE

This statue depicts the god Apollo who has just shot an arrow and is watching it hit the target.

Michelangelo saw this statue and admired, above all, the divine face and hair of the god. He reproduced them in the Sistine Chapel. We will find them in the head of Christ in *The Last Judgment*!

O—⚷ Apollo's body was considered by Michelangelo not to be very muscular, but the majority of art historians consider this statue to be one of the most beautiful ancient sculptures. For

Enrico Bruschini

example, Winkelmann, the famous German art historian, wrote in 1764: "The statue of Apollo is the highest ideal of art among all the works of antiquity to have survived destruction."

Get closer to the statue to admire the lightness of the cloak, which almost doesn't seem to be made of marble; note the perfection of the sandals and the softness of the hair. The quiver with the arrows is supported behind the back by a strap.

The statue was found without hands and without the right forearm. In 1532 the sculptor Montorsoli, a friend of Michelangelo, carved a forearm and new hands for restoration purposes.

The added parts created perplexity among archeologists and art historians, however, because they did not seem to be in harmony with the original parts. Finally in 1924–1925, the added parts were removed.

Very recently, in August 1999, the arm and the hands sculpted by Montorsoli were unexpectedly reattached. The illustration on page 48 shows the statue before the pieces were reattached.

After the initial surprise, and perhaps the disappointment from the habit of seeing the statue without the added parts, I began to think about Apollo's new appearance. It is interesting to see the statue as it was completed in the Renaissance and how it appears in all the old engravings depicting the statue. But strong reservations remain about the wrong restoration done by Montorsoli. The left hand, holding the bow, although acceptable, surely doesn't have the softness and the beauty of the original. But the greatest perplexity is caused by the right arm, which definitely was not originally in that position!

The divine archer has just shot an arrow and is checking his target. The right arm, which sustained the force of the tension of the bow, had to fall, almost vertically, hanging down the side, and most certainly could not have remained almost suspended in that unnatural position as seen in the restoration. To leave the arm suspended, Montorsoli had to add an antiaes-

thetic extension to the original tree trunk to give the additional support needed for the arm. The first Roman arm support, still perfectly visible on the upper part of Apollo's right thigh, demonstrates instead how the arm must have fallen very softly on the hip.

Despite Montorsoli's inaccuracies, it should be recognized that the replacement of the forearm and hands increases interest in the displayed work.

Let's continue with the visit in a clockwise manner. To the right of *Apollo* there is a large bathtub in rose-colored granite (No. 22). The two columns to the left of *Apollo* are also made of this beautiful stone. Remember that almost all of the enormous obelisks brought to Rome from ancient Egypt were made of this elegant and extremely hard volcanic rock.

○━━ We must imagine the rich Roman matrons taking baths in such beautiful and costly bathtubs. The tradition reminds us that the very beautiful Poppea, lover and then wife of Nero, used to bathe in the Domus Aurea in this type of tub, full of lukewarm donkey's milk, because of its softening properties!

ALCOVE OF THE STATUE OF *THE RIVER TIGRIS*

Further to the right, in the central alcove, the statue of *The River Tigris* (No. 16) is displayed. It is a Roman work from the second century A.D. that was found seriously damaged. The head, the right arm holding a jug, and the left hand were added on by sculptors, friends of Michelangelo.

○━━ Take a look at the head. It is so incredibly beautiful that it is possible to think it a work of Michelangelo himself even if we cannot prove it. It closely resembles the famous *Moses* carved by Michelangelo from 1513 to 1516.

Under the statue of the river is a sarcophagus (No. 17) from the second century A.D. with scenes of a battle between the Greeks and the Amazons.

Enrico Bruschini

○━ It is terrible to think about the real meaning of the word *sar-cophagus*. It is composed of the Greek words *sárx-sarkós*, "flesh," and *phagêin*, "to eat," therefore, "flesh-eater." This means that if we put a body inside a sarcophagus, in the end we will find only the bones. It is truly sad. I prefer to look at the sar-cophagi for their artistic beauty, and try to forget about their practical use!

On the two columns that decorate this niche there are two ★ capitals in green marble. It is worth observing them with close attention. They are carved in a particularly elegant stone, Serpentine, so called because this beautiful marble has green spots similar to the color of snakeskin. It was used a great deal in ancient Rome to decorate floors. The use of serpentine mar-ble to sculpt capitals is quite rare.

To the right there is another elegant bathtub in gray granite (No. 13). A good part of the columns of ancient Rome, as well as many of the columns of this courtyard, are made of this resistant volcanic rock.

CABINET OF *THE LAOCOÖN*

In the next corner, to the right, we find perhaps the most famous statue of the entire courtyard. It depicts the priest ★ Laocoön (No. 2), who was killed together with his young sons by two snakes.

○━ Laocoön was the priest of Troy. Remember that the siege of Troy by the Greek King Menelaus was to vindicate the offense by the Prince Paris, who had kidnapped his beautiful wife, Helen, in the thirteenth century B.C. The siege was long, last-ing more than ten years, but the walls were strong and the city resisted. The Greeks needed to find a solution, and Ulysses, the cleverest of the group, finally devised a plan. The great Latin writer Virgil describes it in his epic, the *Aeneid*. Ulysses had a great wooden horse constructed, which his men left on the beach in honor of the goddess Athena. The Greek fleet

In the Footsteps of Popes

then raised their anchors and departed. The inhabitants of Troy were at first perplexed but finally, believing that the siege was over, started a celebration.

As the Trojan Horse was being dragged into the city as a sign of victory, only one man opposed this idea, Laocoön. He had a premonition about the horse (Ulysses, along with the other warriors, had hidden himself inside). Laocoön did everything possible to warn the Trojans against bringing the horse inside their walls, after flinging a lance at the horse, and noticing the sound of banging metal coming from within (the weapons of the Greeks).

But the Trojan War was also a war between Divinities with the gods continuously intervening by assisting or hindering one side or the other. The goddess Athena, protectress of the Greeks and enemy of the Trojans (remember that Paris, who had offended Athena by giving the golden apple of discord to Aphrodite, was a Trojan!) finally intervenes and does everything she can to stop Laocoön. She sends two enormous snakes to kill him together with his two sons.

Note in the astonishing statue Laocoön's powerful muscles, the veins, the taut feet, and the amazed expression on his face. He is suffering not only from the bite of the snake that is gnawing his side, but he is also struggling internally because he is trying to save his city and cannot understand why the gods are against him. He is naked because for the ancients nudity signified purity. See *Laocoön* in the color insert.

○—⚷ The statue of Laocoön was seen in ancient Rome and described by Pliny the Elder, the Roman writer and scientist who died during the eruption of Pompeii. Pliny wrote that the *Laocoön* in Rome was the work of art that surpassed every other sculpture and painting!

The statue had been lost and was only rediscovered in 1506 during excavations carried out at Nero's residence, the Domus Aurea.

Enrico Bruschini

As soon as Julius II heard about the discovery he immediately acquired the statue and displayed it in this courtyard as a precious part of the very young archaeological collection of the Vatican. Michelangelo, who was present at the discovery of the statue, was extremely impressed by its beauty and strength. We can say that the powerful figures of the vault of the Sistine Chapel, begun in 1508, two years after the discovery of the *Laocoön*, were offspring of this statue. The idea of painting the angels of *The Last Judgment* without wings and nude, as a symbol of purity, also found inspiration here!

This is a Greek original sculpture executed in marble by a sculptor from the island of Rhodes, Hagesandros, and his two sons, Athenodoros and Polydoros. It was carved almost certainly in the first century A.D. for the emperor Tiberius.

○—⚷ A brief note to shed light on another aspect of the genius of Michelangelo. The statue was found missing its right arm. According to an old tradition Michelangelo began to sculpt the missing arm, but then, for lack of time, or because he went to Florence, or for other reasons we may never know, he never finished it. Pope Clement VII in 1532 commissioned another sculptor, Montorsoli (the same sculptor of the reattached forearm of the *Apollo Belvedere*), to prepare a new arm, which he erroneously sculpted in a stretched-out position.

In 1905 the Swedish archaeologist Ludwig Pollack found the authentic arm in the marble workshop of a Roman artisan, perhaps the fruit of clandestine excavations, and he donated it to the Vatican. The arm was completely different from what Montorsoli had imagined because it was bent in the act of tearing the snake off his body.

After a good fifty-five years, in 1960, during the accurate restoration done by Filippo Magi, the arm made by Montorsoli was removed (from a visual point of view he had ruined the beautiful pyramidal form of the Laocoön group), and the original arm found by Pollack was attached, as you see it today.

11. LAOCOÖN,
with the
arm by Michelangelo

What happened to the arm carved by Michelangelo? It still exists and it is incredibly near the statue even if we can't see it. The arm sculpted by Michelangelo is attached with two iron fasteners behind the base of the statue. I was fortunate to see it, with special permission, some time ago, and I was left quite shocked! The arm is flexed! Michelangelo had perfectly guessed its position, having understood the movement of the muscles on the torso where the arm was attached. With an almost paranormal genius, he had reproduced the original... without ever having seen it!

An experiment was conducted some years ago. When the Montorsoli arm was removed, and before attaching the arm found by Pollack, the arm created by Michelangelo was attached temporarily to the statue. Searching in the well-organized photographic archives of the Vatican I found a picture taken on that occasion and I am very happy to show it to the readers of this publication so that we might enjoy together the superhuman genius of Michelangelo!

You can see that, incredibly, it is nearly identical to the original arm of the *Laocoön*, the one which was found three centuries after Michelangelo had done his without ever seeing the original, but just envisioning what it should have been like!

Enrico Bruschini

In my opinion, after the close examination that I had of the arm carved—according to the tradition—by Michelangelo, the old attribution to the great artist could be confirmed. The astonishing "non finito" (not finished), and the personal way of using the flat chisel and the toothed chisel are typical of Michelangelo's modus operandi (manner of working)!

It is really a shame that Michelangelo's intuitive solution (or in any case a sculpture of the Renaissance) is not shown to the public. If I can allow myself a modest suggestion, a simple small mirror behind the statue, in the proper position, would be enough to let us see the arm as sculpted by Michelangelo. Perhaps it would be simpler and more logical to put this incredibly perfect arm in a glass showcase in front of the statue!

Further to the right, two Molossians (mastiffs) seem to be guarding the door to the entrance of the museums. We will enter there in a few minutes, but in the meantime let us look at the next statue in the corner further to the right.

ALCOVE OF HERMES

This statue of the Greek god ★ Hermes (for the Romans the god Mercury), the messenger of the gods, is a Roman copy from the time of Hadrian, second century A.D., of a Greek original in bronze from the school of Praxiteles (fourth century B.C.). It was once known as the *Belvedere Antinous,* perhaps because it was found near Castel Sant'Angelo, the mausoleum of the emperor Hadrian, protector of Antinous. The very sad face identifies the statue without a doubt as Hermes' *Psychopompos,* the escort of the dead to the underworld.

From the moment of its discovery, the statue has always been considered as an example for the proportions of the human body. Nicolas Poussin, the French painter of the seventeenth century, esteemed it to be "the most perfect example of the male body."

This statue has been recently restored thanks to the California Patrons of the Art in the Vatican Museums.

In the central niche, to the right of Hermes, is the statue *Venus Felix,* a Roman work derived from the famous *Aphrodite of Cnidos* by Praxiteles. Venus is shown preparing for her bath with her son Eros, the god of love whom the Romans called Cupid, beside her. The head is a portrait from the second century A.D.

Who is the woman whose countenance graces the *Venus Felix,* or "the Fortunate Venus"? The facial type is very reminiscent of the portraits of Faustina Minor preserved in the Capitoline Museums in Rome, as well as those in the Louvre Museum in Paris.

Faustina Minor, wife of the great emperor Marcus Aurelius and mother of the terrible Commodus, was well known in Rome for her dissolute ways and for her subsequent scandals, which the emperor desperately tried to cover up. If the statue really represents Faustina, she is properly represented with the body of Venus, the goddess of love!

It is interesting to remember the origin of the *Aphrodite of Cnidos.* Cnidos, a rich Greek colony in Asia located in front of the island of Cos, was famous for its great temple of Aphrodite. Around the year 363 B.C., the very prosperous inhabitants of this city, hoping to embellish their temple even further, asked one of the greatest Greek sculptors, Praxiteles, to carve a statue that would astonish the world. The Greek artist proceeded to sculpt the statue with white pentelic marble. Praxiteles depicted Aphrodite while she was preparing for her bath, and in so doing created a scandal. It was the first time that a statue of worship had been depicted nude!

But the statue was so beautiful, the marble so shiny, the expression of the goddess so pure as if no human stare could have offended it, that it was not only accepted but was considered a true masterpiece.

Unfortunately, the original has disappeared. Luckily numerous Greek and Roman copies exist (we will encounter another

Enrico Bruschini

in a short while), but no copy comes close to the grandeur of the original, which was described by Pliny in his *Historia naturalis* as one of the most beautiful and reproduced statues of antiquity.

ALCOVE OF PERSEUS

In 1797, when Napoleon transferred to Paris the masterpieces from the picture gallery along with the most beautiful statues—including *Apollo* and *Laocoön*—the small Belvedere Courtyard remained almost empty. Pope Pius VII Chiaramonti commissioned Antonio Canova, the neoclassical sculptor, to carve three statues to fill up the empty spaces.

The most beautiful is the statue to the center, ★ *Perseus*. This fine work is clearly influenced by, if not almost a replica of, the confiscated *Apollo Belvedere*.

With his left hand, Perseus holds the freshly cut head of Medusa, whose curled locks are actually a mass of slithering snakes.

It is widely believed that this is an allusion to the much-desired end of the ruler Napoleon, who would soon succumb to the course of history.

This work is flanked by two other statues by Canova, the boxers *Kreugas* (left) and *Damoxenos* (right), the latter responsible for the most unpleasant act of cheating in antiquity. Pausanias, the Greek author of the second century B.C., wrote about this incident. After a long and exhausting boxing match with the outcome still uncertain, Damoxenos finally appeared to be losing. Unexpectedly he pulled out a knife (someone said he used bare hands), and proceeded to cut open Kreugas's belly, tearing out his intestines. Immediately the referee of the competition disqualified Damoxenos, declaring the dying Kreugas the winner.

Notice how Canova depicts Damoxenos's face with his very

disgusting grimace, just as he is getting ready to use his right hand to commit the hideous act.

○—⚡ While going through the courtyard, let us take a close look at many of the great works of art collected here. In particular, if we stop between the fountain and the statues of the Molossians, we can see and admire the statues *Apollo* and *Perseus* at the same time. It is interesting to compare the skill of the Roman copyist with that of the great neoclassical sculptor Antonio Canova.

It is also a good time to point out an apparently insignificant but very useful device: the entire courtyard is covered with a thin net. This acts as a barrier against the pigeons that are quite numerous in Rome and would otherwise have access to the courtyard—thus ruining the precious ancient marble.

Let us return now to the two Molossians that almost seem to be acting as watchdogs over the entrance to the remaining part of the museums. They are Roman works from the Imperial Age after Greek originals of the third century B.C. The Molossian was a type of dog used in antiquity both for hunting and for war. They became widespread as a result of the movement of the Roman Legions throughout Europe. Almost certainly the breed of mastiff dogs descended from the ancient Molossians.

Passing between the Molossians you will reach the Rooms of the Animals. Depending upon the amount of time at your disposal, you can visit the room to the left and the room to the right, and the Gallery of Statues for about twenty-five minutes, or you can go straight ahead to continue on to the Room of the Muses and the Sistine Chapel.

E2–Rooms of the Animals

These two rooms contain a vast collection of animals sculpted during the time of the ancient Romans and in good part restored or completed in the eighteenth century by the sculptor Francesco Antonio Franzoni.

Enrico Bruschini

Sometimes the Rooms of the Animals are regrettably closed to the public for lack of personnel.

Let us move on to a beautiful Roman mosaic on the floor with black and white tesserae. It was brought here from a Roman house of the second century A.D. In the center we can observe an eagle killing a hare. Note the perfect preservation of the mosaic and consider the fact that every year millions of people who visit the museums walk over these ancient tesserae. When a mosaic is really made well, it is made to last forever!

In the room on the left, we find a most beautiful work, the statue of ★ *Meleager* (No. 40), situated in a niche at the end of the room. It shows the Greek hero Meleager, who was responsible for killing the terrible wild boar that had devastated the fields around his city. The figure of the faithful dog is also notable. The fine quality of the statue, as well as the numerous supports, immediately alert us that we are looking at a very good Roman copy of the second century A.D., from a bronze original by the sculptor Skopas of the fourth century B.C.

Let us proceed to the room on the right. At the center of the right wall we find the huge statue of the god ★ Mithras (No. 150). Mithras, the Sun God, is depicted wearing a Phrygian cap and a short cloak, while in the act of killing a bull. A dog and a snake are both sucking the blood that escapes from the wound, while a scorpion bites his testicles. It is a beautiful work, typically Roman from the second century A.D.

Flanking the god Mithras, there are two small ★ panels with landscapes (Nos. 152 and 138). At first sight they appear to be two paintings, but upon closer examination, you will notice with amazement that they are actually fine mosaics. The tesserae of different marbles in various colors are so small that it is difficult to differentiate them. These panels are, however, some of the most beautiful examples of Roman mosaics displayed in the Vatican. They once embellished the walls of the fabulous villa of the emperor Hadrian in Tivoli (second century A.D.) and were found during the excavations of the eighteenth century. In the small mosaic to the right note with how much calm a herd of goats graze around a sacred grove. The intensity

and the perfect matching of the colors of the small stones, and the depth of the background of the scene, make us wonder about the excitement surrounding the talented Greek artists collaborating on Hadrian's famed villa.

E3–Gallery of Statues

Following until the end of the wall, we arrive at the Gallery of Statues. Sometimes this gallery, for lack of personnel, remains closed to the public.

Just as you enter, at the center of the wall to the left, you will find a striking female figure—the statue of the ★ *Sleeping Ariadne* (No. 548). Remember that Ariadne gave Theseus a long thread to allow him to find the exit from the labyrinth of the Minotaur. Theseus, however, did not treat the thoughtful Ariadne very kindly in return. After arriving on the island of Naxos, Theseus abandoned her as soon as she succumbed to sleep. Fortunately, the beautiful Ariadne did not have time to despair because the god Dionysus (Bacchus for the Romans), who happened to be passing by on a wagon drawn by panthers, saw the lovely Ariadne and fell madly in love with her.

This fine statue was erroneously considered, until the eighteenth century, to be a portrait of Cleopatra because of the bracelet, in the shape of a snake, that adorns her left arm. This type of bracelet was typically worn by Roman and Greek women. It is a beautiful Roman work of the second century A.D. copied from an original of the School of Pergamum in Asia Minor from the second century B.C.

To the sides of the *Ariadne* we can admire two wonderful ★ Barberini candelabra, so called for the name of the noble family that once owned them. They were found in Hadrian's villa in 1630, where they served as artistic supports to hold torches or to contain wax or oil for burning. They are two Roman originals that are considered to be the most beautiful of their type. Note on the base of the candelabrum to the left a beautiful relief of Jupiter (Zeus for the Greeks) with a scepter and thunderbolts, and, on the base of the candelabrum on the right, Mars (Ares for the Greeks) with a lance and helmet.

Enrico Bruschini

Turning our backs to Ariadne, we should pause in front of several significant works of art. The second statue depicts a young boy who is resting on a funeral altar. Although lacking arms and legs, he has a very beautiful face and is known as the ★ *Eros of Centocelle* (No. 85–769), so named for the place south of Rome where he was discovered in 1772. It is most certainly Eros, the son of Venus, because on his back you can still see traces of the attachment of the small wings. This is a copy from the time of Hadrian, second century A.D., of an original in bronze of the fourth century B.C.

Also delightful is the fourth statue, ★ *Apollo "Sauroktonos"* (No. 62–750), from the Greek "he who kills the lizard." Found on the Palatine Hill, the beautiful statue depicts the god Apollo intent on prodding a lizard with an arrow that he is holding gently in his right hand. It is a very good Roman copy of a famous work in bronze by the great Praxiteles, the Greek sculptor of the fourth century B.C. The original was praised for the soft curve of the body that was meant to lean against a trunk in order to stabilize its equilibrium.

Adjacent is the statue of the *Wounded Amazon*. The writer Pliny reminds us that an important artistic competition took place in the fifth century B.C. among the best sculptors of the time. The four artists, Polycletus, Phidias, Kresilas and Phradmon, were each asked to create their own rendering of the Amazons to adorn the great Temple of the goddess Artemis (Diana for the Romans) in the city of Ephesus. The work that we have in front of us is a Roman copy of one of the four competing Amazons, very probably the one created by Phidias.

In the center of the gallery there is a large ★ Roman bath-tub that was sculpted from one enormous piece of transparent rock, the precious alabaster! A few new pieces of alabaster were later added to restore the border.

This is without a doubt the most beautiful and precious bathtub to be preserved in the Vatican museums. For years it has been said that this was actually the tub in which Poppea bathed in donkey's milk in the House of Nero, but we do not

have any proof to confirm this. It is, however, nice to imagine the legend as being true!

ROOM OF THE BUSTS

Under the arch at the back of the gallery you can see the impressive statue ★ *Jupiter "Verospi"* (No. 77–671), so called for the name of the palace where it was displayed. Only the torso and the very beautiful head are original; the rest, unfortunately, had to be restored. It was sculpted in Rome in the second century A.D. as a smaller copy in marble of the Capitoline *Jupiter* located in the great Temple on the Capitol. The original was in gold and ivory and was sculpted in Rome by the Greek sculptor Apollonios in the first century B.C.

It was customary for the Roman generals and emperors to receive a scepter of ivory, and a crown of laurel, during their triumphal reentries in the Roman Forum. At the end of such ceremonies, they would deposit these symbols of triumph onto the lap of the great statue of the Capitoline *Jupiter*.

Let us return toward the entrance, stopping in the small room to the right of the window. Normally this room is closed but the artworks can be admired through the elegant gate.

SMALL ROOM OF THE MASKS

This room is named for the depiction of masks in mosaic that adorns the floor. In front of the gate, in a niche, there is an important replica of the ★ *Venus of Cnidos,* also known as the *Vatican Venus,* perhaps the copy closest to the original by the great Praxiteles. Venus, who has rested her clothes delicately on an amphora, is preparing for her bath.

0—➤ The goddess appears nude for the first time! The very beautiful courtesan Phryne, lover of Praxiteles, posed as the model for this statue. Numerous ancient coins have reproduced the soft beauty of the original. The marble statue of the Venus by Praxiteles, which had been placed in the sanctuary of Cnidos, became an immediate success. The sacellum that contained the

Enrico Bruschini

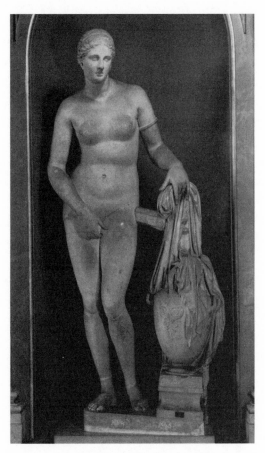

12. VENUS OF CNIDOS

Praxiteles

statue was also open at the back so that none of the splendor of the goddess of love was lost. The fame of her beauty was so great that visitors from distant lands made pilgrimages to Cnidos just to admire her. Of the numerous copies of the original (now lost), this is certainly one of the best. It was restored, which is most obvious, on the left arm and hand, and also the right arm, whose hand is closed almost in the form of a hook. The hand was redone intentionally in this way so that it could hold, until not too long ago, a thin covering in metal (a device used in previous times to camouflage parts of a statue considered immodest).

In the niche to the right we find the statue of the *Crouching Venus,* a replica, slightly reduced in size, of a famous work by the sculptor Doidalsas of Bithynia. The goddess of love is resting on her right knee, intent on admiring herself in a pool of water. It was the preferred kind of statue in ancient Rome for the adornment of small romantic pools. The original in bronze from the third century B.C. still existed in Rome at the time of Pliny the Elder.

Passing again through the Rooms of the Animals, we turn to the right to enter the Room of the Muses.

E4–Room of the Muses

This room is named for the statue of Apollo in the center of the left wall, surrounded by the statues of the Muses placed around the room. It was conceived by the architect Michelangelo Simonetti in 1780. In fact, the sixteen columns with beautiful Corinthian capitals in Carrara marble are his creation. The ceiling, painted by Tommaso Conca, is in harmony with the displayed sculptures depicting Apollo encircled by muses and poets. The beautiful statues from the second century A.D. were rediscovered in 1774 in the so-called Villa of Cassius near Tivoli.

One of the major masterpieces of classical sculpture of all time is displayed in the center of this room, the ★ *Belvedere Torso.*

We know that the word *torso* means a body without the head and the limbs. Notwithstanding the missing parts, this remains one of the most beautiful classical statues in the Vatican collection. It was found at the beginning of the 1400s near Campo de Fiori, a square in the center of Rome. Some say that it was actually found in the workshop of a cobbler who had used the legs of the statue as a cobbler's bench.

After being rediscovered, the statue was quick to receive the admiration of artists from the period. Michelangelo in particular idolized this work. The great Tuscan artist saw in this mutilated body the power that he wished to express in his own creations. The muscular masses, anatomically perfect, were not

Enrico Bruschini

inert but in action, just as he had always imagined them to be. See *Belvedere Torso* in the color insert.

○━━ Fortunately the statue was never restored, perhaps because no one was ever able to determine with certainty whom it was meant to represent. What we have remaining is a muscular body with the bust bent to the right, and the head turned to the upper left. The right arm was in a low position, while the left arm, as is noted by the muscles of the breast, was shifted upward.

There remains some written evidence from the time that allows us to comprehend how much Michelangelo admired this statue. The painter and writer Giovan Battista Paggi wrote in his book *La definitione e divisione della pittura*: "Michelangelo said he was *a student* of the *Belvedere Torso* which attests that he greatly studied it." The painter Giovan Paolo Lomazzo wrote that "Michelangelo drew it in every possible way, and when he became almost blind (in his later years) he took pleasure in going over all of the forms with his skilled hands."

The statue was sculpted in Rome by an Athenian, Apollonios. In the center of the base of the statue, right below the torso, you can read, in Greek, the signature of the artist: "Apollonios, son of Nestor, the Athenian, created [this work]." Apollonios worked in Rome toward the end of the glorious Republic, around the last quarter of the first century B.C. He is perhaps the same Apollonios who sculpted the great statue of the Capitoline *Jupiter.*

○━━ For centuries this figure, which is seated on an animal skin, was identified as Hercules, because the pelt was believed to be the skin of a lion. Only recently have we come to realize that it is the skin of a panther, which has given rise to new speculation. So now someone believes that the statue could represent Dionysus, the god of wine (personally I don't share this opinion, because although the panther is a sacred animal for Dionysus, the god of wine has never been portrayed as muscular). Just recently another interpretation was made attributing

the figure to Ajax Telamon in the act of contemplating suicide, after having been deceived by Ulysses.

Others believe it may represent Philoktetes, the friend of Hercules who was left on the island of Lemnos because he was wounded. I agree completely with this idea—in fact one can envision this strong figure as a wounded warrior who is pulling himself up using his lance (now missing from his left side). In addition, in almost all the paintings describing the might of Philoktetes, the hero is depicted over a panther skin! (See, for instance, the famous painting by Nicolai Abraham Abildgaard at the Statens Museum for Kunst in Copenhagen.) This hypothesis is also credible when comparing ancient reliefs and coins dedicated to the same episode, but it doesn't explain in any way this muscular figure in action and under strain.

Michelangelo, notwithstanding the adoration which he nurtured for this statue, always refused to complete any restoration on it. In his great modesty he maintained that he was unable to do honor to the greatness of the Greek sculptor. Michelangelo himself said: "This is the work of a man who knew how to do it better than nature!"

Observing the statue, look at the 90-degree angle formed by the bust and the right leg; we will find the same angle and the same torsos in all of the figures of the nude seated angels depicted on the sides of the scenes of *The Creation*. On the ceiling of the Sistine Chapel, Michelangelo painted the *Belvedere Torso*, adding limbs and a head, in twenty different poses!

During his visit to Rome in 1876, the French sculptor Auguste Rodin was also struck by the beauty of the Torso; four years later, in Paris, he sculpted it in bronze: *The Thinker*. It is a completion of the *Belvedere Torso*! A copy of *The Thinker* is today in Paris, and another magnificent copy can be admired at the Rodin Museum in Philadelphia.

Before leaving the Room of the Muses, let us admire the last portrait on the right; it is the beautiful *Herm of Pericles* (a herm is a pilaster with a portrait above).

Enrico Bruschini

It is a beautiful Roman copy from the second century A.D. of the portrait of Pericles, the great strategist, sculpted by Kresilas in 430 B.C. to be placed on the Acropolis in Athens.

Pericles, ruler of Athens for about thirty years, beautified the city and was responsible for the building of the Parthenon. Here he is depicted wearing the Corinthian helmet of the commander in chief of the Athenian army. On the fore part of the herm there is an inscription in Greek: PERICLES, SON OF XANTHIPPOS, THE ATHENIAN. Almost all of the images of the great strategist depicted in history books are reproductions of this portrait.

Look closely and you will see one small, interesting curiosity: Through the openings for the eyes on the visor of the helmet, you can see Pericles's hair. Notice, however, that the helmet is shifted quite far back and the head should not be in that position. Pericles's political opponents in Athens ridiculed him because of the irregular form of his cranium! The Greek author Plutarch wrote that artists of the time tried to hide the defect of Pericles's long head with high helmets. This portrait is certainly the most convincing proof!

E5–Round Room

The Round Room is composed of niches flanked by tall pilasters of the Composite order, the work of architect Michelangelo Simonetti around 1781 (the Composite order was an order, typically Roman, formed by an Ionic capital with round volutes, placed above a Corinthian capital with the leaves of acanthus). The room has since been covered by a dome, imitating the domes of ancient Roman buildings. The large niches, with backgrounds in Pompeiian Red and the upper part formed by very large gilded shells, are a perfect backdrop for the wonderful statues on exhibit.

The pavement is formed by a rather large ★ colored mosaic from the third century A.D. that was found at the Baths of Otricoli (a little town north of Rome) and represents combat scenes between the Greeks and Centaurs, and between the Nereids

In the Footsteps of Popes

and Tritons. In the center there is a large basin formed by one enormous piece of red Egyptian porphyry, greater than fourteen feet (4.14 meters) in diameter. It was found in a courtyard of the Emperor Nero's Domus Aurea. See The Round Room in the color insert.

To understand the importance of red porphyry let us look at the *Togaed Statue* (No. 22) to the left of the entrance. The statue is wearing a toga, the large woolen cloak that Romans wore over a light tunic.

Consider that the open toga had the form of a half circle (but wider) with the convexity toward the bottom. Before the toga was put on, it appeared to be wider than three times the height of the man. Once resting on the shoulders, two long wings from the toga remained and would be elegantly draped around the body. The toga was impressive, elegant, and expensive. Wealthy citizens wore white togas. Once elected, Senators added long reddish purple stripes to their togas along the entire upper border.

Only one person was authorized to wear the toga colored entirely reddish purple: the emperor! This is the reason why Egyptian porphyry, which matches the reddish purple color of the imperial toga, could only be used by the Roman emperors. This beautiful basin originated, in fact, from the residence of an emperor who was without doubt one of the cruelest rulers of ancient Rome, but who nonetheless had incredible artistic taste: Nero!

In the Round Room even the bases that support the statues are made from magnificent Egyptian porphyry. The bases were obtained by cutting tall monolithic columns of porphyry into three or four parts.

It is still undetermined which technique was used by the Egyptians and Romans to sculpt the enormous columns, sarcophagi, and statues in porphyry. A Roman *marmoraro* (marble cutter) reminded me not too long ago that porphyry is so hard that it takes almost an hour using modern saws to cut three centimeters of this beautiful volcanic rock!

Enrico Bruschini

In the nineteenth century, the French built a special tomb of red porphyry inside the L'Hotel des invalides in Paris to honor Napoleon I Bonaparte. They used, however, porphyry from Finland and not from Egypt, which is much harder and more difficult to sculpt.

Returning to the other side of the door and proceeding toward the left, in a counterclockwise fashion, we will note the very beautiful ★ *Head of Jupiter* (No. 3) found in Otricoli, north of Rome. Jupiter (Zeus for the Greeks), the ruler of the gods, appears in all of his impressive authority. This is a Roman copy from the first century A.D. of a famous head of Zeus from the fourth century B.C.

Next is the monumental statue of ★ Antinous (No. 4), the favorite of Emperor Hadrian. It is easy to recognize Antinous, still loved today by the women of modern Rome for his beautiful countenance framed by curls, the sad look on his face, the fleshy lips, and the large thorax. In this statue he is represented as the young god Bacchus with a crown of ivy. It is a Roman original from the second century A.D.

०—★ In the year A.D. 130 the young Antinous, who was vacationing in Egypt with Hadrian, heard the prophecy that the emperor would die unless he disposed of that which was most dear to him. Antinous, believing he could save his beloved emperor, committed suicide by throwing himself into the Nile River. Hadrian, having gone almost mad with grief, deified the young Antinous and erected statues in his honor in cities throughout the Empire.

Next, the bust of the Empress Faustina the Elder (No. 5), wife of Antoninus Pius and mother-in-law of Marcus Aurelius, is a portrait of a simple and generous woman. The Temple dedicated to the Divine Antoninus and Faustina is still perfectly preserved in the Roman Forum.

The next statue of a female divinity is restored as ★ *Demeter* (Ceres to the Romans) (No. 6), the goddess of the harvest,

wearing a peplum, the wide and long dress that was worn by noble Greek and Roman women.

The next statue is a large marble ★ *Head of Emperor Hadrian* (No. 7). This work is very important because it was found in his mausoleum, built in the second century A.D., which was subsequently transformed into Castel Sant'Angelo. This is the original head of the impressive statue of the emperor placed in the niche of the large atrium at the entrance.

○━★ Hadrian's family and friends paid homage to this beautiful sculptural representation upon the emperor's death. For years it continued to welcome those who came to pay homage to one of the emperors who was instrumental in making the Roman Empire great. The rest of the statue has disappeared, but the head, fortunately, has survived.

Next this colossal ★ *Statue of Hercules* (No. 8) in gilded bronze, more than 13 feet (4 meters) high, is a Roman work of the second century A.D. The statue is not relevant for its artistic value—in fact it appears a bit heavy for this subject. However, it is interesting for an event in which it was involved.

○━★ Discovered in 1864 near the Theater of Pompey (where on the Ides of March, 44 B.C., the great Julius Caesar was killed), the statue of Hercules was found to have been buried with great attention, well contained between slabs of stone. On the slabs the letters F.C.S., that is, *Fulgur Conditum Summanium*, had been inscribed, explaining that the statue had been struck by lightning flung by Jupiter and was subsequently buried on the spot. This was considered an event of great importance, because the statue was not even minimally damaged, as you can see. Therefore, Hercules was immediately buried in the place of the event to be preserved forever.

To the left is a bust of *Antinous* (No. 9) that is particularly fine, a Roman original from the second century A.D., found in Hadrian's villa, the magnificent residence that Emperor

Enrico Bruschini

Hadrian had erected to the east of Rome. All of the characteristics that made portraits of the emperor's favorite enchanting are recognizable.

Next is a statue of the goddess ★ *Hera "Barberini"* (No. 10), or Juno for the Romans; the statue is called "Barberini" after her first owners. The goddess was both sister and wife to Zeus. This is a Roman replica of a Greek original from the fifth century B.C.

Following this is a statue of *The Emperor Claudius as Jupiter* (No. 16), a Roman original of the year A.D. 50. Claudius, who lived between the years 10 B.C. and A.D. 54, was elected emperor by the praetorians (emperor's bodyguards) after the killing of Caligula. Agrippina, his second wife, almost surely poisoned him with mushrooms to facilitate the ascension of her son Nero to the throne as emperor.

Next, the statue of *Juno Sospis* (No. 19), which was meant for worship, is a Roman work of the second century A.D. *Sòspita,* which means "the Savior," was one of Juno's attributes. With this attribute she was venerated as "Protectress of the Roman State."

Last is a large portrait of *Plotina* (No. 20), wife of Trajan and famous for her qualities of simplicity, fidelity, and dignity. Trajan honored her with the title of "Augusta" in A.D. 105 and deified her at her death in A.D. 129. This portrait, so impressive, could have been sculpted for one of the two occasions.

E6–Greek Cross Room

This room, with its high ceilings, impressive flights of the stairs, and above the wide window with a large ancient crater, is one of the most beautiful examples of the neoclassical style adopted by the architect Michelangelo Simonetti around 1780.

After the Baroque and Rococo periods, the need for a return to classic art was felt again, ideally relieved and seen as a supreme model of perfection. Note the severity and purity of the lines. See the Greek Cross Room in the color insert.

o—⚲ Also in the "young" United States of America in this same time period, neoclassicism was propagated. Just think of

In the Footsteps of Popes

Charles L'Enfant's plans for Washington, D.C., or the numerous homes, such as President Thomas Jefferson's Monticello (1770), which renewed the style of the architect Andrea Palladio. Democratic Athens and Republican Rome were ideal models, both in the political and architectural senses, for the young but already strong American democracy.

The most interesting objects in the Greek Cross Room, so named because the room is shaped like a cross with four equal arms, are the two large sarcophagi from the fourth century A.D. made of Egyptian porphyry. The use of this stone immediately identifies them as imperial sarcophagi.

The sarcophagus on the left is in fact the ★ sarcophagus of Saint Helen (No. 72), mother of the emperor Constantine. In effect the sarcophagus was presumably made for Constantine's father, the emperor Constantius Chlorus, as you can easily understand from the depiction of a military procession with victorious Roman cavalrymen and chained barbarians sculpted in high relief; but it was subsequently used for the emperor's mother. On the cover of the sarcophagus there are also beautiful winged figures. These figures were already known by the Greeks and Romans as Nike or Victories. With the advent of Christianity, credited to Constantine, they officially became "angels" for the first time.

To the right there is the ★ sarcophagus of Constantia (No. 71); Constantine's daughter. This sarcophagus is more interesting from a historical-religious point of view than from an artistic one. Among large acanthus motifs you see putti harvesting the grapevines. The figures are not as soft and perfectly formed as they were in the reliefs of the previous centuries; by the fourth century Roman art was already in a period of decadence.

Historically noteworthy is the new use of symbols. The winged putti, sculpted in relief on the sarcophagus, are no longer Cupids (for the Greeks Eros) occupied with shooting golden arrows into unsuspecting lovers; instead these "cherubs" have become gatherers of grapes which are needed to prepare wine, a symbol of the Blood of Christ!

Enrico Bruschini

This sarcophagus was found in Constantia's mausoleum on the Via Nomentana, and in its place a simple copy in plaster is now displayed.

The Greek Cross Room also houses a little-known portrait that is a real historical jewel. On the left side of Constantia's sarcophagus, just to the left of the window, you will see, marked with the inventory number 21, a female statue. The head is particularly interesting (it doesn't go with the body) with a very simple hairstyle. The hair is pulled back by a hair band that forms a chignon on the nape of the neck. One cannot call this face beautiful, and yet it emanates a mysterious charm: It is almost certainly a portrait of Cleopatra, Queen of Egypt.

Decisive facial features and the strong nose leave us a bit perplexed. Remember the words of Pascal, the great French physicist and philosopher: "If the nose of Cleopatra were shorter, the earth would have completely changed face," meaning that the history of the world would have been different. However, in spite of traditional canons of beauty, this face does convey both energy and intelligence.

Cleopatra, a woman of great culture and fluent in many languages (an uncommon thing for the women of those times), open-minded and ambitious, was able to make two unique men, Julius Caesar and Mark Anthony, fall madly in love with her.

In my opinion, the small doubts that remain about the identification of this portrait can be dispelled if one compares it with the official portraits of Cleopatra represented as Queen of Egypt on the coins of the time, particularly on Roman coins, on the silver drachmas of Alexandria in Egypt, and on the tetra-drachmas of Antioch.

On the back of the wall where you entered, there are two telamones, or the male equivalent of the caryatids. They are Roman originals from the second century A.D. in rose-colored granite and originate from Hadrian's villa.

In the Footsteps of Popes

○━ Remember that the emperor Hadrian had visited almost all of the provinces of the Roman Empire during his reign. Upon returning to Rome, he wished to reproduce for his magnificent summer residence the most beautiful and interesting things that he had seen during his travels. These telamones are the reproductions of similar statues that he had admired in Egypt.

Immediately before the stairs there are two granite sphinxes from the Roman age.

All of these works, collected from Egypt, allow us to understand how highly the ancient Romans esteemed Egyptian art and civilization.

F–Egyptian Museum

The entry to the Egyptian Museum is to the left, before the staircase.

○━ For many centuries the only traces of Egyptian civilization were the Great Pyramids and many imposing temples. Very little was known of the long history and complex religion of the Egyptians. Sporadic excavations, most of them clandestine, were sought to find treasure and not to understand Egyptian civilization. The countless inscriptions in hieroglyphs were of little help because no one could decipher them.

With Napoleon's expedition in 1798–1799, interest in ancient Egypt was reborn in Europe and the world. Together with his troops the emperor had the insight to bring many scholars and artists.

His soldiers were very irritated by the presence of these people, whom they considered an unnecessary burden— indeed, they named them "the useless." But it was, on the contrary, a flash of genius for Napoleon to bring them, for they discovered the famous Rosetta Stone, with its inscription in hieroglyphs, Demotic letters, and ancient Greek. By comparing these inscriptions, the French Egyptologist Jean-François Champollion deciphered the hieroglyphs.

The artists, on the other hand, returned to Europe with an

enormous number of drawings, engravings, watercolors, and paintings that helped to make Egypt known to the whole world. Until then almost unknown, this ancient civilization became stylish. Egyptian palms, now an ordinary ornament in many European cities, began to be imported. Any nobleman's palace had an Egyptian room, or at least paintings and furniture in that style. The first Egyptian museums were opened, and the Vatican museum has primacy here: It was the first museum in the West dedicated to Egyptian art.

The Egyptian museum at the Vatican is important also because, in contrast to the other Egyptian galleries throughout the world, in this museum there are not only the sculptures discovered in the last centuries, but also the original statues carried to ancient Rome from Egypt. These served as ornaments for Roman buildings as well as for cult statues for the Egyptians present in Rome or for the Romans who followed the Egyptian cults, in particular those of Isis and Osiris. In the museum there are also many precious statues based on Egyptian models but sculpted in ancient Rome after the conquest of Egypt.

I suggest a visit to the Egyptian Museum only if you have time at your disposal (about fifteen minutes). For enthusiasts of Egyptian art, given the uniqueness of some of the works exhibited, we advise to return a second time for a more careful examination.

As always we will illustrate above all the masterworks and those works particularly interesting from the historical and artistic point of view.

Please note that many of the exhibited works are properly explained by short notes in English.

In the first room, in the center of the right wall, is a statue approximately 2 feet 4 inches in height (c. 70 centimeters), without its head, that shows the ★ *Priest Udja-hor-res-ne*. He holds in his hands a model of a temple dedicated to the god Osiris. The statue is carved from basalt, a tremendously hard volcanic stone of dark gray color. What makes this statue one

In the Footsteps of Popes

of the most important pieces in the Egyptian Museum is the long inscription in hieroglyphs that records an historical event in Egypt and gives more light to Egypt's conquest by the Persian king Cambyses II in 525 B.C. and the role of Udja-hor-res-ne in this event. The priest was an important medical doctor who gained the trust not only of Cambyses II, but also of his successor Darius I, and with their consent reconstructed important buildings dedicated to knowledge. The inscription makes clear that the Persian kings were not as barbarous and bloodthirsty as they were described in ancient Greek history, particularly in the works of Herodotus.

In the second room we see sarcophagi, sacred scarabs, canopic vases, and other cult objects. In the center display case there are two mummies. In the next to last display case on the right (No. 5), are objects that perhaps are the most touching and bring us closest to ancient Egypt: a pair of small sandals, perfectly preserved, that belonged to an Egyptian child of three thousand years ago.

In the third room we can understand how enchanting the decoration of the magnificent Hadrian's villa built at Tivoli was, and how great was the taste of this emperor who wanted to reproduce all the most fascinating things he saw on his journeys through the immense territories of the Roman Empire. In particular, in this room we see a reconstruction of part of the ★ *Decoration of the Serapeum,* that is, the reconstruction of the Temple of Serapis that Hadrian saw at Canopus, a city joined by a canal to Alexandria, and then had rebuilt in his villa.

At right note the colossal statue of ★ *Antinous,* shown in the guise of the Egyptian god Osiris in memory of his death in the Nile in the year 130. This statue was also found at Hadrian's villa.

In the fourth room are exhibited the statues and bas-reliefs sculpted in Rome in imitation of Egyptian originals in order to decorate temples to Egyptian divinities. Before the left wall is a beautiful statue of *The River Nile* (No. 22838) in gray marble.

In the fifth room, within the hemicycle (the corridor is curved because we are within the niche that holds the bronze

Enrico Bruschini

pine cone we saw in the courtyard) are exhibited original statues from Egypt. To the right of the entrance, before the wall at the beginning of the hemicycle, is the beautiful ★ *Head of the Pharaoh Mentuhotep II* of the Eleventh Dynasty. This is the oldest portrait in the Vatican collection. The Pharaoh Mentuhotep lived toward 2000 B.C. or four thousand years ago! The head is carved from sandstone and is approximately 2 feet (62 centimeters) in height. The king wears the crown of Upper Egypt. On its front is the *Uraeus,* the cobra sacred to the pharaohs. The original colors are still well preserved after forty centuries!

In the center of the hemicycle are four colossal statues in granite. Remarkably, these are linked to the place where the American Embassy to the Italian Republic stands today.

○━┓ These statues were found at the beginning of the eighth century in the gardens of Julius Caesar, better known as the Gardens of Sallust, the ancient historian who owned them after Caesar's death. This was the site where the Roman emperors established their summer residence. In 1946, the new seat of the American Embassy at Rome was established on that site. In excavations of the embassy gardens are still found columns, galleries, and ornaments of the magnificent imperial residence. An astonishing painted underground corridor of the second century B.C. was found, restored, and illuminated in 1998 (at that time I was the fine art curator at the embassy). That incredible part of the imperial residence is, unfortunately, not open to visitors at the moment.

The statues exhibited here were found almost three centuries ago where the gardens of the embassy are now located. They were brought to Rome by the emperor Caligula, who reigned from A.D. 37 to A.D. 41, and were placed by him in the imperial gardens.

At the beginning of his reign Caligula was an excellent emperor, but after eight months an illness unbalanced his mind and he began to behave in a bizarre fashion. He designated his horse as consul, wanted to be adored as a god, and

In the Footsteps of Popes

considered himself a new Egyptian pharaoh. These four statues refer precisely to this final folly. The first three statues are Egyptian originals, the fourth is a Roman work in Egyptian style.

The first statue, in the center of the hemicycle, carved from gray granite, is the portrait of Queen Tuy, mother of the great Pharaoh Ramses II of the Nineteenth Dynasty, approximately 1250 B.C. It was brought to Rome by Caligula to recall how the pharaoh was bound by deep affection to his mother, Tuy, in the same way that Caligula was bound to his mother, Agrippina. This statue was in the Temple of Ramses II at Thebes.

The statue in rose granite in the center of the second niche is a portrait of the Pharaoh Ptolemy Philadelphus, who in 276 B.C. married his sister Arsinoe II and later deified her; similarly Caligula married his sister Julia Drusilla and then deified her. This statue was taken by Caligula from Heliopolis.

The statue in rose granite on his left is the portrait of Queen Arsinoe II, the sister and wife of Ptolemy Philadelphus. This statue too was taken by Caligula from Heliopolis.

The statue on the right of the pharaoh is a replica of that of Arsinoe II, but with the portrait of Julia Drusilla. This statue was sculpted in Rome as Drusilla-Arsinoe for Caligula.

Note: the following rooms are undergoing reorganization. The arrangement of the exhibited works could change completely.

In the sixth room are bronze objects from the sixth and fifth centuries B.C.

In the seventh room are Greco-Roman antiquities from Alexandria in Egypt.

In the eighth room are prehistoric, Mesopotamian, and Roman ceramics.

In a recess of this room are displayed, from the year 2000 B.C., twelve astonishing ★ funerary reliefs from Palmyra (Syria) donated to the Vatican by the great Italian art historian Federico Zeri, who died recently (1998).

Enrico Bruschini

13. QUEEN ARSINOE II

○—⚷ I remember seeing these superb antique marble portraits in Zeri's house. It was the year 1994. I had invited the art historian to see my new discovery, the statue of the Venus by Giambologna, in the Palace of the American Embassy in Rome.

Federico Zeri admired the statue for a long time and, almost to thank me for the kindness, he invited me to visit his residence in Mentana, a little town east of Rome. The residence, a large villa, was famous for the incredible number of works of art which Professor Zeri collected during his numerous trips in Italy and around the world.

At the entrance of the villa I was welcomed by the extraordinary portraits now displayed here. I had never before seen so many of them. I continued through rooms whose walls were

In the Footsteps of Popes

covered with Renaissance and Baroque paintings, as well as many marble and bronze Roman statues. I tried to admire and to store in my memory all the pieces that I saw.

When I reached Zeri, who was quite hidden by a large desk, the top of which was an enormous block of red Egyptian porphyry, I was quite unable to reason. The enormous quantity of works from different times and in various styles had clouded my mind.

I nearly suffered from a real indigestion of art! For the first time I experienced that astonishing mental confusion which is named by the expert "Stendhal's Syndrome." I needed several days and two more visits to the Zeri residence to settle it. Till today, looking at these marble portraits from Palmyra, I am assailed for a moment by that terrible and wonderful sensation of immensity.

Next, turn to a glass showcase at the center of the wall, next to the window. It contains cylindrical seals and tablets with cuneiform inscriptions.

○━┮ We are looking at some of the oldest samples of letters, written more than 3,500 years ago. For me something really astonishing is on the left of the lower shelf of the showcase: an ★ inscribed clay envelope of the Old Babylonian Period (c. 1700 B.C.) *still containing its cuneiform tablet!*

I saw a similar clay envelope only one other time, in the Archaeological Museum of Ankara in Turkey.

In the ninth room are Assyrian bas reliefs. It is interesting to note on some of these the traces of fire that blackened the stone or calcinated it. These reliefs are historically important, for they prove the fire at Nineveh, the splendid city on the river Tigris, the capital of the Assyrians, destroyed in 612 B.C. by Kyaxares, the king of the Medes. With the conquest and destruction of Nineveh the Assyrian empire ended after 1,500 years!

Enrico Bruschini

Let us to go back to the Terrace of the Hemicycle and look at the last Egyptian works exhibited there. Around the great bronze pine cone there are basalt sarcophagi and statues of the goddess Sekhmet with the head of a lioness.

The quickest way to continue the tour is to pass through the Egyptian Museum back to the entrance, to find oneself again in the Greek Cross Room (E6).

From here, we should be able to go up the next two flights of the neoclassic stairway to visit the Etruscan Museum.

G–The Etruscan Museum

Before entering, let us look briefly at the great crater decorated with masks and reliefs, carved from a single block of hard volcanic stone of dark gray color. Craters were used by the ancient Greeks and Romans for mixing water and wine in the correct proportions for banquets. When they are as large as this example they were used as an ornament in gardens.

It is wise to visit the Etruscan Museum only if there is a great deal of time. For those interested in Etruscan art and Greek vases, given the richness of the exhibited works, we advise returning a second time for a more attentive viewing.

A visit to this museum permits us to come closer to an ancient people considered mysterious because not all of their cultural attributes have been rediscovered and studied. History owes much to the Etruscans. They introduced us to the systematic use of the arch and the vault, architectural elements known to the Egyptians and the Persians but not used by them with any constancy. This important architectural development was taken up and developed from the Etruscans by the Romans, who continued to amaze the world with the immense vaults of their buildings (think of the dome of the Pantheon, erected by Hadrian, still the largest unreinforced concrete vault in the world, surpassing by 2 feet (62 centimeters) that of Saint Peter's).

Yet the origin of the Etruscan people is still obscure. Two principal hypotheses suggest that they are either an ancient

local population of central and northern Italy, or else are an immigrant population. It seems to me that the most trustworthy view is that of Herodotus from the fifth century B.C. He is known as the Father of History because of his detailed descriptions of the many places he visited.

According to Herodotus, the Etruscans, whom he called the Tyrrhenians, came from distant Lydia, the ancient and developed region of Asia Minor on the Aegean Sea (the Lydians were the first to coin money in the seventh century B.C.) The archaeological similarities, especially in the tombs and sarcophagi, and the linguistic similarities, such as on the Stele of Lemnos, are convincing. Perhaps the truth is somewhere in between. Etruscan civilization is likely the product of an ancient immigration from Lydia that came in contact with the local population, especially the Villanovan civilization, and developed into a new civilization.

I. HALL OF THE CINERARY URNS

In the case at right there are three hut-shaped urns. These cinerary urns are in the form of the house commonly used in Latium and Etruria, the regions inhabited by the Etruscans in the ninth century B.C. Also take note of a *biga,* or two-horsed chariot, of the sixth century B.C. (No. 20829), whose wooden parts have been redone; the bronze ornament is original.

In the case at left: Little Chair in Sheet Bronze of the 7th century B.C. (No. 12631).

Through the door before us we enter the Room II.

II. ROOM OF THE REGOLINI-GALASSI TOMB

This room takes its name from the two men who discovered in 1836–1837 a large tomb that had never been opened and looted by thieves in the necropolis south of the ancient Etruscan city of Cerveteri. The tomb preserved the remains and furnishings of two important persons who lived in the seventh century B.C.

Some pieces are truly interesting. In the case to the right of the entrance, before the window, we see the bronze remains of a

Enrico Bruschini

throne (No. 217). The interior wooden part of this throne was consumed by time and has been completely reconstructed. The bronze throne is decorated with flower and animal motifs and permits us to understand the social rank of the buried woman. She was a princess!

The ★ gold clasp (No. 20552), used in ceremonies, belonged to this princess. It is so large (about a foot wide [c. 32 centimeters]) that in order to wear it more easily, it was necessary to create knots between the three parts that compose it. Note the lower disc: on seven vertical lines are fifty-five small ducks, *each measuring a few millimeters.*

○—ᴣ To realize these tiny figures, the goldsmiths of Cerveteri worked in *repoussé,* hammering the gold from behind to obtain the figures in relief, half a small duck at a time. They then cut the two halves from the gold sheet and joined them. Finally they soldered each small duck onto the gold disk.

We might wonder today whether it is possible to obtain the temperature for the fusion of gold without minimally ruining the two smaller parts soldered together. Even today with modern instruments and methods it would be a difficult undertaking!

The most interesting part—and still very mysterious—is the granulation, the delicate ornamentation obtained with thousands of microscopic spheres of gold, soldered around and above the small ducks. This is one of the mysteries of the Etruscan civilization. More than 2,600 years ago how could they obtain such small and perfect spheres (it would be appropriate to view them with a magnifying glass) and how was it possible to solder them onto the gold disc without ruining their perfect roundness? What technique was used by these expert goldsmiths?

We are certain that the workshops were at Caere (modern Cerveteri), but of what nationality were the craftsmen? Were they local artists or foreigners? One could think, with a certain probability, that they were oriental artists and artisans, perhaps Phoenicians, immigrants to Etruria, who adapted their art to the local taste.

In any case mystery still surrounds the artisans and their

In the Footsteps of Popes

technique for granulation. Many hypotheses have been formed and many proofs adduced, but we have not succeeded with the most modern technology to achieve or reproduce the process of their creation!

In the same tomb a man of the same social ranking was found in a small space near the princess. He owned the biga of war here exhibited and the very rare ★ bronze funeral bed (No. 15052) set on a ritual cart (here also the wooden sections have been restored). In all Etruscan tombs the deceased was laid out on a funeral bed that usually was carved in the same stone as the subterranean tomb. To find a bronze bed, such as this object, is a truly special event.

In the same case, in the left corner, is a small object that is among the most interesting of the artifacts: a conical ★ ink pot, on which are incised many words and on whose base are incised the letters of the entire Etruscan alphabet. The inkpot is in black bucchero, the typical Etruscan ceramic.

This object also is linked to some interesting mysteries. The first is the writing itself. We know the letters of the Etruscan alphabet, a variation of the Greek alphabet, but we do not know the meaning of Etruscan words, above all because the more than 6,000 extant inscriptions are almost all of a funereal nature. So we know very well some of the words of praise for the deceased that repeat often, but the other words of the language remain obscure. There is hope for the discovery of a bilingual inscription, a kind of Rosetta Stone, to be able finally to decipher the Etruscan language that at the moment we can read but not understand. Even the presence of this inkpot among the precious funerary objects of the Regolini-Galassi tomb lets us understand how important writing was to this culture. An inkpot with the alphabet is a clear indication that the persons buried were not only rich and powerful, but also possessed a culture, that is, they were able to use these strange signs, the alphabet, recently arrived from Greece or better from Magna Graecia, the region of Southern Italy comprising Sicily,

Enrico Bruschini

Calabria, and Apulia, where Greek colonists founded prestigious cities that became beacons of culture and art.

The other mystery not yet resolved involves the type of ceramic, the bucchero nero used to make the inkpot. Bucchero is not normal terra-cotta colored black. If one examines a broken object one can see that the clay itself is black through and through.

We know that the Etruscans invented bucchero to imitate the elegance of the copper vases imported from Greece. The thinness of the most ancient ceramic was such that it was even called "eggshell." The composition of the ceramic and the method of baking it still remain a mystery. Many studies have been made to discover the secret. Among the suggestions are that iron oxides obtained from pyrite dust were added to the mixture, or that a special process of sedimentation divided the elements of the clay and the Etruscans then used only selected elements, or they fired the clay with a unique baking method with filled-in ovens deprived of oxygen in order that the oxygen within the clay was burned. But all attempts to reproduce bucchero have failed. Even when the ceramic appeared black on the surface, by means of smoke or burning, when the object was broken the grayish rose color of the terra-cotta appeared.

But at least one attempt has been successful and it would be interesting to reveal it.

About the year 1983 a noted Italian sculptor and painter, as well as noted Etruscan expert and a close friend, Alessandro Righetti, telephoned me. "Enrico, if you come and see me in Maremma [a typical Etruscan zone on the Tuscan coast], I will show you something special." Knowing his seriousness, I had to expect something unique. It would be difficult to say no. As soon as I reached his laboratory, he showed me a kind of black biscuit and he told me, "Break it!" I hit it against a large stone that the master was preparing to sculpt and the biscuit broke. The pieces were black even within! Using all the previously suggested methods in the proper way, he achieved success in this difficult undertaking. Like other true artists, once the object had been obtained after much work, he turned to other

studies. But for me it was an inexpressible emotion to see for the first time a ceramic perfectly reproduced from 2,600 years ago, the bucchero!

In the last case on the left the most interesting piece is the ★ Calabresi urn, named for its discoverer, who found it in the necropolis of Cerveteri in 1869 (No. 20825). It is a rectangular cinerary urn of terra-cotta, colored and decorated with ornamental designs, dating to the seventh century B.C.

Fascinated by the ancient objects, we might forget to note the beauty of the rooms of the Etruscan Museum. It is well worth looking at the upper section of the wall. The sixteenth-century decoration of the Belvedere Palace is perfectly preserved. Here, in the frieze beneath the ceiling, between the imposing caryatids in stucco, are episodes from the lives of Moses and Aaron, frescoed by Federico Barocci and Federico Zuccari in 1563.

In the center of the ceiling is the coat of arms of Pius IX (1846–1878) which substituted the original coat of arms of Pius IV (1560–1565).

One can continue left to enter the Room of Bronzes.

III. ROOM OF BRONZES

In this room one can see on the wall, between the stucco caryatids, the scenes of Daniel prophesying to Nebuchadnezzar, frescoed by Pomarancio and Santi di Tito in 1564. Above this frieze is a coffered ceiling.

The masterpiece of the Etruscan collection is displayed almost in the center of this room, the so-called ★ *Mars of Todi*, a bronze statue of a warrior (No. 13866) which takes its name from the city in Umbria, near Perugia, where it was found in 1853 buried and perfectly protected by four slabs of travertine. It is a very rare original bronze from the end of the fifth century B.C. In almost natural scale it represents a young warrior holding a spear in his left hand. He is making a libation to the gods with a cup, which he raises with his right hand. Found without a helmet, the statue must be completed in your imagination.

Enrico Bruschini

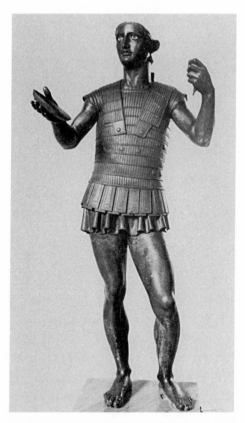

14. BRONZE STATUE OF MARS OF TODI

The beauty and classical composure of the *Mars of Todi* are a testimony to the capacity of Etruscan artists to respond to contacts and stimuli from the magnificent Greek art of the time.

The statue was donated to the sanctuary of Todi by a very wealthy person who, with the precious gift, desired to leave his name to posterity. If you examine the fringe of cuirass, you will see in the central part a light inscription, in the ancient Umbrian language, on two vertical lines, "Ahal Trutitis dunum dede" or "Ahal Trutitis gave as a gift." In this inscription the donor's name has been forever left to the future generations.

From Room III, if one has time, one may proceed through

In the Footsteps of Popes

Rooms IV to IX, which are not always open to the public, and then return to Room III.

From Room III we can go through the door next to that which we just came in and continue into Room XII, or the Hemicycle Room (the corridor is curved because we are on the upper floor of the Hemicycle of the great bronze Pine Cone that we saw in the Courtyard of the Pine Cone.

XII: HEMICYCLE — GREEK VASES

The Etruscans imported art objects from the entire Mediterranean basin to adorn their houses and to decorate their tombs.

The objects most loved by the Etruscans were Greek vases, particularly Attic vases, that is, those coming from Attica, the area of Athens where the quality of the ceramic, the beauty of the forms of the vases, and the incredible precision of the painting on the vases reached levels never equaled. We can say with certainty that the most beautiful ceramics made in Greece were acquired by the Etruscans and were found, for the pleasure of all humanity, in their tombs. The most famous Attic vases in the museums of the world all come from Etruscan tombs. In the Vatican, in this museum, there are two examples among the best in the world.

Entering the Hemicycle, let us turn left to admire in the second case, nearly at the halfway point of the corridor, the remarkable ★ *Amphora of Achilles and Ajax,* the amphora on the right (No. 16757), an incredible black-figured Attic vase signed by the great potter and artist Exekias. His name (written in Greek as ECHSEKIAS) is visible behind the shoulder of Achilles.

His signature as potter, or the one who selected the form of the vases, then modeled and baked them, has been found only on eleven of the most beautiful black-figured vases in different museums of the world.

But only in two special cases, on this amphora and on another exhibited in Berlin, did the great Exekias sign as vase painter, that is, he wanted to make clear that his hand not

only modeled the elegant form of the vase, but also painted it. In fact on the lip at the top of this amphora one can read in Greek "Echsekias egrapsen kapoeseme," or "Exekias painted and made me."

In the large panel between the handles we see the Greek heroes Achilles and Ajax, who have left their shields and are playing dice or *morra,* a game played with the fingers. See *Amphora with Achilles and Ajax* in the color insert.

Which of these two games are the two heroes enjoying so intensely? Archaeologists are still not unanimously decided, divided almost exactly in half between dice and morra. In fact it is difficult to determine. Another possibility recently proposed is that the two heroes are moving the pieces in an unknown game, a kind of backgammon. This hypothesis seems persuasive if we observe the intensity and concentration of their looks.

Beyond the beauty of the painting, the amphora of Exekias is famous for another characteristic: the two figures are speaking to each other!

This is certainly the most ancient example of comic strips. Wearing a helmet, Achilles on the left says, "Tesara," or "four." Ajax responds, "Tria," or "three." Note that this last word is written backwards beginning from the lips of Ajax, to show us that the sound is coming from his mouth. (Think that the comic strip with speaking figures was reborn in modern times only in 1892, when the *San Francisco Examiner* published "The Little Bears," by James Swinnerton!) If Achilles and Ajax are speaking, then perhaps they are playing morra, but they may be simply reading the dice. The doubt remains.

It is easy, however, to recognize the style of Exekias. In his works the commitment and personality of a master are evident. He was indeed one of the great painters of black-figured vases. His language is solemn and austere even when the themes treated are basically light, as in this famous vase.

On the back panel of the amphora one can admire the

In the Footsteps of Popes

remarkable representation of Castor with Kyllaros, the horse he tamed. Behind them appear the figures of his mother, Leda, and his brother, Pollux, accompanied by a dog. Note that the amphora still has its cover, something rather rare, for these are often lost.

To the left of the amphora is another very interesting vase, the precious *Amphora of Kleophrades,* a red-figured Attic vase (No. 16753). On the front of the vase are Herakles and Athena, who cheer each other, saying "Xaipe" ("chaire," or "cheerio"), the word written between the two figures. On the back of the amphora is a man with a lyre and young dancers.

 ○—➤ Finding before us two of the most beautiful examples of black-figured and red-figured vases, it would be interesting to examine their characteristics to better understand and appreciate yet more the masterworks of Greek ceramics.

An amphora, as we know, is a vase with a narrow neck with two handles, and it is used to contain or transport liquids or cereals. The Greek prefix *amphi* in fact means "double," from both sides. This is the same prefix we find on the word *amphibian,* meaning "double life," which is used to indicate animals that can live in water and on land; it is also in the word *amphitheater,* which means "a double theater," one in front of the other.

The amphora by Exekias is a black-figured vase. We see Achilles and Ajax painted in black against a red ground. These figures were obtained by drawing and painting them in black. Around the figures the natural red color of the terra-cotta was left unpainted as the ground (the gray clay becomes red when baked). To obtain the small details such as the eyes, the muscles, the clothes, etc., one used a burin, a small metal stylus, and scratched away the black to make the red of the terra-cotta appear for the desired details. Exekias at times added also the color white. On our amphora we can see this color on the mantle, the hair, and the beard of the figures.

Red-figured vases like that of Kleophrades are obtained by a completely different method.

Enrico Bruschini

15. HYDRIA WITH APOLLO

One did not paint the figure in black, but the entire space around this figure, sparing the surface, within which are the contours of the figure, will remain the red color of the baked vase.

To paint the details of the red figure, the painter did not use a burin but a small brush. Painting with a small brush in place of scratching away with a metal instrument allows more delicate and precise details. One can express the softness of a garment or a particular facial expression.

The passage from the technique of black-figure to red-figure vases occurred in Athens toward 530 B.C. and with probability was first used in the workshop of the great Exekias!

One can return to the beginning of the Hemicycle through the space designated as Room XIX and turn right to enter Room XX where there are many interesting vases. In the next room, Room XXI, you can admire the most beautiful vase together with that of Exekias. It is the astonishingly luminous

In the Footsteps of Popes

black vase in the case to the right. This is another masterpiece of Attic ceramic, the stupendous ★ *Hydria with Apollo* (No. 16568), a red-figured vase by one of the most expert vase painters who worked in Athens between 500 and 480 B.C. Although his name has not been discovered, his style is very distinct and individual.

He is called "The Painter of Berlin" because another famous vase of his is conserved at a museum in Berlin. His splendid style is very unique and easily recognizable by the ample surfaces painted with a luminous black color and in the center an isolated monumental figure. On our vase we see Apollo flying over the ocean. The god is comfortably seated on the great winged tripod of Delphi and he serenely plays his lyre. The ocean is denoted by fishes and an octopus. The transcontinental flight between Attica and the countries of northern regions of the world must be very tranquil, a trip in first class, judging by the relaxed face of Apollo. Smiling, we could say that it almost seems a perfect description of a UFO of 2,500 years ago!

Our red-figured vase is a hydria, that is, a vase for water (from the Greek prefix *hýdōr,* or "water"). A hydria is immediately recognizable because it has three handles. The two lateral handles served for moving and transporting the hydria, while the third, placed behind and a little higher, served to hold the hydria when one drew or poured water.

At the end of this room we can regain the entrance room.

Let us now descend the staircase (or ascend it if we have not visited the last two museums) and stop to see the room on the right before the long hall.

H–The Room of the Biga

This room in Carrara marble is the work of Giuseppe Camporese and was finished in 1794. It is circular in plan, and has a cupola, decorated with octagonal coffers, that is opened at the top. Eight Corinthian columns adorn it, between which are niches and large windows.

This room is often closed and so we must content ourselves with seeing the works through the gate.

Enrico Bruschini

16. DISCUS THROWER

Myron

In the center of the room is a marble Roman Biga (chariot), very probably a votive offering of the first century A.D. It was largely restored by the sculptor Francesco Antonio Franzoni.

The most noted work exhibited in this room is on the left wall, slightly to the right of the window. It is the famous ★ *Discus Thrower,* by Myron. The original bronze statue, sculpted by Myron toward 460 B.C., is lost. There remain some beautiful Roman copies from the time of Hadrian (second century A.D.). This statue, from Hadrian's villa, is one of the most attractive copies and is famous in the world as the "Vatican Discobolus."

It would be worthwhile to say a few words on the subject of Roman copies. Until now we have often spoken of Roman copies of Greek originals. We must not always think of this phrase as pejorative. The marvelous Greek originals have unfortunately almost always disappeared, and this is a grave loss for humanity. We must remember though that already in ancient Greece, as soon as an original work became famous, it began to be used as a model for numerous copies and variations that made it yet more famous in the ancient world. When Greece was conquered by the Romans, some original works were carried to the Eternal City, and others were copied in Greece as well as in Rome and the copies were carried to many parts of the Roman Empire. This happened particularly during the reign of the emperor Hadrian (A.D. 117–138), who greatly admired Greek art. He not only ordered the reproduction of many masterworks that remained in Greece, but also commanded the reproduction of many Greek masterpieces that had been carried to Rome and exhibited in the forums and baths. So when one speaks of a "Roman copy," this can mean either a copy carved by a Roman artist in Rome, or a copy executed by a Greek artist in Rome, or a copy or a new elaboration sculpted by a Greek artist in Greece for the Romans and then transported to Rome. It is almost always impossible to distinguish one from the other, and in general any statue found in Rome is defined as a "Roman copy" when we are certain that it is not an original Egyptian, Greek, or Etruscan work. When we have the good fortune, as in this museum, to admire many Roman copies, we can savor the memory of a past that bettered the aesthetic sense of all humanity.

A long gallery of approximately 855 feet (260 meters) leads to the Vatican Palaces and the Sistine Chapel. Many works of art, even if of an inferior level to those we have seen, together with other curiosities, make this crossing interesting.

As always we advise checking your watch and determining how much time you still have available. In this way you can

Enrico Bruschini

decide whether to glance quickly at the exhibited works or to dedicate more time to them.

On our part, we will describe only those works that are most interesting, especially those of historical and artistic value.

The long gallery is divided in three parts visually and in terms of content. The first part is called:

H1: THE GALLERY OF THE CANDELABRA

This gallery is approximately 215 feet long (65 meters) and is divided in six sections by arches that rest on elegant columns of colored marble. Beside the columns are ancient ★ Roman candelabra. These served, as we have already seen, to hold huge torches or to burn oil, wax, or resin in the receptacles at the top.

The vaults were painted between 1883 and 1887 by Domenico Torti and Ludwig Seitz with events related to the pontificate of Leo XIII. Details of the vault glitter with the mint-quality gold used in the decoration.

First Section In this section we advise admiring the beauty of the many types of colored marble here exhibited. These came from all the territories of the vast Roman empire and were imported by long trips and at enormous expense. In ancient Rome the use of breccias, or pieces of different marbles naturally cemented together over the course of millions of years, was greatly admired. Breccias from the furthest territories of the empire were imported, above all in the form of columns to adorn public buildings and slabs of marble to decorate walls and pavements. The most beautiful examples of colored marble, in my opinion, are immediately after the entrance to the gallery.

To the right there is a little column of red porphyry (No. 2), on which there is one of the most beautiful marbles, a ★ vase in breccia (No. 1), formed of translucent marbles of various colors, held together by a natural cement of a color tending toward green. To the left there is a ★ little column in breccia (No. 74), perhaps the most attractive in the entire collection. Note the

colored marble in varying tones of gray bound together by a natural cement of red color!

○—★ One curiosity: Almost at the end of the first section, on the right wall, in a rectangular niche, one can see the tip of an enormous finger in white marble (No. 26). If this is the tip of a finger, you can imagine how gigantic the statue must have been!

Second Section In the center of the niche at right is a statue of ★ *Artemis of Ephesus* (No. 22). In the ancient Asian city of Ephesus there was an important sanctuary dedicated to Artemis (Diana for the Romans), who was venerated as the goddess of fecundity. The original statue once adored by millions of pilgrims still exists at Ephesus, preserved in the local museum. This statue was considered so important from a religious point of view that reproductions of the Artemis of Ephesus in original scale and in miniature have been found in many sites of the Greco-Roman world.

A unique aspect of the statue is that diverse animals are shown on her body, a symbol of the fecundity of Nature—she can nourish all her children. The upper part of the torso is significant, but do not be fooled! What appear to be numerous typical female attributes (the statue is sometimes wrongly called "Multiple-breasted Artemis") are instead something quite different. If you observe closely, you will recognize that these are a very powerful symbol of fertility, but masculine fertility. They are bull testicles, one of the most powerful images of fertility in nature!

○—★ If you happen to overhear the explanations given by less expert guides before this statue, you will note that almost all make the same mistake of identification wrongly believing the attributes are female. This mistake would be easily avoided by observing more attentively.

On the other side of the gallery, before the window, we can see an elegant marble table leg carved in a mythological theme,

Enrico Bruschini

Ganymede and the Eagle (No. 83). For a piece of furniture the imagination and good taste of the artisans of ancient Rome proposed a mythological legend. Jupiter saw on earth a beautiful boy, Ganymede, who was considered the most handsome among the mortals, and he transformed himself into an eagle, and went to grab the boy and carry him to Olympus, where he became the cupbearer to the gods.

Note with what delicacy the eagle has seized the clothing of the boy, to avoid wounding the precious body.

This is a work of the second century A.D. inspired by a famous masterpiece by the Greek sculptor Leochares of the fourth century B.C. (the same artist of the original of the Apollo Belvedere).

Third Section On the walls of the third section are fragments of ★ Roman frescoes of the second century A.D. representing flying satyrs and nymphs. These were found in the area of Rome called Tor Marancia. Note the details of the chiaroscuro and the plasticity of the bodies, typical characteristics of the art of this period.

On the right, in the center of the wall, is a beautiful ★ still life mosaic, an excellent Roman work of the second century A.D. coming from the same area, Tor Marancia (No. 12).

⊶ Note the minuteness of the marble tesserae, approximately two millimeters square. Let us recall that the smaller the tesserae that compose a mosaic, the higher the quality of the work. In this case the vivacity and the modernity, if I may use this term, of the subjects are admirable. Look, for example, at the perfection of the two fish! It is enjoyable to identify the various species of plants and animals, such as dates, asparagus, chicken, shrimp, and cuttlefish.

Across from the mosaic is a most interesting statue of a ★ Faun with the Infant Dionysus (No. 40). Note how the eyes are alive! They are made of glass!

17. STILL LIFE MOSAIC

○—┳ This permits us to remember how all ancient Greek and
Roman statues were colored! This was a way to make them
appear more realistic. This obviously strikes us as a little
strange. Let us consider, however, if we were to sculpt a statue
in wood of the Virgin Mary today, what would we do? As soon
as the work was finished, we would begin to paint the hair, the
eyes, the lips, the mantle, and so forth. We would not wish to
see only the color of the wood, for this is only a frame. For the
ancients too the marble was only a frame, and so it needed to
be painted.

But why then are there no traces of paint on the statues?

The paints used were natural colors and after two thou-
sand years beneath the earth or under the rain and sun these
have disappeared, but not completely. On two statues in the

Enrico Bruschini

Vatican museums we can discern evident traces of paint. If we have visited the Gallery of the New Wing (Section D1), we have seen them. They are the Augustus of Prima Porta and the Silenus and Infant Dionysus.

Not only the statues, but also all the marble buildings were painted. We must become used to the thought that the great cities of antiquity like Athens, Rome, and Alexandria, even if built in marble, did not appear white but incredibly colored. In ancient Pompeii, freed of the lava and ash of Vesuvius, the traces of color on columns and buildings are still visible!

Fourth Section To the right, at the sides of the second rectangular niche, are two agreeable statuettes of small Satyrs Looking at their Tails (No. 40 and No. 37), typical works for a garden. In ancient Rome they served to create marks of white in the green of the grass and hedges. These are Roman copies of Hellenistic originals.

0—➤ To understand and better appreciate ancient statuary, it is good to keep in mind the distinction between classical Greek works and Hellenistic Greek works.

With the term classical Greek works we mean those sculpted in Greece toward the end of the fifth century B.C. and during part of the fourth century B.C. At the end of the fifth century B.C. sculptors passed beyond the abstraction and rigidity that characterized the works of the previous period, the archaic period. They achieved a supreme equilibrium binding the harmony of bodies to the serenity of expression. The major exponents of the classical period were Myron (in the Vatican museums a beautiful reproduction of his *Discus Thrower* is in Room H), Phidias (the reliefs of the Parthenon in Athens are his), Polycletus (we admired his statue of Doryphorus in Section D1), and Kresilas (in Section E4 a portrait of Pericles is after one of his works).

Perhaps the greatest artist of the period was Lysippus. With his *Apoxyomenus*, sculpted between 330 and 320 B.C., the classical period concludes and the Hellenistic period begins.

In the Footsteps of Popes

We saw the only extant copy of this work in Section E.

Hellenistic art dates from 323 B.C. with the death of Alexander the Great, who had spread Greek culture and art through the Mediterranean basin and as far as Asia. From the division of his empire among his generals, important kingdoms arose in Macedonia, Asia, and Egypt, in which Greek culture absorbed the religious and cultural ideas of the oriental world. Athens became less significant, and cities like Alexandria, Pergamum, Rhodes, and Antioch flourished.

In the Hellenistic period sculptors created works that were modeled more dynamically and with a heightened feeling for light and shadow, displaying in this way the emotions and feelings of the figures.

The major exponent of this period, working toward the middle of the fourth century, was Praxiteles and, in a more minor role, Leochares. The works of Praxiteles, filled with languid tenderness, were greatly appreciated by the Romans. His statues were copied and elaborated in such a great number that we are forced to recall Praxiteles as one of the greatest artists of ancient Greece. Of the numerous copies of Praxiteles' works in this museum we have already admired three magnificent re-elaborations of the Roman period: the *Hermes* (E1), the *Aphrodite of Cnidos* (E1 and E3), and the *Apollo Sauroktonos* (E3). From the works of Leochares, let us recall the remarkable *Apollo Belvedere* and the *Ganymede and the Eagle* we have just seen.

As Rome extended its dominion, the new and powerful kingdoms and cities became part of the Roman Empire. For a while Egypt resisted under Cleopatra and Mark Antony, but in 31 B.C. even it was conquered by Augustus; this officially ended the period of Hellenism. Not entirely, however, because Augustus himself was conquered by Hellenism, which was then reborn under the form of Neo-Atticism. This continued in Roman art all the way to Hadrian's reign (A.D. 117–138) and even influenced the Antonine period (A.D. 138–192).

In the center of the floor of the corridor of the Fourth Section is the coat of arms of Leo XIII, who reigned as pope

Enrico Bruschini

between 1878 and 1903. The blue marble, lapis lazuli, is very beautiful. This magnificent stone was used by Michelangelo to obtain the blue pigment for painting the sky of his *Last Judgment,* frescoed on the wall of the Sistine Chapel.

0—📌 How did Michelangelo work with this stone?

To understand the difficulty encountered for what might appear a simple process, let us recall that lapis lazuli appears to be blue because light, which obviously is white, passes through the crystals of the stone and reflects the color blue. When lapis lazuli is ground, it is necessary to be careful not to exaggerate the force used, otherwise the crystals are destroyed and one obtains only an ugly gray color. Imagine how difficult it must have been for Michelangelo to crush lapis lazuli to the correct fineness and then try to mix these crystals into the fresco.

Imagine the skill of the restorers when they recently cleaned *The Last Judgment* and managed to remove the dust and soot of the candles without disturbing these delicate crystals. All of the blue of the sky of the enormous fresco was cleaned by one restorer using a solvent and a sponge with oxygenated water together with long experience and a great love for art!

Continuing on, we see on the sill of a window a small statue of ★ *Tyche* (No. 2672) or *Fortune,* of the city of Antioch, capital of the Roman province of Syria (today the modern Antakya in Turkey on the border with Syria). Toward 300 B.C. King Seleucus I, formerly a general of Alexander the Great, founded a new city and named it Antioch in honor of his father Antiochus (325–251 B.C.). He was the ancestor of Antiochus IV (215–164 B.C.), who was defeated by the Maccabees in the Holy Land.

Seleucus commissioned the Greek sculptor Eutychides, a pupil of Lysippus, to sculpt a colossal statue in bronze as a symbol and protector for the new city. This was the first Tyche or goddess Fortune. For the first time Eutychides placed on the head of the represented city a turreted crown, a symbol of the walled city, and placed in the right hand ears of wheat, a symbol of the abundance the city must always enjoy. Finally he

In the Footsteps of Popes

placed the Tyche's foot on the shoulder of a young swimmer, the representation of the river Orontes that flowed beside Antioch and that must always be at the service of the city.

This work of the Vatican museums is the most beautiful small copy in marble of the ancient original in bronze that is lost.

Fifth Section On the left side, high to the right of the window, there is a moving statuette of a young slave (No. 32). He shows the objects used in the gym or baths, where perhaps he has accompanied his owner. He holds, in fact, a sponge in his right hand and in his left the container of oil for spreading on the body and a strigil, a kind of spatula for removing it.

Sixth Section At left, above the sarcophagus, is a small statue of the ★ *Fighting Persian* (No. 32). This represents a wounded Persian soldier who is recognizable by the typical conical cap he wears. This was inspired by a Hellenistic original work of the second century B.C. created in the ancient city of Pergamum, in Asia Minor.

○━━ The works from Pergamum, such as the *Great Altar of Pergamum* in Berlin or the *Dying Gaul* in Rome, are immediately recognizable by their dramatic forms and the pathos they express. We could almost distinguish in the grand and exuberant art of Pergamum the first expression of Baroque, for it anticipates many characteristics of this movement. The realistic school of Rhodes, the homeland of the sculptors of the stupendous *Laocoön* (EI), is derived from the art of Pergamum.

To understand the high level of culture among the inhabitants of Pergamum, it is enough to recall that in the second century B.C. the library of the city contained approximately 200,000 papyri and was the second largest library in the Hellenistic world after that of Alexandria. Out of fear of losing the distinction of first place, the Egyptian pharaoh Ptolemy V prohibited the exportation of papyrus rolls for writing.

However, the king of Pergamum, Eumenes II, was not discouraged and asked his citizens to invent a new support for

Enrico Bruschini

writing. Pliny the Elder records that after much study a special tanning of hides produced the first parchment, whose name is derived from the name of this city (parchment is more clearly called "Pergamena" in Italian). Parchment was more robust than papyrus and had the great advantage of allowing writing on both sides. Slowly the use of parchment caught up with the use of papyrus, then overtook it, and finally replaced it entirely!

A little more than halfway up, on the floor to the left, is a milestone (No. 27) from Via Appia, the *Regina Viarum* or "Queen of the Roads," the most famous among the Roman consular roads.

"All roads lead to Rome," and this was literally true, for once all roads departed from Rome they linked the capital of the empire with all its provinces, from Germany to Africa, from Spain to Persia. On all Roman roads there were milestones, placed at intervals of one mile, and indicating the distance from Rome and the name of the emperor or consul who had opened the road or had it restored.

0—⚲ Let us remember that the word *mile* is derived from the Latin word *milia* or *milia passum* and meant a thousand paces. A Roman pace was the equivalent to 4.86 feet (1.48 meters).
　　On this original column we can read first the name of the emperor "Maxentio" and below this the Roman numeral "V," designating the fifth mile of the Old Appian Way moving south from Rome. It was the emperor Maxentius who restored the Via Appia at the beginning of the fourth century A.D.

Let us end by stopping on the right, before the entrance to the next gallery, to admire, just below the window, a magnificent sarcophagus with Selene and Endymion, a beautiful Roman work, interesting both for its technique and its mythology.

0—⚲ In antiquity there was always an attempt to explain natural phenomena that could provoke fear in people. The Moon sud-

In the Footsteps of Popes

18. SARCOPHAGUS WITH SELENE AND ENDYMION

denly disappeared from the sky and then reappeared. Why? Where did it go?

Ancient Greek writers found a solution. Endymion was a young and handsome shepherd and Selene, the Moon, was desperately in love with him. There was only one obstacle to their relationship: Selene was a goddess and thus eternal, and Endymion was human and thus mortal. For this minor inconvenience a brilliant solution was found. Selene asked Jupiter a special grace for her beloved. An eternal sleep was granted to Endymion that would keep him always young and would permit him to enjoy forever the pleasures of life.

Each night Selene passed through the heavens with her chariot and contemplated her beloved Endymion, but in the end she could not resist the call of love and periodically she disappeared from the sky and descended to the earth so that she could be with him. This happened regularly *once a month, every month.* Their love was fruitful, for Selene obtained from the continuously sleeping Endymion some fifty daughters.

On the sarcophagus we see the sleeping Endymion on the right, and in the center Selene descends from her chariot to approach her lover, reproduced a second time on the left.

Enrico Bruschini

Incredibly an expression still used in the United States is tied to the myth of Endymion: "the dogs bark at the moon."

Let us remember that Endymion was a shepherd who kept his dogs with him (on the Vatican sarcophagus the dogs are carved on the two short sides). When the moon descended to visit the young shepherd, the dogs began to bark to alert their master that his beloved was arriving!

The myth of Endymion was represented often on Roman sarcophagi. Why? The idea was that the person within was not dead, but was sleeping an eternal sleep waiting to be visited and kissed by the goddess of the Moon.

H2: THE GALLERY OF THE TAPESTRIES

The second gallery, called the Gallery of the Tapestries, is approximately 245 feet (75 meters) long. Its vault is decorated in trompe l'oeil executed in 1789. On the walls to the right are displayed tapestries of the seventeenth century from the Barberini factory. More beautiful and more interesting are the tapestries on the opposite wall. These tapestries are based on designs by Raphael's pupils and were woven at Brussels by Pieter van Aelst, the same Flemish artist who executed tapestries based on Raphael's designs, which we saw in the Pinacoteca (B).

As always we will pause only before the most interesting works.

The second tapestry on the left is an *Adoration of the Magi* (No. 43860). We can appreciate the high quality of this tapestry. In the center, beneath the hut, are Joseph, Mary, and Jesus, while the three Magi present their gifts. The three kings have arrived from a great distance with horses, camels, and elephants, which are seen in the upper left. The shepherds are also looking at him adoringly. You can note how some of them look into the manger through openings in the back wall.

This tapestry, like all of those on the left wall, did not only have the purpose of ornamentation. These were hung on the lower walls of the Sistine Chapel during winter and then removed in summer. Their purpose was not solely to render the chapel more beautiful, but to warm it, absorbing the heat that

came from the braziers that burned in the chapel as well as from the visitors.

The tapestry we have before us was woven from silk, wool, and silver thread. Look at the shooting star resting on the gable of the manger. This was woven with silver thread and unfortunately appears very dark, a color between gray and brown.

o━━ Using silver thread was in fact an error. Exposed to air silver oxidizes and darkens. Everyone who periodically shines the household silver knows this well. If you look closely you can see that there is a great number of dark marks on all the mantles of the Magi and of other figures; this is tarnished silver. The beautiful tapestry has almost become a negative—the clear parts have become dark. Unfortunately a method of cleaning the silver without ruining the silk has not yet been found!

If we take a few more steps we can see that when the tapestries are woven not with silver thread, but with gold thread, the result is completely different.

Let us stop before one of the smaller tapestries (in particular Nos. 43864–6) that show the *Massacre of the Innocents*. It describes the story narrated in the Gospel of Saint Matthew, in which all the children under the age of two were killed on Herod's order so that the infant Jesus might die. We can see the pain of the mothers who vainly seek to save their children, but we can see too the strong reflections of gold in the garments of these women.

Let us go toward the window, but without proceeding down the gallery, to observe in another tapestry an exceptional example of "moving perspective." Without doubt this is one of the most spectacular examples in the world, and surely the only one executed in such a perfect manner on a tapestry.

We can observe on the same wall as the tapestries of the School of Raphael, but further to the right, an enormous tapestry with a representation of the ★ *Resurrection of Christ*.

Without drawing close, we can see Jesus leaving the tomb, the large rectangular rock that sealed the tomb having fallen to

Enrico Bruschini

19. RESURRECTION OF CHRIST
Raphael

the ground. This stone has fallen in our direction and toward a group of soldiers shown at the left. We can clearly see that the feet of Jesus are resting to the right in relation to the great stone. The Risen Christ turns his serene gaze toward us and raises his hand in blessing.

Incredibly, as we move before the great tapestry not only does the gaze of Jesus follow us, but also the great stone of the Tomb will move continually. We will see it exactly in the center of the tapestry when we are in front, and—something very disorienting—it will move completely to the right and in always a more accentuated manner as we draw away from the tapestry. We will see the feet of the Redeemer resting completely to the left with respect to the point of the stone and still his gaze and his entire body will be turned toward us! We have seen many visitors, when they became aware of this phenomenon, turn back incredulously to verify the event. Regrettably not all texts call attention to this unique phenomenon.

It is possible to imagine that a similar effect could perhaps

In the Footsteps of Popes

be obtained with modern techniques, but think of how this was obtained five centuries ago weaving silk and wool by hand!

The final tapestry (No. 43788) shows the terrible scene of the Ides of March. The great Julius Caesar was killed, as we all remember, on March 15, 44 B.C., in the large hall at the theater of Pompey in Rome. Among the conspirators was Marcus Junius Brutus, Caesar's adopted son. This tapestry was woven in Flanders in 1549.

H3: THE GALLERY OF MAPS

The Gallery of Maps is the longest gallery in the Vatican museums, 395 feet long (120 meters), and it takes its name from the forty great maps of Italy that Gregory XIII commissioned from Antonio Danti between 1580 and 1583. The designs, of incredible precision for those times, were prepared by the priest Egnazio Danti, a noted mathematician and cosmographer, and the brother of the painter. See The Gallery of Maps in the color insert.

○━┳ It was a mathematical study of Egnazio Danti that provoked the updating of the calendar that we use today. Pope Gregory XIII Boncompagni had a tower made, the Tower of the Winds, just above the Gallery of the Tapestries that we just visited, and he installed on the tower a highly accurate sundial. Egnazio Danti used that sundial to demonstrate that the Julian Calendar proposed by Julius Caesar had created a small error after fifteen hundred years: The Spring Equinox, when day and night have the same length, no longer happened on March 21, but on March 11.

Gregory modified the new calendar by ten days and to prevent future errors slightly corrected the computation of leap years. The reform of the calendar was decreed on February 24, 1582, and the new calendar, still in use, was officially called "Gregorian" in honor of this pope.

From a historical point of view we must recall that when the maps were painted, Italy was not a unified country, but was

Enrico Bruschini

divided into many states: the Republic of Venice, the Grand Duchy of Tuscany, the Papal States, the Kingdom of Naples, the Kingdom of Sicily, etc. The future Italy, not yet politically born, appears for the first time here in the Vatican, described meticulously in the Gallery of Maps.

○━━ On the left wall are represented the regions of Italy that face the Tyrrhenian Sea, while on the right wall are the regions that face the Adriatic Sea.

The precision of the maps is such that Americans of Italian descent often enjoy searching for their parents' or grandparents' small hometown, and they find it with the name the town bore five centuries ago. Some names today are actually a little different, but still it is very easy to recognize them.

On the maps the plans of the principal cities are represented in a more realistic way, in three-dimensional perspective.

The vault was richly decorated with stucco and paintings of episodes from the lives of saints and from the history of the church by Girolamo Muziano and Cesare Nebbia with the help of other Mannerist artists.

The windows on the right overlook the Vatican gardens.

It is best to look from the first windows, for the view is truly beautiful. The Vatican gardens have preserved the appearance of typical Italian gardens of the sixteenth century, with cured lawns, woods, and fountains. One can note the typical Mediterranean trees such as the umbrella pines, the Lebanon cedars, the cypresses, and the Egyptian palms.

In the center of the gardens is an elegant building that catches the eye. This is the ★ Casina (Little House) of Pius IV, erected between 1558 and 1561 by the architect Pirro Ligorio and now the seat of the Pontifical Academy of Sciences. Behind it rises a large tower used today as the seat of Vatican Radio. The right side of the garden is close by the long building of the Pinacoteca built in 1930 by the architect Luca Beltrami.

During the summer, when the windows are open, it is very interesting to look out and see, on the left side of the gardens,

In the Footsteps of Popes

the St. Peter's Basilica, with the ★ cupola and the exterior of the ★ apse designed by Michelangelo. The windows on the left open onto the Great Courtyard of the Belvedere, which we will see better when we reach the Rooms of Raphael.

At the halfway point of the gallery, after the counter where publications are sold, you can see the map of Latium and, in the lower left, a very beautiful plan of Rome.

Around the entire city are the perfectly preserved Aurelian Walls of the third century A.D., and in the center we can discern the Colosseum, the columns of Trajan and Marcus Aurelius, the Pantheon, and, surrounded by the Tiber, the Isola Tiberina. Very interesting is the Rome beyond the Tiber, where we are presently. One can recognize Castel Sant'Angelo, and above all one can see the St. Peter's Basilica. Before the basilica one can see the obelisk that already had been moved by Domenico Fontana from the nearby Circus of Nero, but we do not see Bernini's magnificent colonnade, which was begun only seventy-five years later in 1656!

You will have noticed before the windows some panels with large color photographs that illustrate the Sistine Chapel after the restoration—or better, after the cleaning. This latter term is more appropriate because the expert restorers in effect "only" cleaned away the effect of candle smoke that had completely blackened the frescoes. Let us not forget that this room, like all other rooms of the period, was lit entirely by candles.

We are now very close to the Sistine Chapel; the stairs that descend to the chapel begin at the end of the hall. Even if the desire to see the frescoes at this point is very great, we advise stopping briefly before the large photographs to understand a few small secrets and so savor better what we are about to see.

On the left panel we see a photo of the whole chapel. The Sistine Chapel was desired by Francesco Della Rovere, Pope Sixtus IV, and was called Sistine after him. According to tradition, the pontiff wanted it constructed with the same dimensions as the Temple of Jerusalem to demonstrate that

Enrico Bruschini

Christianity was the continuation of Judaism and was absolutely not in contrast with it. The chapel was built by Giovannino de' Dolci between 1477 and 1480. In 1481, to decorate the chapel, Sixtus IV summoned the best artists of the time, such as Botticelli, Perugino, Signorelli, Pinturicchio, Ghirlandaio, and Rosselli. On the left walls they frescoed episodes from the life of Moses, and on the right episodes from the life of Jesus. The vault was simply painted blue with golden stars.

Some years passed without any change. In 1508 Giuliano Della Rovere, having become Pope Julius II, commissioned Michelangelo to fresco the vault.

Although reluctant, above all because he had to leave sculpting, the great artist accepted. This was his first work in fresco, the terrible and marvelous medium of which we spoke before the frescoes of Melozzo da Forlì in the Pinacoteca (B).

Looking at the central panel we can understand how Michelangelo organized this enormous work. Enlarging the original program (Julius II had asked only for the Twelve Apostles to be painted), he conceived a magnificent architectural structure, and designed great thrones all around the vault on which are seated prophets and sibyls, and in the center two rows of *ignudi*. Recall the great Belvedere Torso? Now you can see the torso completed with head, arms, and legs, in twenty different reproductions. The ignudi are angels that Michelangelo painted nude and without wings, because in the classical period this was a symbol of purity (as in *Apollo Belvedere* and *Laocoön,* which were both so much appreciated by Michelangelo).

In the center Michelangelo placed panels of the Creation. Let us see them rapidly, and then more detailed explanations will be given in the chapel.

Beginning below, note:

The Separation of Light from Darkness
The Creation of the Sun and the Moon
The Separation of Water from Land
The Creation of Adam
The Creation of Eve

The Fall and the Expulsion from the Garden
The Sacrifice of Noah
The Great Flood
The Drunkenness of Noah

But Michelangelo did not paint the scenes in this order. Beneath the panel of *The Separation of Light from Darkness* there was, as there is today, the papal altar. The "terrible" Julius II used the chapel for solemn masses and to impress important foreign guests. Michelangelo preferred to avoid beginning to paint over the altar with the risk of paint dropping on the pontiff, and so he erected the scaffolding at the entrance to the chapel and began to paint first *The Great Flood.*

If you observe the central panel from the top to the bottom, that is, the vault from the beginning to the end of the works, you can see how Michelangelo improved his art from day to day in the following way: He gradually enlarged the figures; he gave greater force and naturalness to the figures; he created more transparency in the clothing; and he obtained shifting colors.

Perhaps the most important fact to remember in order to truly understand Michelangelo's genius is this: when he began to paint the vault of the Sistine Chapel in fresco, this technique was completely new to him. He had already painted masterpieces on panel, such as the *Tondo Doni* in the Galleria degli Uffizi in Florence, but he had never become acquainted with fresco. For this reason he asked at the start for the collaboration of a few assistants not to learn how to paint, but to learn the fresco technique, how to apply the wet layer of plaster, how much time to wait before beginning to paint this layer that had to be "just wet enough but not too wet," and so forth. As soon as he had mastered the new technique he sent these assistants away and remained by himself to paint the Sistine Ceiling for four years.

Let us finish by observing on the lower portion of the panel the examples of cleaning. Note that the surface of the fresco dirtied by smoke received a light solvent (a solution of water and ammonium carbonate) applied with a brush. This was immediately followed by a sponge with distilled water, applied

Enrico Bruschini

with great delicacy and professionalism. This is why I prefer to speak of cleaning and not of restoration: not a milligram of new pigment was applied to the ceiling!

The expert restorers of the Sistine Chapel have willingly left small parts of the fresco uncleaned in order to display the state of the frescoes before their intervention. You can have a clear view of this by looking at the third panel, that of *The Last Judgment*.

The nearly black rectangles seen in the lower left as well as in the upper left, in the center and at right, show how dirty the frescoes were before the "recleaning"!

Let us conclude this visit to the Gallery of Maps with a view in perspective of two cities painted on the wall at the end of the gallery. Recall that the maps show the Adriatic Sea at right, and therefore the city that appears above, at the end of the Adriatic, to the right of the exit door, is Venice, the town where, in the year 1254, the great traveler Marco Polo was born. For those who have already visited this city, it is easy to see how nothing has changed in Venice in five centuries—this is precisely the charm of the city. We see houses and palaces constructed on hundreds of small islands linked by bridges; we can recognize St. Mark Square with the basilica and bell tower, and see the Grand Canal and the Rialto Bridge. The only difference today is the form of the ships! But the white Baroque church of Santa Maria Della Salute does not yet appear at the beginning of the Grand Canal. It will be erected only a century later!

On the other side of the Gallery, at the end of the Tyrrhenian Sea, to the left of the exit door, is Genoa, the hometown of Christopher Columbus.

I–The Apartments of Pius V

This part of the museum is called in this fashion because Saint Pius V, Antonio Michele Ghisleri, lived in these rooms and in the chapel at the end (where there is the passage that leads to the Sistine Chapel), between 1566 and 1572. It was he who convinced Spain and the Republic of Venice to organize the fleet that defeated the Turkish fleet at the Battle of Lepanto in 1571.

The beauty of the Vatican museums is that they are not simply spaces filled with artworks, but rather are rooms used in the past as residences, libraries, and chapels; these places keep alive the memory, almost the palpable presence, of the persons who used them.

At the beginning of the left wall, just before the two large tapestries, there are two small rooms that are nearly always closed. If you chance to find them open, do not hesitate to enter. The first room contains Medieval and Renaissance ceramics. The second room holds some of the most refined objects in the museum, the ★ Collection of Micromosaics of the seventeenth and eighteenth centuries. On surfaces of approximately three square inches some of the most spectacular monuments of Rome, such as St. Peter's Square, landscapes, and animals, are represented with glass tesserae one millimeter in size. All were created by artists with a refined taste in color and an acute understanding of proportions.

Returning to the apartments, note two tapestries.

On the left wall are two great Flemish tapestries from the late fifteenth century, woven in Tournai, in Belgium. On the first are three ★ Episodes from the Passion of Jesus. Reading from the left, we see the Entry into Jerusalem, the Last Supper, and the Kiss of Judas. It is amazing how the colors have remained vivid after more than five centuries! The second is called the Tapestry of the Credo, with the Baptism of Christ in the center.

We turn now to the left and enter the Sobieski Room.

I-1: THE SOBIESKI ROOM

This room takes its name from the enormous canvas entitled *Sobieski Liberates Vienna*. It shows the king of Poland, who was victorious over the Turks outside the walls of Vienna in 1683 (the city is shown in the upper right). It was painted by the Polish artist Jan Matejko and given to Pope Leo XIII on September 12, 1883, in memory of the bicentennial of the victory at Vienna. This was an important event in history, for if the Polish king had not halted the Turks, they would have reached Paris and Rome in very little time.

Enrico Bruschini

A very pleasant curiosity is linked to the siege of Vienna and makes us understand how everyday life can be influenced by a long-ago and sometimes forgotten event. Could one ever imagine that the tragic event of the Siege of Vienna could still be linked to the typical breakfast of the Italian people, the cornetto and cappucino?

Note in the large painting how the symbol of the Turks, the half or crescent moon, is present over the tents at the left. This symbol terrified the inhabitants of Vienna, creating true nightmares. When the siege finished, the Viennese reacted to the terror inspired by this emblem by creating a pastry, called *Kiefer*, in the form of a half moon. It was the best way to exorcise the fear by transforming a symbol of terror into a tasty specialty! Something similar happened in Paris, where the crescent became *croissant*, and in Rome, where the crescent became *cornetto* or "small horn." The Romans prefer to call it in this manner in order not to use the same word as the French and also because the pastry is truly similar to a small pair of horns!

In the center of the floor is a beautiful colored Roman mosaic that came from the excavations at Ostia Antica, the port of ancient Rome.

If you love ancient marbles, note that two of the most beautiful marbles are exhibited in this room between the two entrance doors. The table has a stupendous panel of African breccia.

On the table rests a ★ vase in serpentine (No. 29). Serpentine marble, which is green and spotted like the skin of a serpent, is one of the most beautiful marbles in nature. Along with porphyry and *giallo antico* (a beautiful yellow marble), it was used in ancient Rome above all for creating precious pavements. We have already seen, if from a certain distance, two rare capitals in serpentine in the Octagonal Courtyard (EI). Only in this room can we appreciate at a close distance the beauty of this marble.

I-2: THE HALL OF THE IMMACULATE CONCEPTION

This room is named for the large fresco on the wall to the right, which shows the proclamation of the dogma of the Immaculate Conception. This is the 1858 work of the painter Francesco Podesti in memory of the definition and proclamation of the dogma on December 8, 1854, by Pope Pius IX, the last Pope-King. This dogma affirms that the Holy Virgin was preserved from original sin at the time of her conception.

In the center of the hall the case, which is perhaps overembellished, contains reproductions of the volumes that have the text of the dogma translated in almost all the languages and dialects existing in the world in the middle of the last century. It is an important linguistic document because the peoples who used some of these languages (such as Old Slavonic and Dalmatian) have since become extinct.

A ★ large Roman floor mosaic from Ostia Antica of the third century A.D., made up of elegant tesserae of colored marble, was placed in this room.

At this moment let us look at our watches and, according to the time remaining, decide whether to see the beautiful Rooms of Raphael or to head directly for the Sistine Chapel, which is not far away. A visit to the Rooms of Raphael requires at least twenty minutes and is recommended not just for the high quality of the frescoes, but also because it allows one to verify the influence Michelangelo's frescoes had on the young Raphael.

Remember to check the time remaining before closing time. Keep in mind that, if you would like to use the passageway that takes you from the Sistine Chapel to St. Peter's Basilica, it closes around 4:30 P.M. (1:30 P.M. on Saturday).

If there is little time remaining, go directly to the Sistine Chapel, taking the door to the right of the large fresco of the Immaculate Conception.

To visit the Rooms of Raphael take instead the door to the left of the large fresco.

We see for a brief moment one of the rooms that we will visit in a few moments because the one-way direction of the visit (especially during the crowded times) leads us to a long

Enrico Bruschini

external balcony of the sixteenth century, which leads to the first of the Rooms of Raphael.

I-3: THE EXTERNAL BALCONY

From the external balcony one has a clear view of the Great Courtyard of the Belvedere designed—and in part realized—by Donato Bramante at the beginning of the sixteenth century. Here one breathes the atmosphere of the Renaissance. The Roman architect Vitruvius, in his treatise *De architectura* of the first century, described the superposition of the three orders, the Doric, Ionic, and Corinthian, to give greater elegance to important buildings. On all the palaces around the courtyard it is possible to recognize these three orders reborn with the Renaissance. In the distance we can see the great niche of the Pine Cone, and on the left the long hall through which we passed. In the courtyard below we can see a fountain with a large Roman basin and, on the other side, two beautiful bronze doors. The right door leads to the Vatican Library; the left door leads to the Vatican Secret Archive.

The Secret Archive conserves documents not only from the Vatican, but also from around the world. They are preserved in a special vault beneath the courtyard. All the documents and building plans of the ancient palaces of the noble families linked in some manner to the papacy are preserved in the papal archive. Even the documents relating to the Palazzo Margherita, the Embassy of the United States to the Italian Republic, located on Via Veneto, are preserved in the archive. A close examination of those documents permitted me, when I was the curator of fine art of the Embassy, to establish that a statue of Venus at the embassy was sculpted by Giambologna, one of the most important Mannerist sculptors of Florence.

This research added a unique and rare work of art to the American patrimony. Sotheby's in London valued the statue at $18 million. The National Gallery in Washington requested its loan from September 1993 to May 1994. One of the

In the Footsteps of Popes

major Washington newspapers wrote that the discovery of the Venus of Giambologna was the best deal for the country since April 30, 1803, when the Louisiana Territory was acquired from Napoleon for $15 million!

The magnificent statue, which had been neglected for years in a very high niche, is now in a place of honor beside the central staircase and is even visible from the Via Veneto.

Let us finally enter the Rooms of Raphael.

Rooms of Raphael

These four rooms, immediately above the apartments of Alexander VI Borgia, were inhabited by Julius II Della Rovere. In 1503, when Giuliano Della Rovere was elected pope with the name Julius II, he was very reluctant to live in the apartments of his predecessor, the Spaniard Rodrigo de Borja, the notorious Alexander VI Borgia. In November 1507 Julius decided to transfer his residence to the upper floor of the palace, in the three rooms once inhabited by Pope Nicholas V and in another larger room inhabited by Nicholas III. The walls of some of these rooms were painted by noted artists such as Piero Della Francesca and Luca Signorelli. A few of the ceilings needed to be frescoed and some of the decoration needed to be completed.

While the pope lived in a small part of the apartment, noted painters such as Perugino, Baldassarre Peruzzi, Lorenzo Lotto, Sodoma, and Bramantino were commissioned to paint the vaults and finish the decoration of the rooms.

Toward the end of 1508 (the fateful year, we will see, that Michelangelo began to fresco the Sistine Chapel) an event took place that altered the course of the history of art. Donato Bramante, then commissioned to erect the new St. Peter's Basilica on the order of Julius II, suggested to the pope to have a small part of the apartment frescoed by a young painter who had recently arrived from Florence, Raphael Sanzio. As soon as Julius saw the work of this gifted painter, he gave him the commission to decorate the entire apartment, and he fired the

other artists, including Perugino, who had been Raphael's teacher. The works of the other great artists were almost completely destroyed to make space for the masterworks of the young artist.

J–Hall of Constantine

The Hall of Constantine is named among the Rooms of Raphael only because the artist left preparatory drawings for this hall. Unfortunately Raphael died at only thirty-seven years of age, as we will discuss later. After his death on April 6, 1520, this room was completely painted by his pupils. It was used by pontiffs for state ceremonies, receptions, and as a dining room for important guests.

Let us go to the center of the room to see the frescoes. On the wall to the right of the entrance we see *The Apparition of the Cross to Constantine*. This fresco was painted by one of Raphael's most gifted pupils, Giulio Romano, and it records the vigil of the battle between the last pagan emperor, Maxentius, and the first Christian emperor, Constantine. According to tradition, Constantine had a dream in which he saw a cross in the heavens and angels who suggested he place this symbol on the Roman banners to obtain victory.

Note that the frescoes on the life of Constantine are painted to resemble large tapestries hung in the center of walls. We see that the sides are painted to appear furled. Certainly the idea for this illusion was suggested to Raphael by the large Flemish tapestries woven on Raphael's design and hung in the Sistine Chapel (the same works we saw in Room VIII of the Pinacoteca).

A curiosity. The solemn scene is rendered lighter by an unusual detail. In the lower right corner of the fresco we see a dwarf who carries an enormous gold helmet. This is not an invention of the painter, but rather a graceful homage to a dwarf who actually lived at the papal palace as the court jester of Pope Leo X, and whose name, fortunately, has been conserved: "Gradasso" (the Boaster) Berettai.

In the Footsteps of Popes

One the sides of these frescoes we see figures of popes and virtues. Below, battle scenes are painted between the caryatids.

The large fresco to the right of the previous, on the wall facing the windows, shows the *Battle of the Milvian Bridge,* which took place on December 28, 312. We see the army of Constantine with the Christian crosses on the banners. In the center, riding a white horse, the victorious Constantine wears a crown. The emperor Maxentius, also wearing a crown, drowns in the Tiber. The Milvian Bridge, which is seen in the background, is still used today by Romans to cross the Tiber. This fresco too is the work of Giulio Romano, who used a preparatory drawing by Raphael.

To the right is *The Baptism of Constantine,* attributed to Francesco Penni, another of Raphael's pupils. We can see the interior of the baptistery of Saint John Lateran. Saint Sylvester, the pope who baptized the emperor, has the features of Clement VII de' Medici, who reigned between 1523 and 1534 (this pope endured the terrible Sack of Rome of 1527 and took refuge in Castel Sant'Angelo).

On the wall of the windows we see *The Donation of Rome to Pope Sylvester by Constantine.* An old tradition, never proven historically, suggested that the first emperor gave the city of Rome, and thus temporal power, to the pope. The donated city is represented by a small gold statue. This fresco too is the work of Raphael's pupils.

o—☛ This fresco is important because the scene of the donation is set within the old basilica of Saint Peter, built by Constantine, and is one of the very rare representations of the interior of the basilica. Note Solomonic (twisting) columns in the background of the fresco, for these still exist and we will see them in St. Peter's Basilica.

The tragedy of Raphael's early death is acutely felt in this room. The grace and vivacity of the artist, so evident in the following rooms, is absent here. Even if very skillful, the pupils seem to have no sure guide. The frescoes of this room were fin-

Enrico Bruschini

ished in the autumn of 1524. Many artists were then leaving Rome because of the limited economic means of the papacy and the delicate political situation that in a short time would ignite with the Sack of Rome in 1527. With this room the great patronage of the popes that made Rome become a city of art and culture declines for a time. After the Roman emperors, the Roman popes are those who renew and confirm the myth of Rome as the Eternal City.

The ceiling was decorated by Tommaso Laureti in 1585. In the center there is a magnificent illusion of perspective in which we see *The Triumph of Christianity*. A pagan idol, the god Mercury, lies in pieces on the ground. Jesus is on the altar.

The floor is a ★ large colored Roman mosaic of the third century A.D. in which we see four heads that represent the four seasons. This was found in the neighborhood of the Lateran.

To enter the rooms painted by Raphael we must pass through another large room. The door ahead leads to the Room of the Chiaroscuri.

J-1: ROOM OF THE CHIAROSCURI

This room is not part of the Rooms of Raphael. It is called the Room of the Chiaroscuri because the figures of the apostles and saints were painted in this way by Taddeo and Federico Zuccari in 1560. This room was the antechamber of the papal apartment and was used by Giovanni de' Medici, Pope Leo X, for important public and private ceremonies. Here the pope united the cardinals present in Rome for the Council of Cardinals or "Secret Consistory." The room is divided in two by three pilasters. The gilded ceiling is decorated with the emblems of the Medici and was executed according to the designs of Raphael. In the center of the room is a wooden sculpture group of *The Flagellation of Christ*, an Umbrian work of the fourteenth or fifteenth century.

Let us draw near to the windows of the room. Through these we can see the Loggia of Raphael, which is usually closed to the public.

The loggia is 213 feet in length (65 meters) and is completely decorated with stuccowork and ★ frescoes of "grotesques," especially on the pilasters. For this work Raphael also acted as architect, completing between 1512 and 1518 the work begun by Donato Bramante. Raphael's best pupils, such as Giulio Romano, Giovan Francesco Penni, and Perino del Vaga, worked on the frescoes under the direction of the master. The ★ stuccowork, which is very worn, is by Giovanni da Udine who, according to Vasari, rediscovered the ancient technique of stucco by mixing the dust of white marble with the slaked lime from travertine.

Raphael conceived the decoration, prepared the cartoons, and checked the work of his pupils.

This is one of the most beautiful examples of fresco of grotesques of which we spoke in describing the staircase of the Pio-Clementine Museum (E).

Unfortunately time has strongly obscured the magnificent white colors of the pilasters that are the background to the grotesques. Certainly a good cleaning would bring the loggia back to its original splendor.

A small door in the corner diagonal to the door we entered leads to a small chapel that is unobserved by some visitors. It is the wonderful Chapel of Nicholas V.

The Chapel of Nicholas V

Fra Giovanni da Fiesole, called Fra Angelico, frescoed this chapel between 1447 and 1451 on the commission of Pope Nicholas V. One can still feel within this small and marvelous chapel the atmosphere of simplicity and mysticism in which the artist and patron lived.

On the cross vault we see the Four Evangelists within clouds against a blue background.

Garlands of flowers and laurel leaves divide the walls of the chapel in two sections. Observing the thickness of the walls in the openings of the long and narrow windows, we become aware that we are in a medieval tower. The chapel, in fact, is

Enrico Bruschini

located in a thirteenth-century tower in the oldest part of the pontifical palace.

In the upper section of the walls are frescoed ★ episodes of the life of Saint Stephen. Beginning with the wall of the windows, we see:

Saint Stephen ordained assistant or "deacon" by Saint Peter
 in Jerusalem
Saint Stephen distributing alms to the poor
Saint Stephen preaching to the people of Jerusalem, who
 listen as the young saint counts on his fingers the rea-
 sons for belief in Christ
The discussion in the Sanhedrin
Saint Stephen brought to Judgment
The Stoning of Saint Stephen outside the doors of
 Jerusalem

Saint Stephen is called Protomartyr because he was the first Christian martyred in the name of Christ. This stoning happened at the time of Jesus. Saul (Paul), who had not yet been converted, was present at the execution.

In the lower section we see frescoes of ★ episodes from the life of Saint Lawrence.

Beginning again with the wall of the windows:

Saint Lawrence ordained deacon by Saint Sixtus II (note
 that the pope has the features of Nicholas V)
Saint Sixtus II confiding the treasures of the church to
 Saint Lawrence
Saint Lawrence distributing alms to the poor
Saint Lawrence condemned for refusing to give to the pre-
 fect of Rome the treasures of the Church
The martyrdom of Saint Lawrence

Saint Lawrence was burned alive during the terrible persecution by the emperor Valerian in the year 258. A few days before this, Sixtus II was also martyred. The sarcophagus with

the ashes of Saint Lawrence is preserved in the catacombs under the basilica of Saint Lawrence at Rome.

o—⚷ To permit the Swiss Guard, who lived in the large room beside the chapel, to hear the mass of the pope and at the same time to protect the pontiff a window was opened on the left wall that ruined the fresco of the martyrdom of Saint Lawrence. This was in part redone under Pope Gregory XIII (1572–1585), and we can see that the figures on the far right are quite ugly when we compare them to those of Fra Angelico.

On the pilasters are portraits of saints. Over the altar is a beautiful painting in oil of the sixteenth century by Giorgio Vasari showing *The Stoning of Saint Stephen*. We already have mentioned Vasari several times as the lively writer of the biographies of Renaissance artists. He also was an able architect and a skillful painter, as we can see here.

The beautiful floor is original and dates from the time of Fra Angelico.

o—⚷ As we leave the room let us observe above the small door the papal coat of arms and name of Julius II Della Rovere, who used this as his private chapel. The name *rovere* is also the word for a species of oak tree, the *quercus robur*. The symbol of the oak tree, but smaller, is over the door that leads to a small room that now is used for selling publications and souvenirs. This room was the antechamber of the *cubiculum* or bedroom of Julius II.

Let us finally enter the first room painted by Raphael.

K–Room of Heliodorus

This was the private antechamber of the papal apartment. It was the second room frescoed by Raphael and was done between 1511 and 1514. (Unfortunately the imposed direction of the tour does not allow us to visit the rooms in chronological order.) To appreciate the frescoes best, let us go to the angle after the window.

Remember that Raphael died very young, at the age of thirty-seven, but, as we can see in this and in the following rooms, he tried to better his style every day by continually absorbing elements of the manner of other artists.

In this room Raphael demonstrates that he knew and assimilated the art of the great Venetians such as Lorenzo Lotto and Sebastiano del Piombo, but certainly the greatest influence was Michelangelo, whose frescoes in the Sistine Chapel Raphael had admired and studied carefully in 1511. Painting this room he searched for new solutions in the way to use light in his works.

On the wall in front of you is a fresco of a biblical scene taken from the second Book of Maccabees, ★ *The Expulsion of Heliodorus from the Temple*. This room takes its name from this painting. Note in the central portion of the fresco the reflections on the bronze vault of the Temple of Solomon in Jerusalem from the flames of the Menorah, the seven-branched candelabra. This was an accurate study of illumination. The walls of this room have not been cleaned yet of the dust and smoke of the centuries, and so appear somewhat dark. Imagine how splendid the frescoes would be after cleaning.

The biblical episode describes how Heliodorus, ordered by the king of Syria, Seleucus IV, to steal the treasure of the Temple of Jerusalem, was stopped by three angels of the Lord. In the right portion we see Heliodorus on the ground with the treasure, two angels in flight and another on a horse to block him, while the high priest Onias prays at the altar for divine intervention. The meaning of the fresco is patent: Whoever is so bold as to seize the possessions of the Church will be punished immediately. It is a clear message in support of the temporal power of the Church. To give greater force to this, Pope Julius had himself portrayed to the left in a sedan chair.

O—π Here's a historical curiosity: Julius II appears with a beard. It was not common for popes to have a beard in the sixteenth century, and Julius did not have one when he was elected in 1503. In the autumn of 1510 he vowed not to shave his beard

until Italy was freed from the French, and he wore this beard until his death in 1513.

Under the fresco you can note a graffito of great historical interest. It is visible between two caryatids, almost near the thigh of the right caryatid. It was left by the lansquenets, the German mercenary troops of the emperor Charles V, who sacked Rome in 1527 and stormed the papal apartment, Pope Clement VII in the meantime taking refuge in Castel Sant'Angelo. The soldiers left the signs of their passing on the precious frescoes of this room.

On the graffito it is possible to see five letters probably scratched in with a dagger V K IMP, that is, Karolus V IMPerator, the man who sent the troops to Rome! Recently it was suggested that the graffito be read as "Vivat Karolus IMPerator" (Long Live Emperor Charles).

The graffito continues with some words in Old German: "Got hab dy Sela Borbons," or "God have the soul of the Bourbon." This is a clear reference to the killing of the commander of the lansquenets, Charles III, Duke of Bourbon, who was killed by Benvenuto Cellini (at least so the sculptor wrote) during the siege of Castel Sant'Angelo. This is without a doubt one of the most interesting graffiti from an historical point of view in the Vatican, and it is known to very few.

The most beautiful and interesting wall, in my opinion, is the wall to the left of this scene. A large window in the middle of the wall would have constituted a serious problem for any artist, but not for the great Raphael.

He experimented on this wall with a new and refined use of light.

This scene represents ★ *The Liberation of Saint Peter from Prison*. The scene takes place at night. In the center, behind a heavy iron grill, an angel radiating light puts the guards to sleep and frees Saint Peter, who had been arrested in Jerusalem by King Herod.

Covering with one hand the light coming from the window increases the effect of the glow produced by the angel.

Enrico Bruschini

More extraordinary yet, on the right one can actually see light in movement. Let us observe the angel who takes the hand of Saint Peter and accompanies him out of the prison. The angel approaches us, as we can see by looking at the pilaster beside Saint Peter. This pilaster is barely lit, or rather, is becoming lit by the intensity of light emanating from the approaching angel!

No other artist ever succeeded again in achieving a similar effect of light in movement.

In the left section the soldiers begin to realize what is happening. The light here comes from four different sources: the torch that creates reflection on the metal armor of the soldiers, the moon nearly hidden behind the clouds, the wonderful light of dawn, and the splendid angel in the center.

○━➤ Remember, all these effects were obtained in fresco, a technique that does not allow corrections or second thoughts. The stupendous light effects demonstrate that the young Raphael saw and assimilated from Venetian color. They anticipate by almost a century the marvelous chiaroscuro of Caravaggio and Rembrandt.

Imagine what a powerful effect this wall would have after cleaning. Almost certainly it would be the most beautiful nocturnal scene of the entire Italian Renaissance!

Let us remember that there is a strong connection between the theme of the liberation of Saint Peter and the life of Julius II. The chains that bound the hands and feet of the apostle are conserved in the church of Saint Peter in Chains (where Michelangelo's Moses is located). Before his election Julius was the titular cardinal of this church. As that church was property of the Della Rovere family, the members of his family desired that he be buried there. Looking at the fresco, which was painted immediately after the death of the pope, the scene could allude to the liberation of the pontiff from the chains that bound him to earth so that he could be led to heaven by an angel!

Let us move under this fresco to see the remaining two better. Before us now is the fresco known as ★ *The Miracle at*

In the Footsteps of Popes

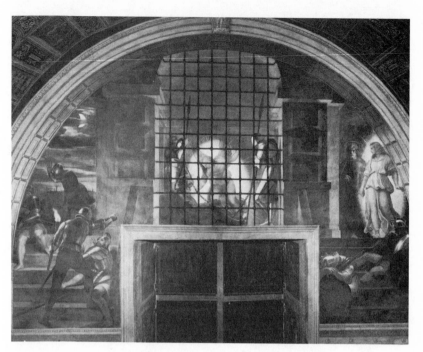

20. THE LIBERATION OF SAINT PETER
Raphael

Bolsena. This shows a miracle that occurred in 1263 in the small town of Bolsena. A priest from Bohemia who was traveling from Prague to Rome was celebrating the mass. He was skeptical about Transubstantiation, that is, the transformation of bread and wine into the Body and Blood of Jesus during the Eucharist. At the moment of breaking the host in consecration many drops of blood fell from the host to the white corporal, the cloth on which the priest places the chalice. To preserve the corporal stained with the blood of Christ the cathedral of Orvieto was erected, and in memory of the event the Feast of Corpus Domini was proclaimed.

In the fresco we see the Bohemian priest in the center as he looks with astonishment at the Host and the drops of blood; at left is the marveling crowd. Even the flames of the candles appear affected by the miracle. On the right are Julius II and his court, who do not marvel, maintaining their calm because they know that the Host is the Body of Christ.

Enrico Bruschini

○━ Again there is a window and, worse, it is not set perfectly in the middle of the wall. How can one hide this architectural irregularity?

Raphael found a brilliant solution. He placed the altar in the center, enlarged the platform of the altar, surrounded the entire upper level with a painted wooden arch, and then filled the large space at right with a highly colorful group of *sediari,* noblemen charged with carrying the papal sedan chair. The irregular setting of the window is almost not visible anymore!

On the last wall is a fresco entitled *Meeting of Leo the Great and Attila,* painted by Raphael and his pupils Giulio Romano and Giulio Penni. Attila, the "Scourge of God," the king of the Huns, descended on Italy in 452 and devastated the region around Venice. Pope Leo I, better known as Saint Leo the Great, although he had no troops, arranged an encounter with Attila and convinced him to return north. According to tradition, Attila was terrified by a vision in heaven of Saints Peter and Paul with swords in hand, both ready to defend the pontiff. The episode took place in the north of Italy, near Mantua, but it pleased Raphael to represent the encounter just outside the city of Rome. In the background we can see the Colosseum, an obelisk, and an aqueduct, while at right black smoke announces the arrival of the Huns. We can note that Raphael began to give more freedom to his pupils. In this fresco almost only the figures to the left are by his hand.

○━ If you look closely at the three figures at left, you will note that the first and the third are identical. Why is this?

Raphael had begun to paint the cardinals following the pope, and to the first he gave the plump features of the Florentine cardinal Giovanni de' Medici, the son of Lorenzo the Magnificent. He began to give to Saint Leo the Great the features of Julius II, but the pope then died suddenly in 1513. The Conclave elected Giovanni de' Medici as Leo X. Raphael then gave the features of this pope to Saint Leo and then did not cancel his first portrait!

The frescoes on the ceiling were almost certainly executed by Raphael's pupils and were executed on the designs of the master. Appearing as four canvases hung on the vault, these show events of the Old Testament: the burning bush, Jacob's ladder, the appearance of the Lord to Noah, and the sacrifice of Isaac. In the center of the ceiling we see a papal coat of arms with the keys of Peter crosses, recalling how Nicholas V lived in these rooms before Julius II.

The caryatids on the dado are by Francesco Penni or Perino del Vaga, pupils of Raphael.

Another demonstration that the room was begun by Julius II and finished by Leo X is found within the openings of the windows. Under the fresco of the *Miracle at Bolsena* we see a large coat of arms with an oak tree in the center. This is the coat of arms of Julius II Della Rovere.

Under the fresco of the *Liberation of St. Peter* we see instead a large coat of arms with six spheres, a blue one at the top and five red ones on a ground of gold. This is the coat of arms of Leo X de' Medici of Florence.

According to tradition—which has never been proven—Michelangelo designed the new uniforms of the Swiss Guard in the service of the pope using the colors of the Medici coat of arms: red, blue, and yellow. If this is true, we can say that the tradition of Italian stylists, such as Armani, Valentino, or Versace goes back to the great Michelangelo!

A smaller curiosity helps us to understand that these rooms were actually inhabited by the popes and visited by many guests (some important, some not) who wanted to leave a sign of their presence. If you look under the fresco of Attila turned back from Rome, you can see a graffito on the wall between the first and second caryatids, within the painted square. There is a date, 1560, and an illegible name along with a sentence in the Old Italian of the sixteenth century: "Ogi magiai co lo papa." "Today I ate with the pope." Five centuries ago a guest of Pope Pius IV Medici felt the need to leave this written on

Enrico Bruschini

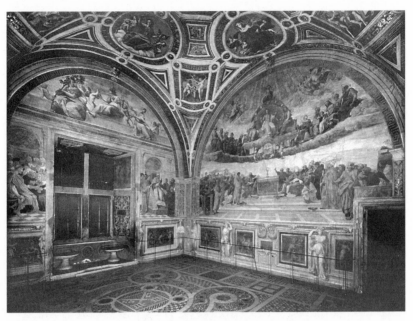

21. ROOM OF THE SEGNATURA

Raphael

the wall of the antechamber of the papal apartment to record
an event that was very important to him!

K-1: ROOM OF THE SEGNATURA (SIGNATURE)

Raphael was only twenty-five years old when he was sum-
moned by Julius II in 1508 to this room, the first decorated by
him. The work was almost completely executed by him. Fres-
coed between 1508 and 1511, it was used as a library and study
by the pope. It is called "of the Signature" because the decrees
of the highest court of the Holy See, the *Segnatura Gratiae et
Iustitiae,* were signed in this room.

The recent restoration has given the room the brilliant col-
ors that had been obscured by the dust and smoke of the cen-
turies.

The first wall frescoed by the young Raphael was that in
front of the door we entered. The usual title of the work is ★
The Disputation on the Holy Sacrament, but this traditional

title is due to an inexact seventeenth-century interpretation of the description made by Vasari. The correct title would be *The Triumph of Religion*.

Raphael organized this composition with great linearity. He placed God the Father, the Son, and the Holy Spirit in a vertical line. Immediately beneath these three figures he placed the Eucharist, the special point of contact between Heaven and humanity.

The young painter arranged his figures in three concentric planes. Above we have the Triumphant Church of the Saints and the Elect. We can see God the Father accompanied by angels, and in the center there is Jesus with the Virgin Mary and John the Baptist in Paradise with the Elect. We can identify, from the left, Saint Peter, the first pope, who holds in his hands the keys which symbolize spiritual power (the gold key) and temporal power (the silver key). The second figure is Adam with a most beautiful face. On the other side, with a red mantle, we see Saint Paul with the sword, which, as we know, is a double symbol: Saul (or Paul) used the sword when he was a soldier and persecuted Christians in ancient Palestine, and, later, at Rome he was decapitated with this same weapon. On the same side is Moses with the Tablets of the Law. Under Christ is the Dove of the Holy Spirit with four cherubs who hold the open books of the four Gospels.

Around the altar below is the Militant Church, that is, the popes and the faithful.

Raphael wanted to reproduce the features of many noted people. At the extreme left the old man looking into heaven is Fra Angelico, and to his right, leaning against the balustrade, is a balding man with a book in his hand who has the features of Donato Bramante, the great architect who, like Raphael, was born in Urbino.

To the right of the altar the seated pope who contemplates the Trinity is Julius II (the pope who in the year 1508 commissioned Michelangelo and Raphael to fresco the Vatican), and the standing pope wearing a magnificent gold mantle and the triple tiara is Sixtus IV (the pope who commissioned the building of

the Sistine Chapel), the uncle of Julius II. Behind Sixtus IV is a figure dressed in red and crowned with laurel; this is the sublime poet Dante Alighieri, the author of *The Divine Comedy*.

○—🔑 Further to the right is a monk whose face is partially covered by his hood. This is Girolamo Savonarola, the Dominican friar excommunicated by Pope Alexander VI Borgia for exposing the corruption of the church at that time, and burned at the stake in Florence only ten years before this fresco, in 1498.

The fact that Julius II asked, or allowed, Raphael to portray him among the members of the Militant Church is a strong sign of the full rehabilitation of the great preacher. Behind Savonarola there is a large and imposing white wall that is unfinished; this represents the new St. Peter's Basilica that Bramante had begun under Julius II.

The impression of the painting is at once powerful and delicate. We can understand how Julius II, seeing it, did not hesitate a moment to order the destruction of the paintings that covered the other walls!

Two graffiti on the fresco are very important from an historical and religious point of view. The German mercenary troops of the emperor Charles V left two noteworthy signs of their passing on the precious frescoes of this room. The two most interesting are on the fresco of the Disputation of the Holy Sacrament.

At the feet of the pope in the beautiful golden mantle a book is resting. On the spine of the book it is possible to read again, as in the previous room, five letters scratched in with a dagger in the year 1527 and dedicated to Charles V: V K IMP.

More interesting from a religious point of view is the second graffito that is found on the painted pavement, in a red rectangle beneath the book. Scrutinizing more closely, we can see the letters of the graffito that are approximately nine centimeters tall; they form the word LUTHER.

As a warning to the pope, the German soldiers wanted to leave in this room the name of Martin Luther, the religious

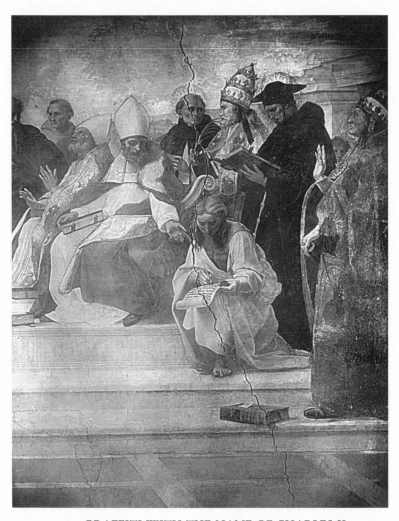

22. GRAFFITI WITH THE NAME OF CHARLES II

reformer who nearly ten years earlier, on October 31, 1517, had left his *95 Theses* on the door of the church of Wittenberg.

But why did the lansquenets write these words so high, in a place that is difficult to reach and so delicate? Because the lower part of the wall at that time was covered by a wainscot decorated in intarsia by Fra Giovanni da Verona and Giovanni Barile.

In front of the wall of *The Disputation* is the fresco by Raphael that perhaps is the most known and surely is the one

Enrico Bruschini

23. GRAFFITI WITH THE NAME OF LUTHER

most often reproduced, ★ *The School of Athens.* Within this work Raphael painted a magnificent architectural structure, and it is thought that Bramante passed on to the young Raphael the plans for the future St. Peter's Basilica. In fact, we can recognize that the coffered ceiling is nearly identical to that in the basilica, and, like the basilica, this edifice is surmounted by an enormous dome. To the left and right, in niches, are large statues of Apollo and Minerva, who symbolize the Arts and Knowledge. See *The School of Athens* in the color insert.

In the center of the composition are the two great philosophers of ancient Greece. At left in a red mantle is Plato, the founder of the Academy. He holds in his left hand his book *Timaeus,* and with his right hand indicates Heaven to signify that he is most concerned with the transcendental world of the ideas and the immortality of the soul. For the features of Plato Raphael used a portrait of Leonardo da Vinci. Let us remember that the young Raphael journeyed to Florence in 1504 and there

knew Leonardo, who at that moment was preparing the cartoons for the *Battle of Anghiari* painting in the Salone dei Cinquecento in the Palazzo della Signoria. Vasari observed that in Florence Raphael "distanced himself from the manner of Pietro (il Perugino), seeking to imitate the manner of Leonardo . . . especially in the gracefulness of his colors." To the left of Plato, in a blue mantle, is Aristotle, the founder of the Peripatetic School, the disciple of Plato and teacher of Alexander the Great. He holds in his left hand his book *Ethics,* and holds his right hand extended between heaven and earth, probably to indicate the practicality of his teaching, or perhaps to signify that virtue's path is between the two extremes. (Aristotle proposed a political model of equilibrium between extremes, so that an aristocracy could exist with democracy, a system made stable by a middle class of citizens who were neither too rich nor too poor. These ideas appear very modern but were formulated more than 2,300 years ago.)

To Plato's left, in a green garment and having the profile typical of Silenus, is the great philosopher Socrates, Plato's teacher, depicted as he enumerates deductions on his fingertips. His pupils listen to him raptly.

Seated in the lower left corner, concentrating on writing, is the mathematician Pythagoras. In the center, lying on the steps and intent on reading a sheet of paper, is Diogenes, the great philosopher, who proposed a return to nature and the abolition of the superfluous. To the right, bent over to trace a circle with a compass, is the mathematician Euclid. Raphael gave to Euclid the features of Donato Bramante, as we can recognize from his baldness, a necessary homage because it was Bramante who introduced Raphael to the papal court and made possible the commission to fresco these rooms. It is just on this figure of Euclid-Bramante that Raphael wanted to leave his signature. If we look with attention at the gilded collar of Bramante's garment you will note the letters R.V.S.M., the first letters of the Latin words Raphael Vrbinas Sua Manu, that is: "Raphael of Urbino with his own hand [painted this]." Raphael also placed his own portrait among the great men of the past. In the right corner, half hidden, we see a young man in a black cap who

looks out at us with a sweet and intelligent gaze; this is the young Raphael.

After the fresco had been finished for some time, Raphael returned to it and added another figure, the philosopher Heraclitus. We see him seated on the first step, dressed in purple, resting on a block of marble that has been set across. This figure is painted in a completely different style from the rest of the fresco: The knees are powerful, and the facial features are similar to Michelangelo's. Why was this figure later painted in this way?

Let us recall that in August 1511 Julius II ordered the removal of the scaffolding that covered half the ceiling of the Sistine Chapel, so that he could see Michelangelo's frescoes. On that occasion Raphael also saw the powerful frescoes and perhaps he saw them without being noted by Michelangelo, who did not want anyone near while he was working.

The historian and painter Giorgio Vasari wrote, "Raphael saw the frescoes of Michelangelo and changed style." Before us we have the concrete proof of this change, for Raphael removed a portion of the fresco, applied new plaster, and then painted a figure resembling Michelangelo, but, what is more, painted this figure in the style of Michelangelo! Raphael's preparatory cartoon, in which the figure of Heraclitus-Michelangelo does not appear, is preserved in the Pinacoteca Ambrosiana in Milan.

↝ In my opinion this is one of the most important documents in the history of art. It is a recognition and an homage made by a great artist to a master whom Raphael acknowledged was greater than he in giving plasticity and vigor to figures. Personally I hold that Raphael wanted to show, in a playful but respectful way, the truest aspect of Michelangelo, a solitary genius always absorbed in his thoughts!

Let us try for a moment to imagine these two great artists. They are working on the same days and in the same places, just a little distance from each other. Michelangelo is painting alone the immense ceiling of the Sistine Chapel; Raphael is

busy with his many pupils in the Rooms. Surely the two artists encountered each other, perhaps not speaking, for their characters were so different; but they esteemed each other.

Raphael had only enough time to paint frescoes in two churches in Rome (Santa Maria della Pace and Sant'Agostino) with figures in this new, powerful style before he died.

Vasari gives us a hint about Raphael's early death. After declaring that Raphael was very amorous and attached to the company of women, he informs us that Raphael "continued in amorous pleasures without moderation," and one day "returned home with a great fever." In addition, we must remember that at that time it was normal to treat sick persons with bleedings, which would have weakened more and more the young Raphael.

We receive this notice with a faint and melancholic smile of connivance, but what a great loss for humanity! Raphael is buried in the Pantheon in Rome.

On the wall beside the entrance door is the third fresco painted by Raphael, ★ *The Parnassus*. This represents the mountain sacred to Apollo and the Muses. In the center is Apollo, who strangely is not playing the lyre but a *lira da braccio,* an instrument similar to the viola that was very fashionable from the Middle Ages until the middle of the seventeenth century. It is, then, a musical instrument of Raphael's time.

०—⚷ This image suggests that music, poetry, and the arts in general are always living and contemporary. Apollo in all likelihood still plays, and plays with a modern instrument. If Raphael were to paint this fresco today, he would put an electric guitar in the hands of the god!

Around him are the nine Muses. Many poets are present and can be identified. In the upper left we can see Dante Alighieri in red, the blind Homer, and the Latin poet Virgil. To the left, seated beside and almost leaning against the window frame is

Sappho, the Greek poetess of Lesbos, while on the opposite side we can see the Roman poet Horace beside the window.

○━━ Note how the two figures lean out into the rooms, almost inviting us to participate in the meeting with Apollo. This is an incredible anticipation of Baroque illusionism and even of the "invasion into space" of Caravaggio.

Beneath the fresco of the Parnassus, on the sides of the window, are two interesting small scenes in monochrome. The one on the left shows Alexander the Great, who orders that the works of Homer be placed in the tomb of Achilles; the one on the right shows Augustus, who prohibits the executors of Virgil's will from burning *The Aeneid*. Both monochrome paintings render homage to poetry.

In the lunettes of the wall, before the fresco of *The Parnassus,* are figures of women and putti who represent ★ the Cardinal and Theological Virtues.

At left, Fortitude, in a cuirass and with a lion, holds a robust branch of oak (the heraldic emblem of Julius II), Prudence gazes into a mirror, or rather "reflects" before acting, and Temperance holds reins to slow and guide the satisfaction of desires and passions. The fourth cardinal virtue, Justice, which was considered the greatest virtue in platonic philosophy, is painted on the ceiling by Raphael immediately above the other three virtues.

At the extreme right of the lunette the putto indicating Heaven represents Faith, the one with a torch represents Hope, and the putto who gathers acorns from the oak branch represents Charity. In this fresco too, painted at the end of 1511, we see the influence of Michelangelo's frescoes on Raphael in the figures of the women who posed with a new solemnity and in the figure of Fortitude, which almost reproduces a Sibyl by Michelangelo.

The two frescoes by Raphael's pupils below the Virtues are related to the figure of Justice painted on the ceiling, and they show two historical events linked with early jurisprudence.

At left, as a symbol of civil law, the Byzantine jurist Tri-

bonian presents to the emperor Justinian the Pandects, a collection of decisions and opinions of Roman jurists. At right, as a symbol of canonical law, Saint Raymond of Penafort presents to Pope Gregory IX the Decretals, a collection of pontifical letters and decrees that have a bearing on law. The pontiff has the features of Julius II.

○━ The two cardinals are represented as they lift the rich vestment of the pontiff. This fresco painted toward 1511 seems to have brought good fortune to both men, for each became pope! At left, recognizable for his chubby face, is Giovanni de' Medici, the son of Lorenzo the Magnificent, who became pope Leo X in 1513. At right is Alessandro Farnese, who became Pope Paul III in 1534 and commissioned *The Last Judgment* from Michelangelo!

The ★ magnificent ceiling was given more force with the recent cleaning that brought the original splendor back to the frescoes.

Of the ornamentation painted before Raphael's arrival, there remains the coat of arms in the center with the crossed keys, the octagon with cherubs attributed to Bramantino, and the small paintings of historical and mythological scenes, in the spaces between the medallions, attributed to Sodoma. But the most astonishing parts of the ceiling are the four circular paintings and the large rectangular ones which are sublime works of the young Raphael. The figures in the roundels (called *tondi*) are closely bound to the scenes frescoed on the walls. We could even say that the wall frescoes are narratives on the themes of the allegorical figures of the ceiling.

We have already seen how the three other cardinal virtues descend from Justice. Above the *Disputation,* or *Triumph of Religion,* there obviously is Theology with its head veiled; above *The Parnassus* there is understandably a figure of Poetry with a lyre in its hand and with wings to represent the flight of imagination; and finally, above *The School of Athens* there is a seated figure of Philosophy.

Enrico Bruschini

The four stupendous rectangles show episodes from the Old Testament and from classical mythology. Beginning with the rectangle to the right of Justice, we see *Adam and Eve, Apollo and Marsyas, Astronomy,* and *The Judgment of Solomon.* It must be noted that the gilded mosaic that acts as a background to these beautiful works is not really a mosaic but is perfectly painted to appear as one!

The monochromes beneath the scenes in the whole room are by Perino del Vaga and were painted during the pontificate of Paul III to replace the wooden wainscot destroyed by the lansquenets during the Sack of Rome.

On the floor, decorated in marble intarsia, we see in the center the crossed keys of Nicholas V, the name of Julius II, and the emblems of Leo X.

⚷ Usually when one visits this room it is terribly crowded, but it is somewhat less so in the afternoon hours. With a small effort, try to imagine yourself alone, or with a few friends, in the center of the room. It will seem to you that you are in the center of the Universe; the great frescoes painted in a fascinating and enveloping form make you feel that you are participating in the narratives they display—you are there with the saints and the philosophers. Wherever you turn you see that all is governed by the law of supreme harmony, the representation of the greatest ideals of humanity: Justice, philosophy, religion, and art surround you and are within your reach. With this perfect beauty around you, you can experience a fleeting moment of ecstasy.

K-2: THE ROOM OF THE FIRE IN THE BORGO

This room was frescoed between 1514 and 1517 and was the private dining room of the pope. This was the last room in which Raphael worked, although his pupils executed most of the painting.

Pope Leo X wanted Raphael to paint episodes from the lives of two holy pontiffs, who in 795 and in 847 had chosen the same name: Leo III and Leo IV.

The room takes its name from the fresco painted on the wall before the window, ★ *The Fire in the Borgo.* This records the fire that broke out in 847 in the Borgo Santo Spirito, the neighborhood before St. Peter's Basilica.

In the background we see the Benediction Loggia of the old St. Peter's Basilica, from which Pope Leo IV gave a blessing that miraculously extinguished the flames. To the left of the loggia we see a rare image of the old St. Peter's Basilica, which was built by the emperor Constantine in the fourth century. The basilica was torn down on the orders of Julius II in order to erect the present basilica. On the left, the fire is linked with the fire of Troy. It is easy to recognize the Trojan hero Aeneas, who leaves the city carrying his elderly father, Anchises, and leading by the hand his young son Ascanius, his wife, Creusa, following.

The composition and part of the execution are the work of Raphael with the collaboration of Giulio Romano and Giovan Francesco Penni. Almost certainly the group of Aeneas, and the young woman on the right who carries an amphora on her head are by the hand of the master. The voluminous and powerful bodies make one understand how Raphael distinctly changed style after having seen Michelangelo's frescoes in the Sistine Chapel.

○━╼ A curiosity tied to this fresco: Beneath the Benediction Loggia the name of the pontiff is read LEO P.P. IIII.

P.P. is the abbreviation for the words *Pater Patrum,* or "Father of the Fathers," that is, of the bishops in all the world. But why is the number four written in that unusual way rather than IV? It is not an error. In the first centuries the number was still written with four I's, as we see in inscriptions in the Roman Forum as well as in the numbers over the entrance arches of the Colosseum. If you have a watch written in Roman numerals, look at it. You will be amazed—almost certainly the number four is written IIII and not IV!

On the right the fresco depicts *The Coronation of Charlemagne.* This was executed almost completely by Raphael's

pupils after the designs of the master. The scene is located within St. Peter's Basilica, where indeed on Christmas Day in the year 800 Pope Leo III crowned Charlemagne as Holy Roman Emperor. In the fresco Leo has been given the features of Leo X and Charlemagne the features of Francis I, the king of France, in commemoration of the treaty of 1515 between the Church and France.

On the walls of the window is frescoed the *Justification of Leo III.* This was almost surely designed and painted by Raphael's pupils. Pope Leo III succeeded Hadrian I in the year 795. Of humble origin, he was elected pope only by the clergy, and he immediately encountered hostility from the Roman nobility and even false accusations from the nephews of Hadrian I.

On December 23, 800, in St. Peter's Basilica, Leo III publicly swore before God that he had not committed any wrongdoing. At that instant a voice was heard from above that warned, "Only God and not men may judge bishops." After this event everyone immediately accepted Leo III. This was a clear reference to the Council of 1516 that had supported the same principle.

Charlemagne was present at the ceremony and he is shown on the left wearing an embroidered fur mantle with a gold chain on his shoulders. On the altar is a graceful representation of Saint Catherine of Alexandria, who also had been unjustly accused.

On the wall to the right is the fresco of *The Battle of Ostia.* In the year 849 a Saracen fleet attacked the papal fleet, and Leo IV was saved by a providential storm. At the left we see Pope Leo IV, who has been given the features of Leo X, give thanks for divine assistance. Raphael prepared many drawings for this episode, but the execution was entrusted to his followers. The decoration of the ceiling with four tondi (roundels) is the work of Perugino, Raphael's teacher, and was spared from any alteration by his former pupil.

Starting with *The Fire in the Borgo,* and turning clockwise, the tondi depict Christ the Judge, Christ and the Apostles with

In the Footsteps of Popes

God the Father and the Holy Spirit, Christ among the Angels and Two Saints, and God the Father among the Angels. Vasari wrote, "As the vault of this room had been painted by Pietro Perugino, his master, Raphael did not want to destroy it out of respect for him and out of the affection he felt for him."

o—➤ The door under *The Fire of the Borgo* once led to a large papal kitchen; that space has since been turned into a public restroom. Observe the splendid doors with the coat of arms of the Medici, an exquisite intarsia work of Fra Giovanni da Verona and Giovanni Barile, the same artists who had carved the wainscot of the Room of the Signature. Certainly no public bathroom in the world has more elegant doors!

The door to the right of *The Fire in the Borgo* leads to a small chapel.

The Chapel of Urban VIII

This was the small private chapel of Pope Urban VIII Barberini, the pope of Baroque Rome. In the corners one can recognize the coat of arms with the three bees, the symbol of the Barberini. The fresco *The Deposition of Christ* over the altar is by Pietro da Cortona.

In a glass case in the small passage that leads to the Sistine Chapel are displayed terra-cotta and plaster models by Antonio Canova.

Now you find two signs, a left arrow that indicates the most direct route to the Sistine Chapel, and a right arrow that indicates the direction to the Borgia Apartments, where the Collection of Modern Religious Art is exhibited. If you still have at least more than an hour of time, wish to see Pinturicchio's frescoes, and enjoy modern art, descend the stairs to the right. Otherwise, to continue to the Sistine Chapel, turn to the very narrow corridor on the left.

We will begin with an explanation for those who visit the Borgia Apartments, immediately after which will follow a description for those who reach the Sistine Chapel.

Enrico Bruschini

L–The Borgia Apartments and the Collection of Modern Religious Art

Cardinal Rodrigo de Borja, or Borgia, as he was called in Rome, was a Spaniard from Aragon, and when he was elected pope in 1492, he took the name Alexander VI. As he had to live in the Vatican, he asked the great painter Bernardino di Betto, called Pinturicchio, to decorate his apartments in order to render them more elegant and worthy of his powerful ambition. In 1492 the painter went to work with numerous collaborators; he finished the commission two years later.

○━━ Unfortunately, Alexander VI has remained infamous for his selfish use of the papacy. Nephew of Pope Callixtus III, Alexander reigned as pope from 1492 to 1503. He had several children, among them the beautiful Lucrezia Borgia and the cruel Cesare, who became one of the heroes of Machiavelli's *The Prince*. He was more a temporal monarch than spiritual leader, terrorizing cardinals and princes who did not submit to his power. It is unpleasant to recall that these stupendous rooms witnessed the exploits of Rodrigo Borgia, his children, and his court.

It was just for these reasons that the new pope, the great Julius II, refused in 1507 to live in these apartments and he went to live in the rooms above these, the rooms later frescoed by Raphael. After him other pontiffs too refused to live in these rooms despite the beauty of Pinturicchio's frescoes. The apartment was later blessed by the stay of Saint Charles Borromeo, who lived here from 1559 as nephew of Pope Pius IV. The beautiful rooms were used again in 1816 as the temporary site of the Vatican Pinacoteca to exhibit the paintings confiscated by Napoleon and then recovered that year. Toward the end of the previous century the floors, which were very worn, were redone in majolica tiles copying the few original tiles that had survived.

Now the Borgia Apartments are the site of the Collection of Modern Religious Art, which was formed and inaugurated by

Pope Paul VI in 1973. The collection consists of works of sculpture, painting, and prints given to the Holy Father by the artists themselves or by collectors from many nations. Besides the Borgia Apartments, this collection also fills many rooms beneath the Sistine Chapel.

The exhibition of modern works in rooms that were frescoed and lived in centuries ago provokes a strange feeling. Modern art needs space to be seen and judged. It certainly is not always easy to comprehend modern art. Often the message is not immediate, and special preparation is needed to appreciate it. Let us remember that if the artists of the past had not attempted new ways and diverse techniques we would have stopped at Byzantine painting, with its gold backgrounds. We would not have had the Renaissance, the Baroque, Impressionism, and so forth.

When Caravaggio painted a canvas like his *Deposition* (which we saw in the Pinacoteca), it was judged too modern, almost scandalous, and it was surely not easy to understand it during the period in which it was painted.

Many hundred modern works are displayed and it will not be possible to enumerate all of them. It is also difficult to select. The criterion adopted will be to indicate the artists most noted on an international level.

I AND II: THE ROOM OF THE SIBYLS

This is the first room one encounters at the end of the stairs that descend to the apartments, and immediately the terrible atmosphere that reigned in the time of Borgia seems to materialize. In this room, so beautiful for its frescoes, a ghastly crime took place. Right here, during a night in the year 1500, Cesare Borgia, the first-born son of Rodrigo, for political reasons (the end of the alliance with Naples) and jealousy, had his guard kill Alfonso of Aragon, the twenty-one-year-old husband of his sister, the beautiful Lucrezia Borgia. In this room the same Cesare Borgia, three years later, shortly after the death of Alexander VI, was imprisoned by Julius II. The room takes its name from

Enrico Bruschini

the Sibyls, or pagan prophetesses, who together with the prophets adorn the twelve lunettes, holding scrolls with prophecies on the coming of the Messiah. The frescoes were almost surely painted by Antonio da Viterbo, a painter in Pinturicchio's workshop.

To guide you better through the many works of modern religious art in this and in the following rooms, we will begin with the first work to the left of the entrance, and continue clockwise.

Take care and note that the numbers over the doors indicate the number of the next room and not the room you are in.

In this room are works by Ottone Rosai, Auguste Rodin, Armando Spadini, Ernst Barlach, Lello Scorzelli, and Ardengo Soffici.

In the small room to the left (II) are displayed works by Henri Matisse and Auguste Rodin.

III: THE ROOM OF THE CREED

In the lunettes twelve couples of prophets and apostles hold scrolls with verses from the Apostolic Creed, the prayer according to tradition composed by the apostles before separating to spread the Gospel throughout the world. These figures are the work of Pinturicchio's workshop.

Here are exhibited works by Bruno Cassinari, Domenico Purificato, Virgilio Guidi, Pietro Annigoni, Felice Casorati, Adolfo Wildt, and Mario Sironi.

IV: THE ROOM OF THE LIBERAL ARTS

This room has a ceiling of two cross vaults decorated with grotesques and stuccowork representing many, many bulls, the oppressive coat of arms of the Borgia. The beautiful sixteenth-century fireplace was perhaps brought here from Castel Sant' Angelo. It almost certainly is the work of Simone Mosca, based on the designs of Jacopo Tatti, called "il Sansovino."

This room was used by Alexander VI as a private dining room and study. When the pope suddenly died in August 1503, his body lay in state in this room.

The sculptures exhibited here are by Francesco Nagni, Alfredo Biagini, Fausto Pirandello, Mario Mafai, Orfeo Tamburi, Corrado Cagli, and Mirko Basaldella.

V: THE ROOM OF THE SAINTS

This room is richly decorated and is one of Pinturicchio's most attractive works. The abundant use of gold recalling the medieval world is typical of this painter.

The room is divided in two by cross vaults. In the segments of the vault Pinturicchio painted episodes of Egyptian mythology concerning Isis, Osiris, and the bull Apis (close to the painted pyramid), a clear allusion to the Borgia family coat of arms. In the lunettes, beginning above the large window and continuing clockwise, we see:

The Martyrdom of St. Sebastian with the Colosseum in the background
The Biblical Story of Susanna and the Elders
The Story of Saint Barbara
★ The Disputation of Saint Catherine of Alexandria
The Meeting of Saint Paul the Hermit and Saint Anthony the Abbot in the wilderness
The Visitation of the Virgin to Elizabeth

Without a doubt, ★ *The Disputation of Saint Catherine of Alexandria* is the most beautiful and spectacular fresco in the Borgia apartment. The scene is set within an idyllic landscape: slender trees stand out against the sky. Above the Roman triumphal arch is a bull, the symbol of the Borgia. In the foreground, before the Roman emperor Maxentius, Saint Catherine of Alexandria is declaring the principles of Christian faith. Pinturicchio has enriched the fresco with countless points of gold, tiny lights glowing on the trees and grass. It is thought that the sweet young woman with long blond hair is an image of the celebrated and unfortunate Lucrezia Borgia. In the left angle of the lunette appears the architect Antonio da Sangallo the Elder, with a square in his right hand, and at his left is Pinturicchio himself.

Enrico Bruschini

THE DEPOSITION

Caravaggio

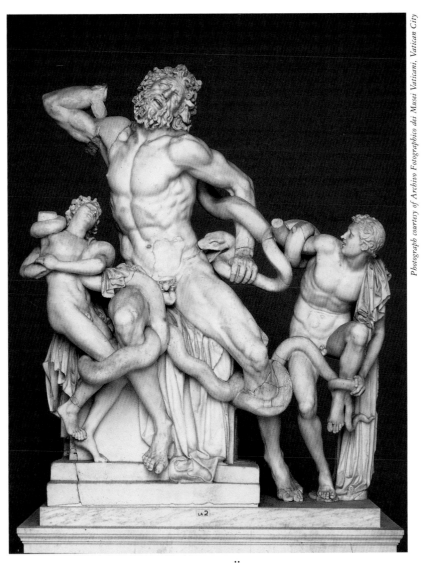

Photograph courtesy of Archivio Fotografico dei Musei Vaticani, Vatican City

LAOCOÖN

Hagesandros

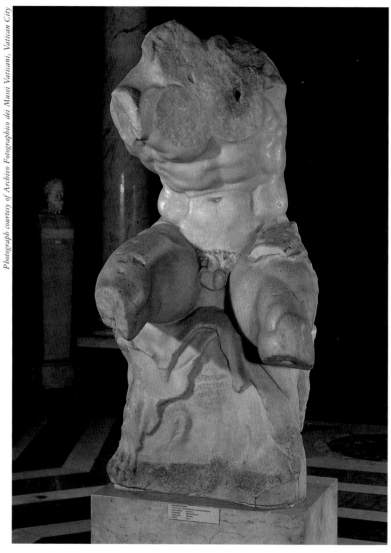

BELVEDERE TORSO

Apollonios

THE ROUND ROOM

AMPHORA WITH
ACHILLES AND AJAX

Echsekias

GREEK CROSS ROOM

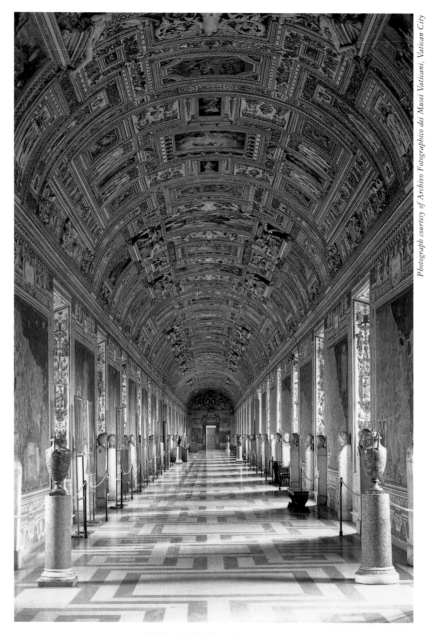

THE GALLERY OF MAPS

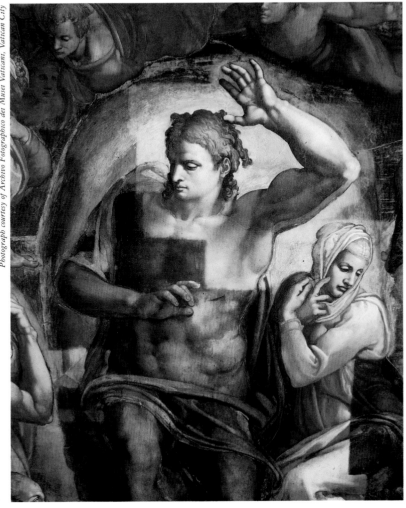

GALLERY OF MAPS—CHRIST THE JUDGE

(during the cleaning)

THE SCHOOL OF ATHENS

THE SISTINE CHAPEL WITH THE TAPESTRIES

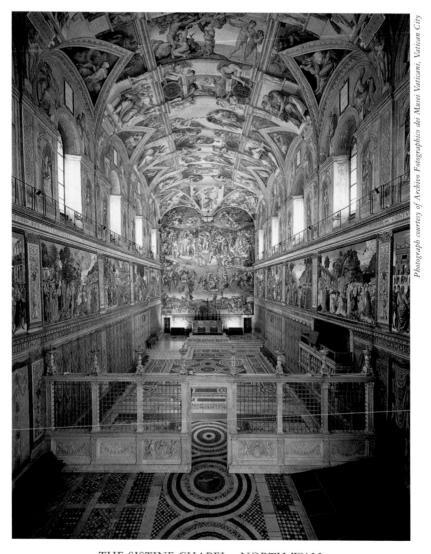

THE SISTINE CHAPEL — NORTH WALL

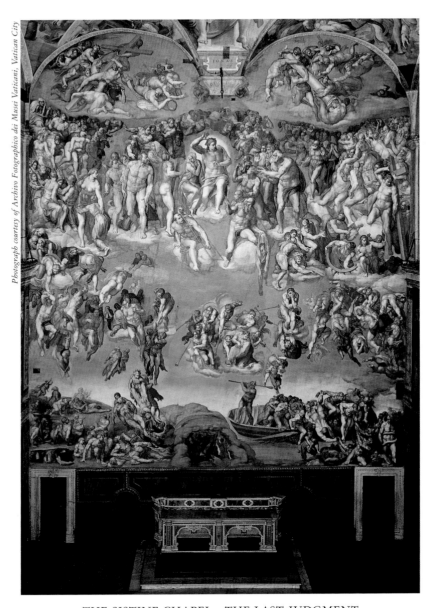

THE SISTINE CHAPEL—THE LAST JUDGMENT

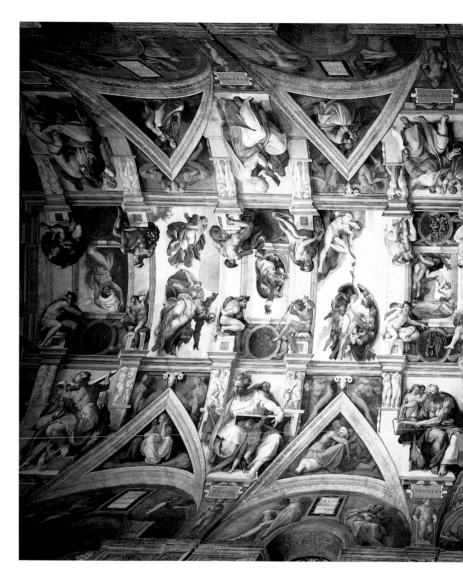

THE SISTINE CHAPEL CEILING

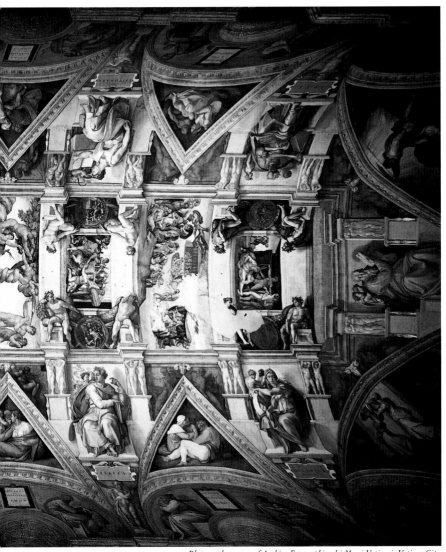

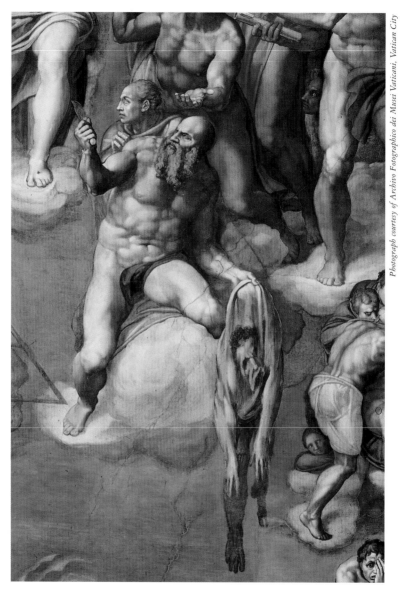

THE SISTINE CHAPEL — THE LAST JUDGEMENT,
DETAIL OF ST. BARTHOLOMEW

BRONZE BALDACHIN

Bernini and Borromini

MONUMENT TO ALEXANDER VII

Bernini

The fresco over the door that leads to the next room shows a Madonna and Child, by Pinturicchio's hand. The beautiful face of the Virgin is probably a portrait of the enchanting Giulia Farnese or "Giulia Bella," the young sister of Cardinal Giuliano Farnese, the future Pope Paul III.

All the beautiful sculptures in this room are by Francesco Messina.

VI: THE ROOM OF THE MYSTERIES OF THE FAITH

The form of this room duplicates that of the previous. It was the last room frescoed by Pinturicchio, who largely used his assistants in the execution. In the segments of the vault is decoration in stucco and eight roundels with busts of prophets. In the lunettes the principal mysteries of the Christian faith are represented. Beginning with the lunette above the window and continuing clockwise, we can see:

The Ascension
Pentecost
The Assumption of the Virgin
The Annunciation
The Nativity
The Adoration of the Magi
★ The Resurrection

In the lunette of ★ *The Resurrection* it is possible to see a portrait of the terrible Alexander VI, who is shown at the left, kneeling in profile in rich papal regalia; a triple tiara covered with pearls lies beside him. It is almost certainly by Pinturicchio's hand. The central soldier, with a lance, may be a portrait of Cesare Borgia.

In this room works by Marino Marini are displayed.

VII: THE ROOM OF THE POPES

This is the largest room of the Borgia Apartments. The ceiling was redone after the original, on June 29, 1500, suddenly fell on Alexander VI, who barely saved himself. Giovanni da

Udine and Perino del Vaga, commissioned by Leo X, decorated it with stuccowork and frescoes. The signs of the zodiac, constellations, and planets are depicted.

The name of the room is taken from the scrolls with the names of the popes. The room was used for audiences, solemn banquets, and official functions. In recent times it was used as a dining room by the cardinals united in conclave to elect the pope.

The works exhibited are by Lucio Fontana, Pericle Fazzini, Luciano Minguzzi, Giacomo Manzù, Emilio Greco, and Corrado Cagli.

ROOMS VIII–XII

These rooms are normally closed to the public.

To reach the Sistine Chapel, go back to Room IV (the Room of the Liberal Art) and turn left.

ROOM XIII

This was the bedroom of Alexander VI Borgia. One can see his name on the fireplace and his coat of arms on the wooden ceiling. One who crosses the threshold of this room almost shivers. Here Alexander VI died suddenly on August 18, 1503, probably poisoned. That same day the cruel Cesare Borgia began the systematic sacking of the apartment. In this room he found numerous silver objects and personal items of the pope, but the real Borgia treasure, two large caskets filled with gold coins, was found in a room "behind" this room (quite surely the next room, XXVIII) and it was instantly confiscated.

In this room are exhibited works by Franco Gentilini, Renato Guttuso, Luigi Bartolini, and, in the short passageway, by Carlo Levi.

Enrico Bruschini

ROOMS XIV–XVII

The rooms on the upper floor are normally closed to the public.

ROOM XXVIII

The small room is dedicated to the fascinating ceramics by Angelo Biancini.

ROOMS XXIX–XXXII

A staircase descends to the ground floor, where many different works are gathered: mosaics by Domenico Cantatore; stained glass by the French artists Fernand Léger, Jacques Villon, and Roger Bissière; reliefs by Lello Scorzelli and paintings by Giovanni Hajnal, and works by Lucio Fontana, Floriano Bodini, Umberto Mastroianni, Ivan Městrovic, and Gregorio Sciltian.

ROOMS XXXIII–XXXVII

The rooms that follow are in the area below the Sistine Chapel, which can be quickly reached at the end of this visit. Here are works of artists from many nations, including these artists from the United States: Ben Shahn, Lyonel Feininger, Jack Levine, Max Weber, and Philip Evergood.

ROOM XXXVIII

This room is almost entirely dedicated to the master Gino Severini.

ROOM XXXIX

This room has works by Primo Conti.

ROOMS XL–XLIII

These are dedicated to the Expressionists. The exhibited works, among others, are by the German artists Paula Modersohn-Becker, Emil Nolde, and Otto Dix, the Belgian artist James Ensor, and the Austrian artist Oscar Kokoschka.

ROOMS XLIV–XLVII

The exhibited works are by Graham Sutherland, Pablo Picasso, Francis Bacon, Salvador Dalí, José Clemente Orozco, and David Alfaro Siqueiros.

ROOMS XLVIII–LV

In the last rooms are works by the French artists Alfred Manessier and Jean Fautrier, as well as by the Italians Umberto Mastroianni and Giuseppe Capogrossi.

From the rooms of the Collection of Modern Religious Art one can rapidly reach the Sistine Chapel. If you have time, or are tired and thirsty, there is a bar open on a terrace behind the old palace, with a beautiful view of the dome of St. Peter's.

CONTINUING TO THE SISTINE CHAPEL FROM THE ROOMS OF RAPHAEL

If you did not descend to see the Borgia Apartments, you must pass through the Room of Sobieski for a moment. It is worthwhile to draw near to the windows, for from there you can see the exterior of the Sistine Chapel. It appears like a fortress with its merlons and passageways for soldiers. In fact, one of the reasons for its construction was the defense of the Vatican. Within it, of course, the space would have had an entirely different function: the glorification of God. Note how the illumination of the chapel is obtained from large lamps placed outside the windows and how this light is filtered by a special paper on the windows. The problem of light is very important.

The small dome of the chapel of Saint Pius V crowns the corridor that leads to the chapel. This dome is decorated with spectacular frescoes of *The Fall of Lucifer and the Rebel Angels,* the work of Federico Zuccari and Giorgio Vasari. (Do you remember? Vasari was the writer who described the lives and works of Raphael and Michelangelo.)

If the window before you is open, look out of it! You will have an exceptional view of St. Peter's magnificent dome and apse designed by Michelangelo.

Enrico Bruschini

A long and narrow staircase that follows the old walls leads to the door of the Sistine Chapel. During the descent a voice over a loudspeaker gives information. One of the most important things to know is that it is not permitted to photograph or take video within the chapel. We advise that you follow this rule in order to avoid scolding and censure of the numerous custodians present. While the desire to photograph is understandable, in this case it is truly worthwhile to purchase a book of the most beautiful photographs of the frescoes.

M—The Sistine Chapel

No other place in the world has been so often described as the ★ Sistine Chapel, and yet in visiting we become aware that no description can equal the powerful impact of seeing Michelangelo's frescoes in person.

Entering the chapel from a small door beside the altar, it would be advisable to descend the stairs and continue to the other side of the chapel, more or less beneath the third large lateral fresco, in order to see the panorama of the works.

The chapel takes its name from Pope Sixtus IV, who had it built between 1475 and 1483 by Giovannino de' Dolci on the designs of Baccio Pontelli. Sixtus wanted to give the Vatican a large and splendid chapel for solemn ceremonies. See the North Wall of The Sistine Chapel in the color insert.

The structure is 132 feet (40.23 meters) long, 44 feet (13.40 meters) large, and 68 feet (20.70 meters) in height, and is illuminated by twelve windows. The superb fifteenth-century floor is decorated imitating the style of the Cosmati, the famous medieval Roman marble workers, with intarsia of ancient Roman marble. It is easy to recognize the red porphyry from Egypt, the green serpentine from Greece, the antic yellow from ancient Numidia (modern Algeria), and the white Italian marble from Carrara (Tuscany). The marble screen, or balustrade, surmounted by candelabra is decorated by splendid bas-reliefs. It is the work of Mino da Fiesole, perhaps with the collaboration of Andrea Bregno and Giovanni Dalmata. It divides the chapel into two unequal parts: the larger is nearer

the altar and was reserved for the clergy, the smaller was for laity. The same sculptors carved the cantoria (choir).

As we know, Sixtus IV summoned the great artists of his time to fresco the walls of the chapel. Umbrian masters, such as Perugino and Pinturicchio, and Tuscan masters, such as Botticelli, Ghirlandaio, Signorelli, and Rosselli, came to Rome. They painted, between 1481 and 1483, the episodes from the life of Moses on the left wall and the episodes from the life of Jesus on the right wall. The same artists painted a series of papal portraits above these scenes.

Tapestries, on which we see the oak trees of the coat of arms of Sixtus IV Della Rovere, were painted beneath the frescoes. See the tapestries in the color insert.

○—✦ Let us recall that in the winter months, to make the chapel more beautiful and warm, the large tapestries prepared following Raphael's cartoons were hung over this painted decoration. We saw some of these tapestries in the Pinacoteca.

In 1983, after some centuries, Pope John Paul II requested that the tapestries preserved in the Pinacoteca be hung again on the walls of the Sistine Chapel for the Easter ceremony. It was a wonderful and unforgettable sight!

The ceiling of the chapel was, at the beginning, painted simply in blue with golden stars. See the ceiling in the color insert.

Only in 1508 did another Della Rovere pontiff, the great Julius II, order and almost force Michelangelo to fresco the ceiling of the Sistine Chapel, compelling him to leave for a period the sculpture that Michelangelo loved so much. According to tradition the suggestion to call Michelangelo was made to the pope by Donato Bramante, the architect commissioned to construct the new St. Peter's Basilica. The motivation for the suggestion was not generosity, but envy and jealousy: Bramante was certain that Michelangelo would either refuse the commission or fail in the execution of the immense work.

We must recall that Bramante was from a town near Urbino, Raphael's hometown, and perhaps was even Raphael's

Enrico Bruschini

relative. One can think that Bramante hoped that the work of frescoing the vault of the chapel, after a refusal or failure by Michelangelo, would be given to Raphael.

Michelangelo, however, accepted the challenge, though we can be sure that he was assailed by terrible fears. He had to paint an immense surface, and fresco was a difficult technique that he did not know. In addition his works would be compared to the frescoes painted by the skilled artists who had painted the walls below.

In any case, he went to work on May 10, 1508. He had scaffolding raised over the entrance door at the other side of the chapel and began to paint. For four years he remained alone on the scaffolding, working on his back, the paint dripping into his eyes, until he finished his masterpiece in 1512.

Twenty-four years passed, and in 1536 another pope, Paul III Farnese, commissioned Michelangelo to fresco the wall above the altar. On the ceiling Michelangelo had described *The Creation,* or the beginnings of humanity; he completed the cycle with the end of humanity, *The Last Judgment.* To paint the large wall, Michelangelo was forced to wall up two windows and to sacrifice two frescoes by Perugino as well as two lunettes he himself had painted in 1512.

Work on this new fresco continued for five years, from 1536 to 1541.

From the point in the chapel where we are at present, it would be best to begin to appreciate the beauty of the chapel by observing *The Last Judgment.*

THE LAST JUDGMENT

Michelangelo was sixty one years old when he began to fresco the wall at the end of the Sistine Chapel, and he had achieved an incredible ability in the art of painting. Note first of all the great circular movement given to the figures, beginning at the lower left, rising to the figure of Christ the Judge, and then descending to the lower right where the damned are. Note too in the heavens the deep and magnificent blue obtained with the crystals of lapis lazuli.

Finally, by observing the rectangles left uncleaned by the restorers, note how incredibly dark the wall was before its cleaning. Two rectangles are above the small door to the left, one is in the upper left beside the window, another is in the upper center beneath the figure of Jonah, and yet another is in the upper right corner.

After the perfect cleaning between 1990 and 1994, the wall reappeared as it was conceived by the great Michelangelo: an enormous window thrown open on the events of the last day of humanity.

In the lower left the dead rise to reach their final destination, awakened by the sound of the trumpets of the angels (at center), who are depicted by Michelangelo without wings but in classical and almost spiritual nudity (let us recall the statue of the priest Laocoön). Beside the trumpeting angels, on the left, note an angel who assists and saves two souls hanging by a rosary. This is a clear allusion to the practice of saying the rosary, and its message is clear: use the rosary often and you will be saved. See *The Last Judgment* in the color insert.

To me personally the representation of a powerful nude figure with its head veiled, who flies toward two people who wait with open arms is very moving. Are they the parents? It is consoling to think that there is someone above who loves us and is ready to receive us.

At the center is the figure of Christ the Judge, represented in youth (as in Early Christian art) with a powerful body and the face and hair of the Apollo Belvedere. Beside him is the figure of the Virgin Mary, the living link, the advocate of humanity.

To the right is the potent figure of Saint Peter, the first pope. He holds out his keys. Note that one is gold and the other silver. Respectively, these symbolize papal power in heaven and on earth, on souls and on living humanity, that is, spiritual and temporal power. These symbols still appear in the yellow and white of the papal flag today.

Beneath the figure of Christ the Judge are two Christian martyrs. To the left is Saint Lawrence, who was burned alive;

the instrument he holds in his left hand is not a straight ladder, but the iron "grill" used in his martyrdom! To the right is Saint Bartholomew, the apostle who was flayed alive for love of Christ, and he holds in his right hand the flaying knife used in his martyrdom; he holds in his left hand his skin. If you look closely at the skin you will see that the features of Bartholomew's face are Michelangelo's. The great artist portrayed himself in this tragic way! See *The Last Judgment* with details of St. Bartholomew in the color insert.

The suffering shown on the face makes us understand the intense spiritual moment that Michelangelo was undergoing at that time.

○━ Let us remember that in contrast to Julius II, who did not adequately pay the young Michelangelo as he painted the vault of the Sistine Chapel, the new pope Paul III paid Michelangelo generously as he frescoed *The Last Judgment* and showered many honors upon him. Michelangelo painted *The Last Judgment* without any assistants, and certainly this was a vast and tiring labor. I am convinced that the self-portrait of Michelangelo, who was about sixty-three years old, was placed in such a particular position not to show the pope his physical and moral suffering, as some have asserted. I believe that Michelangelo painted his face in place of Saint Bartholomew to participate directly, as a good Christian, in the atrocious sufferings of the first martyrs of the Church!

To the right of Saint Bartholomew three other saints are recognizable. Clothed in a red mantle, Saint Blaise is recognizable as he shows us the iron combs with which he was tortured. Before him is Saint Catherine of Alexandria with the hooked wheel used for her torture, and to her left is Saint Sebastian, who shows us the arrows that made him suffer terribly.

In the lunettes above are the instruments of the Passion of Christ: the Cross, the Crown of Thorns, and the Column of the Flagellation.

In the lower right of the fresco are those condemned to eter-

nal suffering. The figure to the immediate right of the trumpeting angels is striking. He is suffering greatly, not only because a devil gnaws his leg (as on the statue *Laocoön*), but he is desperate above all because he will be dragged below for all eternity. Other figures, interestingly, are taken from mythology, including Charon, the boatman of the netherworld, who hits the damned with his oar to get them away from his boat; and Minos, the wise king and lawgiver on Crete, whom Homer (and later Dante in *The Divine Comedy*) places in the hereafter as the judge of the dead.

○━ You can see Minos painted in the lower right just above the small entry door to the Sistine Chapel. A long serpent's tail twists twice about his body. This signifies that the entire group of damned souls rudely pushed by the boatman Charon is destined for the second circle of hell.

Michelangelo put two enjoyable allusions in *The Last Judgment*. If you observe the figure of Minos attentively, you note that he has the long ears of an ass. Why? The answer is uniquely entertaining. Paul III, the pope who commissioned the fresco from Michelangelo, had a master of ceremonies by the name of Biagio da Cesena, who continually reproached Michelangelo for the nudity in his works. The artist punished this critic in an unforgettable way by giving Minos Biagio's features, as Vasari records, and adding the ears of the ass. When Biagio became aware that he was portrayed by Michelangelo in this ridiculous way, he ran to the pope to protest. The pope, who was aware of all the details of the story, was quick to respond wittily, "Perhaps from Purgatory I would have been able to free you, but I have no power over Hell." And poor Biagio da Cesena has remained there forever!

After the recent restoration, which took away the veils later placed on the nudes, as we will see next, it was discovered that the great painter was yet more cruel with the master of ceremonies. Now one can clearly see that the serpent that coils around Biagio da Cesena has a head that until now was cov-

Enrico Bruschini

ered. And what does this head do? It bites Biagio's private parts!

Also entertaining is another detail. Observe the group of angels with the trumpets. See how two angels hold books, the list of the saved on the left, and the list of the damned at the right? Note the enormous difference between the two books. Was Michelangelo a pessimist, or was he perhaps a realist?

Paul III, a man of culture, openly appreciated Michelangelo's work, but his successors did not to the same degree. Paul IV Carafa defined *The Last Judgment* as a "brothel of nudes," and in 1564 his successor Pius IV, Giovanni Angelo Medici, on the advice of the Council of Trent, ordered Daniele da Volterra, a follower of the great Michelangelo, to cover the nudity. Very reluctant, the painter attempted to respect as much as possible the masterpiece of his master. But this did not save him from the pejorative nickname of "il Braghettone" or "the breeches maker." Later popes ordered further veiling of nudes.

The magnificent recent restoration has removed almost all the later repaintings, leaving only those ordered by the Council of Trent, considered, at least for the moment, as historically important. Pope John Paul II, in the address given on the day of the inauguration of the restoration, underlined the profound religious and theological meaning of Michelangelo's work, defining the Sistine Chapel as "the sanctuary of the theology of the human body."

THE LATERAL WALLS

Before beginning to appreciate the scenes on the walls, let us recall that the episodes from the life of Moses on the left and from the life of Christ on the right really begin on the wall before us, that is, on the wall of *The Last Judgment*. When Michelangelo was commissioned to paint *The Last Judgment* he had walled up the two windows that were there and covered Perugino's frescoes that represented the first scenes from the two cycles. These showed *Moses Saved from the Waters* to the left, and *The Nativity of Jesus* to the right.

In the Footsteps of Popes

o━━ Before we begin, let me make one observation concerning these fifteenth-century frescoes. They recently underwent a five-year cleaning, thanks to funds donated privately by the American Patrons of the Vatican Museums. This cleaning, besides giving back the astonishing colors of the works, has made possible a more precise identification of the individual contributions of the major artists, allowing a clearer vision of the participation of their workshops.

On the occasion of their unveiling on December 11, 1999, I noticed a very appropriate comment in a Roman newspaper: "If these works were in any other place in the world, each of these twelve painted rectangles would merit a journey so that it could be seen."

Remaining more or less at the point where we are, let us begin to look at the other walls, starting with that on the right before us, where episodes from the life of Jesus are painted. The large frescoes are separated by pilasters decorated with grotesques. Let us observe the first three frescoes, beginning with those nearest the altar.

On the wall we see *The Baptism of Christ*, by Perugino and Pinturicchio. At the center Jesus and St. John the Baptist are in the waters of the Jordan River. In the upper left and right are scenes of preaching.

In ★ *The Temptation of Christ*, by Botticelli and his assistants, the remarkable hand of the master is evident in the painting of the young woman at right, whose blue and white dress is fluttering. This immediately recalls similar figures in Botticelli's *Birth of Venus* or *Springtime*, which perhaps you have seen, or will see, in Florence. Also by his hand is the young man dressed in white at center. At center too is the façade of the hospital of Santo Spirito in Sassia, built by Sixtus IV between 1473 and 1478, almost before St. Peter's Basilica. It is one of the oldest hospitals in the world, restructured according to modern needs, and still in use today.

Next is ★ *The Calling of Peter and Andrew,* by Ghirlandaio.

Enrico Bruschini

At the center of this fresco are Peter and Andrew, who kneel before Jesus. According to tradition the Romans martyred Saint Andrew at Patras by fastening him on an X-shaped cross, a form which has come to be known as the cross of Saint Andrew.

On the walls in front the first three episodes of the life of Moses are frescoed. Again beginning from near the altar, these represent:

The Journey of Moses into Egypt, by Perugino and Pinturicchio

★ *Events from the Life of Moses,* by Botticelli and his assistants

The Crossing of the Red Sea, by Cosimo Rosselli

In the foreground of *The Journey of Moses into Egypt,* an angel sent by God reproves Moses for not circumcising his son; at right is the scene of circumcision. The fresco is lightly damaged; we can see paint losses. It also suffered from not having been cleaned for many years. Two small uncleaned sections, one on the left, and one near the circumcision, show how dark the fresco was. The recent cleaning has brought the colors back to their original splendor. Note the beauty of the background and the almost magical atmosphere created by the trees.

In the fresco ★ *Events from the Life of Moses,* Moses chases the shepherds away from the well (at center) and helps the daughters of Jethro give water to the flock. At right he slays the Egyptian who had mistreated an Israelite. In the upper left Moses removes his sandals and kneels before the burning bush. At the lower left Moses guides the Israelites out of Egypt. Here the hand of the master Botticelli is evident in the drapery and long flowing hair of Jethro's daughters as well as in the figures of the Israelites who follow Moses. The recent restoration has given luminosity back to this fresco.

The Crossing of the Red Sea shows the Egyptians, under a stormy sky, overtaken by the waters of the Red Sea. In the lower left, a woman plays a hymn of gratitude to the Lord.

The point where we are now is the best place to begin to look at the ceiling. If you succeed in finding a place on the long bench, sit down so that you can consider with more peace what is considered to be one of the great masterpieces of all time.

Let us recall that Michelangelo began to paint the cycle above the entrance door, and he continued by painting across, improving his style and experimenting with new ideas as he went. We see this in comparing the first two scenes painted, *The Drunkenness of Noah,* with one of the last two episodes, *God Separating Light from Darkness and the Creation of the sun, the moon, and the planet life.* We see that the dimensions of the figures grow so much that they begin to disturb the space around them. Above *The Last Judgment,* the Prophet Jonah, one of the last figures painted, almost does not fit on his throne and is compelled to twist back to admire the just finished *Creation.* The prophet is shown with the whale he stayed inside for three days.

The ignudi, that is, the wingless nude angels seated above the prophets (recalling the Belvedere Torso), are at first seated serenely, but gradually lose their composure, becoming agitated, each taking on its own life. Even the small putti that sustain the frame are first posed classically, like the Telamones we saw in the Room of the Greek Cross. Slowly, however, they begin to move, to feel free, and almost play among themselves.

Compare the Delphic Sibyl, painted first, at the far end of the wall before you, with the Libyan Sibyl in the corner just in front of you.

Without a doubt the Delphic Sibyl is beautiful and is even one of the most often reproduced. Look, though, at the Libyan Sibyl: the magnificent torsion of the body as she takes the large book, the colors of her clothing, which pass from yellow to orange to rose, the remarkable transparency of the veil over her legs, an effect obtained even in the difficult medium of fresco.

Michelangelo first painted the figure nude, someone imagined, and immediately afterward, with very diluted colors,

24. THE CEILING: LIBYAN SIBYL
Michelangelo

painted the clothing and veil. Given the size of the figure, and the difficulty of the technique of fresco (which we described in speaking of the frescoes of Melozzo da Forlì in the Pinacoteca), this appears unthinkable; let us not forget, however, that we are before the work of a genius!

The prophet to the left, in front of the Delphic Sibyl, is Jeremiah, the second major prophet of the Old Testament, who suffered martyrdom in Egypt. In the powerful figure of Jeremiah it is possible to see all the pain of the persecution suffered by the Israelites at the hand of Nebuchadnezzar, an episode that concluded with the destruction of the Temple in 587 B.C., the deportation of the Israelites, and the martyrdom of Jeremiah himself.

25. PROPHET JEREMIAH
Michelangelo

Let us now look at the pendentives, the triangular lunettes that join the walls and the ceiling.

In the pendentive to the left of the Prophet Jonah is *The Punishment of Haman*. This important biblical scene, not commonly known, is narrated in the Book of Esther. Esther was a young Jewish woman of the Tribe of Benjamin. Her parents were taken in captivity to Babylon, she remained an orphan and was adopted by her uncle Mordecai. The King of Persia, Ahasuerus, repudiated Queen Vashti, and—unaware that she was Jewish—chose the extraordinarily beautiful young Esther as his new wife. Mordecai discovered that Haman, one of the king's favorites, had obtained a decree for the massacre of all

Enrico Bruschini

the Jewish people in the kingdom. To save her people, Queen Esther invited Ahasuerus and Haman to a banquet, and then implored the king to punish Haman for the attempted massacre. Ahasuerus ordered Haman to be hung on the gallows he had prepared for Mordecai. In the painted scene we view King Ahasuerus reclining on a bed at right, and from this position he observes Haman's execution. The figure of Haman was almost certainly suggested to Michelangelo by the statue *Laocoön*.

In the pendentive to the right a famous biblical story, The Bronze Serpent, is illustrated. In this narrative from the Book of Numbers the Israelites journeying in the desert were discouraged and began to protest against God and Moses. As a punishment God sent poisonous serpents that bit many who later died. Moses appealed to God to save his people, and God told him to shape a serpent from bronze and to fix this on a pole; whoever looked on it would be healed.

From the point where we are we can observe the first three scenes of Creation:

The Separation of Light from Darkness
The Creation of the Sun, the Moon, and the Plant Life
The Separation of the Land from the Waters

Let us think of the verse from the Book of Genesis, how God said: "Let there be light, and there was light. God saw that the light was beautiful and he separated the light from the darkness."

In *The Creation of the Sun, the Moon, and the Plant Life,* we see the figure of God twice, from the front, and from behind. He is tremendously busy—he has only seven days to create the universe and life! Of course we know that in reality many millions of years were necessary, but the emotion and immediacy of Michelangelo's portrayal of the instants of Creation are extraordinary.

0—☞ Michelangelo put two enjoyable details in this scene, and we became aware of these only after the cleaning, for the fresco

In the Footsteps of Popes

was so dirty before that the details were not at all visible. Note under the right arm of the Creator an angel who shields his eyes against the blinding light of the newly formed sun. Only now can we see clearly the shadow cast from his arm over his eyes. The moon is frozen, and an angel under the left arm of the Creator covers itself with a scarf to escape the cold of the moon. The discovery of these two enjoyable details makes us think that Michelangelo, almost at the end of his enormous labor, felt somewhat more relaxed.

At the sides, within the lunettes, we see the Ancestors of Christ, whose names can be clearly read in the framed plaques.

In observing *The Separation of the Land from the Waters,* let us recall again the account in Genesis of how God created a dome and separated the waters from the land, and how he called the dome the sky.

The Prophet Daniel is to the right. The putto who helps Daniel support the heavy book is a pleasing embellishment. To the left is the aging Persian Sibyl, very old and hunched; she must bring the book of prophecies closer to her eyes in order to read.

Let us move now to see the scene that is perhaps the most beautiful and certainly the most famous of the entire Sistine Chapel, *The Creation of Adam.* One of the best points from which to view and appreciate this scene is near the door of the marble screen.

Against the sky the powerful Creator sits to one side with his angelic court; on the other side lies Adam—nude, unmoving, waiting. The inert hand of the first man, created a moment before and lying without strength on the earth, waits faithfully for the invisible spark that will issue from the finger of God. Millions of descriptions have been made of these two marvelous figures, and yet no one has been able to render the sense of trust of the one, and the immense love of the other. It is worthwhile to stop for a moment and contemplate how the genius of Michelangelo conceived the first instant of the birth of humanity.

Enrico Bruschini

26. THE CREATION OF ADAM
Michelangelo

Commentators from all over the world have expressed their opinion on this masterpiece; even the United States—famous for its common sense—has made a contribution. Years ago an American surgeon, seeing the form of the red mantle that covers God and the angels, said that, with its convolutions, this was the exact form of the human brain cut transversely. According to the surgeon, Michelangelo wanted to express indirectly to the viewers that he had seen the human brain. In fact, at the time Michelangelo was prohibited from dissecting and studying cadavers, and it was even more illicit to open the cranium. We know, however, that he did this. In London there are marvelous drawings by the artist that demonstrate with remarkable precision the various sections of the human brain. But above all, the surgeon wrote, Michelangelo wanted to demonstrate that the Creator at that moment was not only giving life to his beloved creation, he was transmitting a special gift, intelligence!

I reflected for a long time on this observation, which I hold to be very perceptive. Experts in anatomy can discern in the left arm of God the Creator the *corpus callosum*, in the body of God the *pons Varolii*, and in the legs of the Creator the beginning of the *medulla oblongata*!

A few months ago, a gentlemen from New Orleans asked

In the Footsteps of Popes

me, "Why did Michelangelo paint a navel on Adam?" I was surprised. It is true: Adam was created, he cannot have a navel. A mistake done by Michelangelo? Later, I explained the form of the mantle of the Creator to a lady, a noted American psychiatrist and gynecologist; as soon as I began to say, "If we look at the form of the mantle, we can clearly see..." she exclaimed, "A human uterus! Of course I have seen many."

I had not thought of this. In effect, the Creator had just given birth to the first human being! And other experts are quick to see in the green veil that floats from the figure the umbilical cord just cut. Adam was just delivered! And suddenly I understood why Michelangelo painted the navel.

We cannot prove these hypotheses, but, at the same time, we cannot discount them. Certainly Michelangelo placed within the ceiling a large number of symbols and messages that are yet to be discovered.

Now it would be best to proceed to the back of the chapel to have a view of the entire cycle and to appreciate better the final scenes. Let us return to appreciate the earlier frescoes on the right wall.

Let us look first at *The Sermon on the Mount,* by Cosimo Rosselli and Piero di Cosimo.

In the center of this fresco is the Sermon; on the right is the *Healing of the Leper.* The background is the work of the pupil Piero di Cosimo, who demonstrates, at least in this work, to be more skilled than his master, Cosimo Rosselli.

At the extreme left, standing, is the Venetian Queen of Cyprus, Caterina Cornaro (1454–1510). Behind her, looking at us, with black cup and black robe, is the self-portrait of Cosimo Rosselli, the painter of the fresco.

One of the most beautiful works in the earlier cycle and the work of Perugino, Raphael's teacher, is ★ *The Donation of the Keys.*

At center Peter, the first pope, receives the gold and silver keys, symbolizing spiritual and temporal power. The linear

Enrico Bruschini

27. THE DONATION OF THE KEYS
Perugino

perspective is very beautiful. Note the figures who run in the middle ground. In the background, at center, there is an elegant, centrally planned Renaissance church, and on either side of this the Arch of Constantine, a double tribute to the emperor who gave freedom to the Christians and temporal power to the popes.

Perugino portrayed himself in this fresco. He is the fifth figure from the right who looks at us. He is dressed in black and is wearing a cap of the same color over his long hair.

The last fresco represents *The Last Supper* and is by Cosimo Rosselli.

The scene is almost a synthesis of the last events of the earthly life of Jesus. Through the window we can see Jesus praying in the Garden of Gethsemane, the arrest of Jesus, and the Crucifixion.

On the left wall we see *Moses Receiving the Tablets of the Law,* by Cosimo Rosselli and Piero di Cosimo. At the center top of the fresco we see Moses kneeling as he receives the

Tablets of the Law; beneath that the Israelites who await the return of Moses have fashioned the golden calf. At left, an infuriated Moses smashes the tablets by hurling them on the ground, and then Moses returning with new tablets, his face radiant with light. In this fresco the landscapes are fortunately by Piero di Cosimo.

Next is the ★ *Punishment of Korah and His Sons Dathan and Abiram,* by Botticelli. In the right portion of this work the three men and their followers are shown as they rebel against the authority of Moses and attempt to stone him. In the center Moses halts them, raising his staff. To the left the earth gapes open to swallow the rebels. There was an effort to classicize the setting by inserting at center the Arch of Constantine and at right the Septizodium, a large Roman monument at the foot of the Palatine Hill that was still visible in the fifteenth century but which has since disappeared.

o—✶ Botticelli wanted to portray himself in the fresco, and we see him to the left, behind Moses, dressed in black with a black cap, black mantle, and black hair. He is looking at us.

The last fresco represents ★ *Moses Reading His Will,* by Luca Signorelli. On the right we see Moses, seated as he reads his will to the Twelve Tribes of Israel. At his feet is the Ark of the Covenant, which contains the Tablets of the Law and the golden receptacle with manna gathered in the desert. The young man in the center, classically nude, perhaps represents the Tribe of Levi, which is destined for priestly service. Above, on Mount Nebo, an angel shows Moses the Promised Land that he will never reach—a land depicted as rich with valleys, hills, mountains, and water. Moses then descends the mountain and gives his staff of authority to Joshua. In the upper left, there is the depiction of Moses' death in a delicate landscape.

o—✶ Signorelli also portrayed himself in this fresco. He is the third figure from the left who looks at us. He is dressed in black and is wearing a black cap over his long hair.

Enrico Bruschini

On the entrance wall, on the other side from *The Last Judgment,* there were two magnificent frescoes by Luca Signorelli and Ghirlandaio, the two scenes concluding each cycle. On the right of the large central door was *Angels Protecting the Body of Moses,* depicting the quarrel between the angels and the demons for the possession of Moses' body. On the left side was *The Resurrection of Jesus.* Regrettably both were destroyed when the wall collapsed in the sixteenth century, and they were indifferently repainted at the end of the same century by Matteo da Lecce and Hendrick van den Broeck. These frescoes were cleaned from 1979 to 1989, and you can note the small rectangular portions that show how dirty the works were before cleaning.

The scenes on the ceiling continue with Michelangelo's *The Creation of Eve.* Again, let us recall the words of Genesis: "God said that it was not good for man to be alone, I will fashion a helper for him." He made Adam sleep, and from a rib he made Eve. Eve looks gratefully at God. To the right is the Cumean Sibyl, old but still powerful, and intent on consulting the book of prophecies. To the left is the Prophet Ezekiel, who holds in his left hand a scroll of prophecies.

In the next scene, Michelangelo united in one field two episodes from *Genesis, The Fall* and *The Expulsion from the Garden.* A fig tree (a variation by Michelangelo) divides the scenes, its branches giving shade and serenity only to the left side of the fresco, Eden.

Adam and Eve, with splendid bodies, surely the two most beautiful nudes painted by Michelangelo, are intimately close. The devil, who has a woman's body, as was commonly seen in the Middle Ages, offers Eve the prohibited fruit. At variance from the account in Genesis, Adam himself picks fruit from the tree. The divine reaction is immediate. The devil is replaced by an angel who chases the sinners from earthly Paradise with a sword. Eve, frightened, takes refuge behind Adam. Both have become more ugly; they find themselves alone, naked, and desperate in a desertlike land. They disobeyed the Lord and lost His favor.

The next scene, *The Sacrifice of Noah,* shows the sacrifice Noah offered immediately after the flood. Michelangelo painted this scene before the flood in order to leave the larger space to the dramatic event.

The Book of Genesis records how, on leaving the Ark, Noah prepared an altar and offered a sacrifice to God. This sacrifice pleased God and he promised that, despite the savageness of men, he would never again cause a flood to destroy all mankind. To the right of this scene is the Prophet Isaiah, who marks his place in the book with his right finger. To the left is the Erythraean Sibyl and a putto who is lighting a lantern so that the Sibyl can read her book of prophecies.

The Sacrifice of Noah is followed by *The Great Flood.* On a small island at right an elderly man, perhaps a father, seeks to save an unconscious young man. To the left a few survivors try to gain the top of a crest of rocks. The figure of a mother with two terrorized children is very moving. In the center is the Ark, as solid as a house—or better, a temple, the Church. On the right part of the Ark you can see, perhaps with the help of a small pair of binoculars, the arm of Moses, who is waiting for the return of the dove. Michelangelo realized immediately that the figures were too small and numerous here, and in the successive scenes he always painted larger figures.

You will note that there is a gap on one side of the fresco. It happened in 1797, when an explosion of some barrels of gunpowder stored at the top of the nearby Castel Sant'Angelo caused this portion of the ceiling to fall. Thank God we lost only a small portion and not the whole ceiling!

In the last scene, *The Drunkenness of Noah,* the waters of the flood have receded and the Ark rests again on land, on the summit of Mount Ararat. After the sacrifice illustrated in the preceding painting, Noah freed the animals and began to cultivate the land, planting, for the first time, a vineyard. Tasting the newly pressed wine, he becomes drunk and falls asleep naked. His son Ham comes upon him and, deriding his father,

Enrico Bruschini

tells his two brothers, Shem and Japheth. In the fresco we see Ham from behind as he ridicules his father, Japheth as he covers his father and avoids looking on his nakedness, and Shem as he scolds Ham. On waking, Noah blessed only Shem and Japheth and their descendants.

To the right of this scene is the Delphic Sibyl, the first painted by Michelangelo and one of the most beautiful and most often reproduced.

It does not, however, have the *cangianti*, or "changing" colors, nor the effects of transparency of the *Libyan Sibyl*.

To the left of the scene is the Prophet Joel. Perhaps in his features Michelangelo left us a portrait of the architect Donato Bramante.

o━➤ It is in reality possible to recognize the ample forehead of the great Renaissance architect, as he appears in two portraits by Raphael in *The Disputation on the Holy Sacrament* and *The School of Athens* in the apartments of Julius II. Bramante was certainly jealous of Michelangelo, and he understood his possible competition even in architecture, but Michelangelo recognized in Bramante his great talent as the architect of the new St. Peter's Basilica. It will in fact, many years later, be above Bramante's powerful vaults that Michelangelo one day will raise his immense dome!

At the end of the vault, between the two pendentives, we see the Prophet Zechariah seated comfortably on his throne, having abundant space because Michelangelo had not yet thought of enlarging the figures.

o━➤ Just below this is the heraldic shield of the Della Rovere family, the family of both popes associated most closely with the Sistine Chapel, Sixtus IV and Julius II. A tall oak tree is in the center. If we look closely at the ceiling, we become aware that Michelangelo makes many references to this coat of arms. Some of the ignudi, for example, seated on the sides of the

28. DELPHIC SIBYL
Michelangelo

scenes of Creation, hold large cartouches from which issue enormous acorns, the fruit of the oak!

In the pendentive to the right of the coat of arms we see *David and Goliath*. The giant Philistine has been killed and young David prepares to cut off his head. In the left pendentive we see the story of *Judith and Holofernes*. This story from the Book of Judith recounts how when the Assyrian troops of Holofernes, a general of Nebuchadnezzar, were assailing the city of Bethulia, the young Judith succeeded in seducing the general and then, during the night, cut off his head. At right we see the decapitated body of Holofernes, and at left the maiden Judith, who carries the head on a platter over her head.

Enrico Bruschini

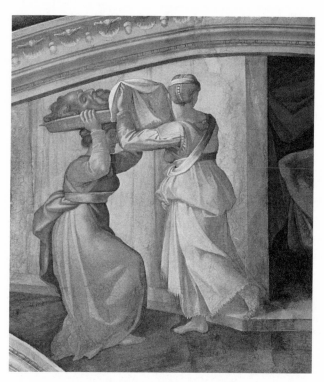

29. JUDITH AND HOLOFERNES
Michelangelo

If you look closely at the head on the platter, you can see that which almost all consider to be a magnificent self-portrait of Michelangelo. I also consider it to be such. One can in fact see the famous profile characterized by the ample forehead and the flattened nose from a punch perhaps received from a boyhood companion. The face is very similar to that sculpted by Daniele da Volterra and preserved in Florence in the Casa Buonarroti.

My certainty was recently shaken by a simple question asked by Perry, a young art enthusiast from Fort Worth, Texas: "But how old was Michelangelo when he began to paint the Sistine Ceiling?"

The scene with Judith and Holofernes was one of the first to be painted on the vault. Therefore it was 1508, and Michelangelo, born in 1475, was only thirty-three years old.

The face certainly appears more mature. It is not too daring to suggest that the great artist wanted to depict himself as older so as not to render immediately recognizable his self-portrait and appear to be egocentric!

A piece of advice: If you can find a free space on the long bench along the back wall, take the opportunity to sit there, for it is an ideal position from which to have a complete view of the Sistine Chapel!

If you look again from here at *The Last Judgment,* it will truly seem as if the wall has vanished and you are seeing the events of the last day. Admire again the incredible depth of the figures that appear to move in three-dimensional space, the last figures behind Christ losing them in the illusion of infinite space.

Look then at the figure of Jonah, above *The Last Judgment,* alongside the huge fish that swallowed him for three days. To see the vault, the prophet is constrained to twist around backward, for he is too large for his throne. But the figure is painted to a surface that curves outward! It is one of the most beautiful examples of perspective. Michelangelo wanted to leave an example of his great mastery, a kind of signature, by means of one of the final figures on the ceiling.

Johann Wolfgang von Goethe would stay hours upon hours in the Sistine Chapel, unable to pull himself away. He wrote, "Only in the Sistine Chapel can one understand what one human being alone is capable of doing." Here we can comprehend how Michelangelo, working alone for four years on the ceiling and for five on the altar wall, achieved not only the largest fresco in the world, but also the most fascinating masterpiece. The frescoes of the Sistine ceiling are considered unanimously the most important work of art in the world.

⊶ We must truly say "Bravo!" to the restorers who have made Michelangelo's masterpiece understandable, and downplay the few criticisms made during the cleaning process. The seriousness and competence of the restorers, whom I have had the

Enrico Bruschini

privilege to know personally in the course of many visits to the site of restoration on the scaffolding, have given back to humanity Michelangelo's magnificent colors.

Recently I was called to hold a series of lectures on the Sistine Chapel for my Rotary Club in Rome, and I showed a slide taken toward 1983, when the cleaning of the ceiling was about half done. One sees the scaffolding at center; on the right is a portion already cleaned, on the left a portion uncleaned. We all marveled in seeing how the vault appeared half in color, and half almost in black-and-white! See *Christ the Judge* during the cleaning in the color insert.

Five centuries of smoke from the candles and the braziers used in winter had completely covered the frescoes with a thick, dark patina. Greater damage was created by inept attempts at restoration over the centuries. To make the colors glow again, a layer of animal glue was passed over the surface, and this in the end absorbed even more smoke and dust. When the colors and even the figures were not legible the contour lines were strengthened with different colors to accentuate them. All this filth was delicately removed and only now can we admire the Sistine Chapel as it was painted by the great Michelangelo.

If we could draw nearer to the frescoes and possibly touch them, we would perhaps be able to understand better why they fascinate us so much. During the restoration of the ceiling and of *The Last Judgment* I had the good fortune to be invited several times to see the cleaning from a close distance. I think you can imagine the emotions you experience being only a few centimeters from the masterpiece, to run one's eyes over the painted surface with attention and care, and then realize how this surface was as smooth as ceramic, a sign of the perfection of Michelangelo's technique. But something else struck me more.

We were with the restorers before the beautiful face of Eve in the scene of *The Fall*. The face was covered by a thick layer of dust and soot, and the thick layer of glue that had been smeared on the fresco during an old restoration had

30. THE CEILING OF THE SISTINE CHAPEL
(DURING THE CLEANING)

darkened instead of functioning as a varnish to bring the colors out more. Indeed this glue threatened to mark the surface indelibly.

After applying a softening solution, one of the restorers then took a sponge of distilled water and with delicacy and enormous skill passed it over Eve's face. First the sweet eyes appeared, then Eve's lips. We shuddered as we became aware that Michelangelo had painted the lips of Eve as only a genius could: Using a very small brush he had painted Eve's lips with all the small vertical lines, as they appear in reality, with gradual modulations of color to endow the flesh with volume and mass. We looked at one another and understood that Michelangelo, alone in his labor on the scaffolding, had wanted to achieve perfection even if no one would ever be able to see the work except from a distance!

Let us try to imagine a scene that was repeated almost every morning. Michelangelo was alone on the scaffolding,

Enrico Bruschini

lying on his back in a very uncomfortable position. The pope entered by the door at the end of the chapel. He could not see Michelangelo through the scaffolding above him, but he knew and felt that he was there.

Entering the chapel, the pope would not greet Michelangelo. The only thing he said—or rather shouted—was, "But when will you finish?" Michelangelo's response, as he was intent perhaps at the moment in painting a delicate detail (the lips of Eve?) was inevitably and surely very nervously, "When I will have finished!"

Only the collaboration/clash of two true giants could give to humanity such an immense masterpiece!

When you entered the Sistine Chapel from that small door near the altar, you probably had two reactions: apart from the great emotion to have finally arrived, your unconscious almost instantly suggested the thought, "Is this it? I imagine it bigger and less dark!" You were in some way deluded. Now, having seen it well and understood it, you are more aware that it is immense and luminous. This is an intense feeling you can have only in the Sistine Chapel.

One last observation on Michelangelo. We have just seen him as the great painter; we know him as the great sculptor of the *Pietà, Moses,* and *David;* we have seen his work as architect as we passed the great dome of St. Peter's; but Michelangelo was also an engineer. When Julius II summoned him to paint the ceiling, he stipulated that Michelangelo was not to raise cumbersome scaffolding filling the chapel because he needed to use it for masses that were often attended by many guests.

Without scaffolding it would be difficult to stand an arm's length away from the ceiling. But Michelangelo did not worry. He thought for a while and discovered a solution. He had great holes opened in the walls above the highest cornice and through these he inserted short but strong poles, leaving about twenty centimeters outside. On the poles he fixed two long

In the Footsteps of Popes

tracks along the walls. On top of these he rested bridge-like scaffolding that was very close to the ceiling and did not touch the floor at any point. He used a series of stairs to reach the scaffolding and transport his painting materials.

In 1980, when the Director of the Museum decided to clean the ceiling, the same problem had to be confronted. One had to be very near the ceiling and at the same time not occupy or obstruct the floor of the chapel, for it had to remain open for the millions of visitors. After attentive and precise studies done by modern architects and engineers, Michelangelo's solution was embraced again. The holes opened by the great artist were reopened, the tracks fixed, and a scaffolding was constructed almost identical to his. (Michelangelo had built his longer because he did not want anyone to see what he was painting!) The solution found five centuries ago by the man who was first called a genius was still valid.

Before leaving the chapel let us recall that this is still the place used for the conclaves that elect the pope.

Often friends whom I accompany to see the chapel ask for little secrets concerning the conclaves that have taken place here. Perhaps this is the proper moment to say something about the election of the pope, always with the greatest respect for religion and the truth.

The word *conclave* comes from the Latin words *cum clave* or "with a key," indicating a place locked with a key. Why are the cardinals from all over the world really locked in the Sistine Chapel and the rooms nearby where they must pass night and day? Why can they not leave before the voting is completed and a successor is elected? Why is there so much severity?

It all began in 1268, after the death of Clement IV. The cardinals were gathered in Viterbo, a town whose powerful walls, still perfectly preserved, made it safer than Rome. The selection of the new pope was difficult from the beginning. Days passed, but new religious, political, and dynastic problems made the election arduous. Months passed, then years. Three years passed. The Church could not remain for so long with-

out a guide and the townspeople of Viterbo were not happy with the prolonged process.

One day the cardinals arrived in the large hall of the papal palace for another vote. The governor of Viterbo, Ranieri Gatti, locked the room with a key, opened the roof, and dramatically reduced the food, in order to compel the group to make a decision. Gregory X was elected almost immediately.

The rules for conclaves could alter in the future, but in the last conclaves the following ceremony was observed. Within eighteen days of the pope's death the cardinals must gather in conclave that takes place in the Sistine Chapel. On the day established for the beginning of voting the cardinals are sealed within the chapel and the surrounding rooms. The Marshall of the Conclave holds the keys. Usually he is an illustrious nobleman.

Along with the cardinals a few religious are also closed within. They function as assistants and secretaries, and there are servants who help the cardinals, and cook and serve meals.

The constitution of Pius XII established two votes in the morning and two in the afternoon. A majority is two-thirds plus one votes. After 1970 it was decided that cardinals over the age of eighty cannot participate in the voting.

After each vote the ballots are burned in an oven placed beside the door under the fresco of *Moses Reading His Will*, at the end of the Sistine Chapel. A long pipe that passes through the first window, located over the same fresco, transmits the results of the vote. If no cardinal has obtained the necessary majority, the ballots are burned with wet straw and the smoke that issues is black. When a new pontiff is elected, the ballots are burned alone, producing a white smoke, the famous white smoke signal.

A little updating: Pope John XXIII decreed that the ballots should no longer be burned, but rather saved for history. In the Conclave of 1978 special smoke-producing chemicals were used to announce to the world the election of John Paul I.

I have known the religious charged with collecting and burning the ballots, Fra Alfonso Rossi, an uncle of my wife.

He was the religious physically closest to the pope, assisting him in donning the vestments and adjusting them correctly; and he also accompanied him on his trips to attend him personally. During the conclaves Fra Alfonso, also closed within, was charged to assist the cardinals and to immediately help the newly elected pope. Unfortunately a few years ago, having served five pontiffs, from Pius XII to John Paul II, Fra Alfonso was called to Paradise, leaving sadness in his confreres and many friends in the Vatican and throughout Italy.

When a cardinal obtains the necessary majority, the dean of the cardinals, the most senior cardinal, asks if the elected man accepts the office. At the moment of accepting, he becomes the new pontiff and must indicate the name by which he will be called.

It could be interesting to recall that the first pope to change name was a priest of the Church of Saint Clement in Rome, who, when he was elected in A.D. 533 did not find it appropriate to call himself Pope Mercury, the name of a pagan divinity. He selected the name John II.

The cardinals then demonstrate their veneration and obedience to the new pope.

The dean of the cardinals then approaches the central balcony of St. Peter's to give the official announcement of the election, "Habemus Papam!"

In the meantime a moving ceremony is taking place in the Sistine Chapel. The elected cardinal is accompanied by a religious (as Fra Alfonso did until recently) through a small door (the door at the left of the altar of the Sistine Chapel) into a room where he puts on the white papal vestments. In the room are three sets of white vestments of different sizes, and three pairs of white shoes, and the religious helps the new pontiff dress. When the new pope finds himself dressed in white, he realizes the burden of his new office, the enormous spiritual, moral, and political problems of the whole world that have suddenly been thrown on his shoulders (for it is not at all easy to be pope), and he often breaks down weeping. It was once

Enrico Bruschini

for Fra Alfonso to embrace and comfort him. With his profound religiosity and his moving humanity, he reminded the new pope that he was not alone, that the Holy Spirit who had selected him was still with him, that the Church, all the faithful, were praying for him.

Finally, dressed in pontifical vestments and accompanied by the cardinals, the pope reaches the dean of the college on the balcony of St. Peter's and, facing the piazza overflowing with people, he gives his first benediction, "Urbi et Orbi," to the city of Rome and to the world!

Let us leave the Sistine Chapel after giving a last look at the entire cycle of frescoes.

If we now want to leave the museums and visit St. Peter's Basilica we must leave by the small door beneath the fresco of *Moses Reading His Will*. (This door is not always open.)

I will describe the piazza and St. Peter's Basilica at the end of the description of the other part of the museums. If you wish to proceed there directly, go to p. 197.

If instead we want to proceed in visiting the other museums, exit through the door beneath the fresco of *The Donation of the Keys*.

O–Vatican Library

A narrow corridor whose small windows look into the old courtyards of the Vatican palaces leads to the Room of the Addresses to Pius IX.

ROOM OF THE ADDRESSES TO PIUS IX

This room is named in this manner because it was created to conserve the addresses of homage and devotion sent from all over the world to Pius IX. In 1849 the pope visited Pompeii, the Roman city buried by the eruption of Vesuvius in A.D. 79. On the occasion of this visit on October 22, an excavation was done in the presence of the pope. All the objects discovered that day are found in the case in the center of the room. This

makes us think of how many treasures must still be in that city, of which a third still remains to be excavated.

The most interesting objects in the case are the perfectly preserved glass bottles, and, below, the marble bas-relief of a galloping horseman, an original Greek work of the fourth century B.C.

Let us continue and reach the beginning of the long corridor situated exactly under the other long corridor we walked to gain the Sistine Chapel.

CHAPEL OF SAINT PIUS V

This room was decorated by Jacopo Zucchi in the sixteenth century with stories from Saint Peter Martyr's life. In the cases are precious reliquaries that constitute the treasury of the chapel of the *Sancta Sanctorum,* "the most holy of holy places," the chapel of the papal palace of the Lateran, which was the residence of the popes during the Middle Ages. The chapel is still perfectly preserved in the building of the Scala Santa in Laterano.

ROOM OF THE ADDRESSES

This room is called in this manner because here were collected the addresses sent to Leo XIII and Pius X. In the first case to the left are preserved delicate Roman glass and crystalware. In the second case are the gold hammers used by various pontiffs to open the Holy Door of St. Peter's on the occasion of the Jubilee, and the gold trowels used to seal it. The silver hammers and trowels were used for the other major Roman basilicas.

At the end of the long hall, to the left a door that is often closed gives access to the Room of the Aldobrandini Wedding.

O1—Room of the Aldobrandini Wedding

The room is sometimes closed.

○─── This room takes its name from the magnificent fresco at the end of the room, which was removed from a building of the Augustan era (first century B.C.–first century A.D.) located near

the church of Santa Maria Maggiore. It shows the preparation for a ★ wedding ceremony. Note the beauty of the bodies and the perfection of the chiaroscuro. Found in 1605, it was once the property of Cardinal Aldobrandini and still bears his name. For a hundred and fifty years—until the discovery of the frescoes of Pompeii—it was the most beautiful example of ancient Roman painting.

Such fine execution was lost in the Middle Ages. To reach a new level of perfection comparable to this fresco, humanity would have to wait fourteen hundred years. One must wait for painters like Masaccio (1402–1428) and others from the Renaissance to achieve once again such classical excellence!

The Gilded Glass of the Catacombs are conserved under the fresco. These were made by placing a sheet of gold leaf over a piece of glass and then incising the leaf with a small burin, achieving from this portraits of such perfection that we wonder how it was ever possible. Over the portrait another piece of glass was placed, and then this object was placed in an oven to bond the glass and seal the gold leaf. Many have an almost photographic precision. All these magnificent portraits were found in the Christian catacombs and were used, like modern photographs, to show the features of the buried persons.

Two portraits here exhibited exceed the others in quality and beauty; perhaps they are among the most interesting objects in all the Vatican museums. It is easy to find them; one is a ★ double portrait, in the left case. The other is a portrait of a man named ★ Eusebius in the upper right corner of the right case. His facial expression and the amiability of his eyes persuade us that he was a good man. The inscription, still perfectly legible, defines him as "Eusebi anima dulcis" (Eusebius sweet soul). Only an excellent, highly skilled artist could have made masterpieces of this kind; unfortunately, we do not even know his name.

○—ᴧ There is hope that we can find many similar works, for there are in Rome miles and miles of catacombs that have not been explored!

On the other walls there are Roman frescoes of buildings of ancient Rome. On the ceiling are paintings by Guido Reni, a seventeenth-century artist.

ROOM OF THE PAPYRI

This room was named in this manner because it was destined to preserve the medieval papyri of Ravenna written in Latin between the years 540 and 854. In reality on the walls we see reproductions of these, as the originals are preserved in the Vatican Library. On either side of the room we can see wonderful clay models by Gian Lorenzo Bernini.

On the ceiling a fresco records the inauguration in 1773 of the Clementine Museum. It is an interesting work by the German painter Anton Raphael Mengs, who was, along with Johann Joachim Winckelmann, the originator of neoclassicism.

CHRISTIAN MUSEUM

In these cases are preserved Early Christian antiquities. In the cases at right there is an interesting collection of cast and blown glass from the first to the fourth centuries. There are also examples of *millefiori* ("thousand flowers," a glass with a lot of colors) of the second and third centuries, from which the famous Murano glass is derived. In the lower left corner of the last case is a large fragment of an ancient Roman glass windowpane, which makes us realize that the very wealthy in ancient Rome had true glass for the windows of their houses!

In the second and third cases to the left are Christian oil lamps found in the catacombs. Note that parts of some oil lamps are blackened. This proves they were really used!

THE GALLERY OF URBAN VIII

In the first case to the right the ★ large "planisphere," or world map, on vellum is noteworthy. The entire pelt of a calf was used for this work. Made in 1529, it records the contours of Europe and Africa well, but we remain amazed at the perfec-

Enrico Bruschini

tion of the rendering of Central America and even more so by the drawing of South America. Think how this was done only thirty-seven years after the discovery of the new continent! Also interesting is how the larger portion of North America had not been explored, and in fact one reads the clear inscription, "Terra Incognita" (unknown land).

Let us not marvel too much at the precision of the details, for this is the work of Girolamo da Verrazzano, brother and companion of the great Florentine navigator Giovanni da Verrazzano, who in 1524 discovered the Hudson River and Manhattan Island.

On the facing wall is another planisphere of 1530.

FIRST SISTINE ROOM

These rooms were created by Sixtus V to conserve documents of the Vatican Archives. From an historical point of view the frescoes in the first room, painted by Giovanni Guerra and Cesare Nebbia, are very interesting. In the lunette before you, you can see the scene of *The Transportation of the Obelisk into St. Peter's Square*. Let us remember that this obelisk was originally transported from Alexandria to Rome for decoration of the circus of Caligula and Nero. In 1586 Sixtus V wanted to move the obelisk, which still stood to the left of the basilica. It is very interesting too to see the construction of the dome of St. Peter's still halted at the drum, the point where it stopped after Michelangelo's death in 1564.

Behind you, in the lunette, there is *The View of the Basilica of St. Peter* according to the plan of Michelangelo. To understand the importance of this fresco, you must recall that it was through the powerful will of Sixtus V that Michelangelo's dome, uncompleted for twenty-four years, was finished in less than two years between July 1588 and May 1590. It is obvious that in this room Sixtus V wanted with great pride to show off two of the most important works he achieved in his pontificate. From an art historical point of view, the interesting aspect of this fresco is that it shows the basilica as

Michelangelo had designed it, i.e., as a Greek Cross, much shorter than the actual edifice, in order to enhance more the appearance of the dome.

At the end of the room, to the left, let us note a strange machine made from wood and iron. It was the machine created by the great architect Donato Bramante to apply the lead seals to papal bulls.

SECOND SISTINE ROOM

In this room are preserved presents received by the popes. In the glass case to the left there is a present from the United States: *The Mute Swans of Peace,* created in porcelain by Bohem Studios of America. It was presented to His Holiness Pope Paul VI by the Archdioceses of New York in June 1976.

In the glass case to the right there is an historical present which, I am sure, will astonish the future generations for a thousand years: four little fragments of the Moon's surface brought to Earth by the crew of the Apollo XI in 1969. They were presented to His Holiness Pope Paul VI and to the people of the Vatican City by President Richard Nixon.

O2–The Sistine Salon

This was constructed for Sixtus V by Domenico Fontana between 1587 and 1589 as a reading room of the Vatican Library. Large pillars divide the room in two, and the ceiling is cross-vaulted. It is adorned with frescoes of grotesques and with views of Rome that show the important urban planning Sixtus V implemented during his pontificate.

The bookcases of the salon were once filled with precious manuscripts and the glass cases displayed the famous treasures of the Vatican Library such as the Vatican Virgil of the fourth century, the Gospel of Matthew of the sixth century written in gold and silver on purple parchment, the copy of *The Divine Comedy* with the dedication of Boccaccio to Petrarch, and works from the hands of Henry VIII, Martin Luther, and Saint Thomas Aquinas. Now the cases are empty; the treasures have been carried to a safer place.

Enrico Bruschini

31. SISTINE SALON, THE READING ROOM OF THE LIBRARY

Recently I had the great privilege to visit the beautiful rooms in the back of the library in the company of the director of one of the most important libraries in the world. We were then accompanied to the basement of the library, a veritable armored bunker. We were led to an even more protected place, and there, on a large table, were the treasures of the Vatican Library, including manuscript Bibles adorned with precious miniatures and gold leaf and *incunabula,* that is the first books printed in the fifteenth century when printing had only just been invented. I must confess that I was most touched by a simple cardboard box on which was written by hand, LETTERS OF MICHELANGELO. A kind gentleman opened the box and I could see and almost touch the writings of the great artist. One could easily recognize the words written in Michelangelo's minute and precise calligraphy! This was the most touching experience of my life.

In the Footsteps of Popes

FIRST PAULINE ROOM

These rooms were decorated by Giovanni Battista Ricci during the pontificate of Paul V Borghese (1605–1621) with episodes from the life of the pontiff. Here are displayed, in a little glass case to the right, the largest and the smallest books in the entire library. Both are *codices,* that is, books written by hand before the invention of printing. The larger is a famous Hebrew Bible from the end of the thirteenth century, written in a very elegant calligraphy. The smaller codex is from the sixteenth century and contains the masses of Saint Francis and Saint Anne with beautiful miniatures.

SECOND PAULINE ROOM

Here are preserved additional presents to the popes.

THE ALEXANDRINE ROOM

This room was named for Pope Alexander VIII in 1690. In the third case to the left, note a *cope* (a liturgical cape) from the thirteenth century in red silk and very fine embroidery. It is a little larger than three meters (10 feet) and can give a fairly precise idea of the form of the ancient Roman toga, which was however usually more ample, easily reaching five meters (16 feet)!

On the right you can see an entrance to the New Wing, which we have already toured.

THE CLEMENTINE GALLERY

Created by Clement XII, this gallery was divided into five sections by Pius VI with a pair of porphyry columns. Behind the last two columns are carved, in high relief, two Holy Roman Emperors who embrace each other.

THE PROFANE MUSEUM

This room at the end of the long corridor is sometimes closed to the public.

The Profane Museum was created in 1767 by Clement XIII

Enrico Bruschini

to display various antiquities. The furnishings in fine Brazilian wood were designed by Valadier. Two notable works are on the back wall. In the right niche is a very rare bronze head of Nero, one of the few portraits of this emperor. Let us recall that at his death a *Damnatio Memoriae* was declared, and his name was erased from all monuments, and all his portraits were destroyed. This head is one of the very few to survive this decree!

To the left we see a very beautiful head of Augustus, who was described as intelligent, powerful, and handsome. Here we have the proof.

Just before the exit from the museum is the entrance to the Gregorian Profane Museum of Greek and Roman Art.

P–Gregorian Profane Museum of Greek and Roman Art

Rooms in this museum are sometimes closed.

The museum in this building was created and inaugurated by Paul VI in 1970. Here are displayed original Greek and Roman works, Roman copies and Roman variations of Greek works.

On the right wall of the vestibule is a mosaic representing a basket of fruit from the second century.

To the right of the entrance are a marble bust of Gregory XVI, and a cast-iron bust of Pius XI.

SECTION I: GREEK ORIGINALS

Our eyes are instantly attracted to the marble bas-relief on the wall before the entrance. It is the famous ★ *Funeral Stele of a Youth,* an original Attic burial marker of c. 450 B.C. (Attica, as we know, was the historical and administrative region whose capital was Athens.) The relief is very beautiful, representing a young athlete who is about to take a small vase of oil with his right hand from a young servant. This would have marked the grave site of a young man.

○━┳ The story of this marvelous Greek original is incredible. In the sixteenth century it was in a private collection, and at the beginning of the eighteenth century it was sawed in two and the pieces used as simple slabs of marble. The lower part was used as the cover of a drain, and was rediscovered at the beginning of the 1900s. The upper part was found again only in 1949. It was being used as a sewer cover! The two parts were reunited in 1955.

Following at the right are three fragments from the original decoration of the Parthenon in Athens, works of the celebrated sculptor Phidias of the fifth century B.C.: a ★ *Head of a Horse of Athena* from the western pediment sculpture, a ★ *Head of a Boy*, and a ★ *Bearded Head*.

Also at right are a *Head of Athena* of the fifth century B.C. and a magnificent *Bas-relief with Horseman*, an Attic work of the fourth century B.C.

SECTION II: ROMAN IMPERIAL AGE COPIES AND ELABORATIONS OF GREEK ORIGINALS

The two statues in the center of this section are antique copies of a celebrated bronze group, *Athena* and *Marsyas*, sculpted by Myron in 440 B.C. and placed at the entrance of the Acropolis in Athens.

One must turn to mythology to understand Marsyas's odd pose. Minerva created the first flute by piercing holes in a reed. Passing a lake as she played, Minerva saw that her cheeks swelled when she played, and this distortion made her ugly, so she threw the flute on the ground. Marsyas had been listening to her with great pleasure, and he made a movement to pick up the flute, but Minerva stopped him with an imperial glare.

This is the moment represented in this marble group before us. At right we see Marsyas withdrawing, frightened by Minerva's look.

Unfortunately the statue of Minerva lacks the head. We can understand the expression of the goddess by observing another Roman copy of the head of the same statue, completed

Enrico Bruschini

in plaster and displayed on a shelf on the left of the group. This remarkable head was found only in 1922 among the enormous quantity of pieces in the storerooms of the Vatican museums.

To the right is a section dedicated to the portraits of famous Greeks. At left is a statue of famous tragic poet Sophocles (No. 9973). This is a copy of the bronze statue of the fourth century B.C. which was displayed in the theater of Dionysus in Athens.

Passing further behind, one enters a room where a large statue of Neptune is displayed, a replica of the celebrated *Poseidon* Lysippus sculpted in the fourth century B.C. for the city of Corinth.

On the floor of the room is the very famous ★ Asàroton mosaic, whose name in Greek means "not swept floor." The central portion unfortunately has been lost, but the framing strips survive. What we see are the remains of a banquet on the ground. In ancient Greece and Rome, according to tradition, food that fell from the table was not picked up, as it belonged to the spirits of the dead who had a right to participate in the banquet with their loved ones. On the mosaic one sees many different details—fish bones, snails, even a small mouse that gnaws a nut.

This mosaic, found in an ancient building on the Aventine Hill, is noted for the minuteness of its tesserae, which measure very few millimeters, as well as for the precision of its drawing. It is a copy of a mosaic executed at Pergamum by the mosaicist Sosus and described by Pliny the Elder.

In the next room we can admire the remarkable ★ *Chiaramonti Niobid* (so called from the name of Pope Pius VII Chiaramonti). We see a marvelous young woman, one of the children of Niobe, in flight. Unfortunately the statue has lost its head. From whom is she fleeing?

To understand the statue, let us look again at the myth. Niobe, the wife of the king of Thebes, had seven sons and seven daughters. One day Niobe deeply offended Leto, the mother of Apollo and Diana, by reproaching her for having only two children. The revenge of Apollo and Diana was terrible: One by one

they killed all the children of Niobe. Niobe's sorrow was so great that she was turned to stone, but her eyes continued to weep. The stupendous figure caught in the moment of flight (note the lightness of her clothing) is one of Niobe's daughters trying desperately to save herself from the divine arrows.

It is almost certainly an original Hellenistic work of the second century B.C. derived from a work of Skopas or Praxiteles.

SECTION III: ROMAN SCULPTURE OF THE FIRST AND EARLY SECOND CENTURIES A.D.

In this section the most noteworthy pieces are ★ *The Altar of the Vicomagistri,* a bas-relief of A.D. 30–40 that represents the magistrates of the *vici,* the small districts composing Rome; and a ★ *Shrine with the Bust of a Man and Woman* (Nos. 10025,10026). The man represented in the relief is a member of the Haterii family, and is almost certainly the building contractor who built the Colosseum.

On the trellis on the right is a ★ relief representing five buildings in Rome (No. 9998). This relief also belonged to the tomb of the Haterii. Five monuments of ancient Rome that the Haterii constructed are represented. The second monument is surely the Colosseum; the fourth is the Arch of Titus. The representation of the crane used in building is very interesting. The "motor" is a large wheel in which slaves walk (very similar to the wheel small animals like pet hamsters run in).

PI–Pio-Christian Museum

The Pio-Christian Museum follows the last section of the Gregorian Profane Museum. It is sometimes closed to the public.

This museum displays material from ancient Christian basilicas and from the catacombs.

The most interesting statue without doubt is ★ *The Good Shepherd,* by an unknown sculptor. Here Jesus is represented as a beardless youth who bears a lamb on his shoulders and a bag across his torso.

Enrico Bruschini

P2–Missionary-Ethnological Museum

This museum gathers material from the Missionary Exhibition organized for the Jubilee of 1925, to which many gifts have been added from missionary congregations. There are many objects from cultures beyond the European continent. Particularly interesting for our readers could be the sections dedicated to South America, including artifacts from Argentina, Brazil, Chile, Colombia, Ecuador, Guyana, Peru, Surinam, and Venezuela; Central America, including artifacts from Costa Rica, Guatemala, Honduras, Mexico, Nicaragua, and Panama; and North America, including artifacts from the United States and Canada. The reliefs sculpted by Ferdinand Pettrich are very interesting. In particular, in the case at the entrance, there is a War Dance of the Sauks-Foxes and Mississippi Sioux tribes.

In the section "Christianity in America," there is an object tied to the discovery of the new continent, a wooden lectern decorated with shell-shaped mounts in mother-of-pearl, which belonged to Fra Bartolomeo de Las Heras, the chaplain to Christopher Columbus during his voyage. Note that this museum is sometimes closed.

P3–Carriage Museum

This museum, which is sometimes closed to the public, contains the collection of carriages and cars used by popes and cardinals, starting with the ★ "Gran Gala" Berlin, pulled by six horses, built for Leo XII (1823–1829), and continuing to the special cars built by Citroen and Mercedes used by Pius XI and Pius XII.

Leaving the museum one can see the long and deep spiral ramp by the architect Giuseppe Momo. Note that the stairway's form is a double spiral. Until the beginning of the year 2000 this was the only means to access the museum and the staircase served to divide the crowd that entered from the crowd that left. On the bronze balustrade of the stairs, sculpted by Antonio Maraini, note the elegant pairs of angels who hold

up the heraldic shields of the popes up to the year 1932, the year the old entrance was constructed.

Reaching St. Peter's Basilica

Leaving the Sistine Chapel, you see at left an enormous door, one of the entrances to the Sala Regia, or Royal Room (N), the large hall where the popes receive the ambassadors to the Holy See. Usually the door is closed, as it is opened only for special visitors. Should you be present when it is open, take a quick look for an idea of the magnificent decoration of the Vatican's rooms.

At the end of the large staircase lean over the cordon at left and look at the ★ Scala Regia, or Royal Stairway, by Bernini. You can see at the end of the corridor the Swiss Guards at the Bronze Door, the official entrance to Vatican City. The Royal Stairway and the Swiss Guard will be described later when we see the Bronze Door from St. Peter's Square.

Enrico Bruschini

ST. PETER'S BASILICA

From April to the end of September, the entrance gates open at 7:00 in the morning and close at 7:30 in the evening.

From October to the end of March, they open at 7:00 and close at 6:00.

For more information on any change in the hours, or for any information regarding the Vatican, you can call the operator of Vatican City: 06 6982. Very kind religious sisters will try to help you to the best of their ability.

It is worthwhile to keep in mind some of the historical details of the basilica. As we know, the first basilica was erected over the humble tomb of the apostle by the emperor Constantine toward the year 324.

After nearly 1,200 years the ancient basilica gave strong signs of structural stress. Pope Julius II commissioned the architect Donato Bramante to raze the old basilica and then build a new and larger structure that would also be more beautiful. Bramante went to work, and perhaps was overzealous in leaving almost nothing of the Constantinian basilica. Many contemporaries were critical of the complete destruction of the historic building

and gave Bramante, despite his established fame as an architect, the nickname "Maestro Ruinante" or "The Ruining Master."

On April 18, 1506, work began on the new basilica. Bramante's plan was for a Greek Cross structure, that is, a cross with arms of equal length. However, both Julius II and Bramante died before the work was completed. In 1547 Michelangelo became director of the project, and although he embraced Bramante's general plan, he altered it in important ways to give more emphasis and importance to the dome.

Paul V Borghese modified the plan of the basilica again and, ordering the extension of the nave, imposed a Latin Cross plan. For this commission he selected Carlo Maderno, who completed the edifice by adding three chapels on each side of the longer nave and by raising the powerful façade. After more than a century, the work was finished in 1614.

THE PRINCIPAL MONUMENTS OF THE BASILICA:

Q — COURT ON THE RIGHT SIDE OF THE BASILICA

ATRIUM

1	Door of the Old St. Peter's	By Filarete
	Mosaic of the "Navicella"	By Giotto
	Coat of arms of John XXIII	
2	Door of Death	By Giacomo Manzù
3	Door of Good and Evil	By Luciano Minguzzi
4	Door of the Sacrament	By Venanzio Crocetti
5	The Holy Door	By Vico Consorti

INTERIOR

6	Statue of the Pietà	By Michelangelo
7	Chapel of the Holy Sacrament	
8	Monument to Gregory XIII	
9	Bronze Statue of Saint Peter	By Arnolfo di Cambio
10	Papal Altar	
11	The Baldachin	By Bernini and Borromini

Enrico Bruschini

MAP OF ST. PETER'S BASILICA

Q–Court on the Right Side of the Basilica

A series of stairs leads to the museum exit into Courtyard Q between the Sistine Chapel and St. Peter's Basilica (see map). From this courtyard it is possible to see one of the walls of the Sistine Chapel, so that on one side you have its compact fortress form and on the other the right external wall of St. Peter's Basilica, Michelangelo's breathtaking work. Note the gigantic pilasters that articulate the wall, so-called because they are higher than a single floor of the edifice. Their powerful visual impact makes us understand better Michelangelo's genius as an architect.

In this courtyard is the ticket booth for the ascent to the Dome of Saint Peter.

VISITING THE DOME

For those with less time, or for those who simply wish to avoid the great fatigue of the stairs, an elevator is available that reaches the terrace above the basilica, from which one can have a beautiful view of Rome and of the power of Michelangelo's enormous architectural feat. From the terrace one can reach in a few seconds the circular balcony within the drum of the dome that overlooks the interior of the basilica from a distance of 174 feet (53 meters) above the floor. It is

Enrico Bruschini

very thrilling to see from a short distance the gigantic figures of the mosaics on the ceiling of the dome, and even more exciting to see the people below, tiny as ants, circulating around Bernini's baldachin, which appears to be a child's small toy.

If you have much time at your disposal, and if you have very sturdy legs and no heart problems, it is very worthwhile to ascend to the top of the dome, passing through the space between the two domes (like the dome of the Capitol in Washington, this is a double dome), climbing a seemingly unending series of stairs. From the external balcony, 364 feet (111 meters) above the ground, one surely has the most beautiful and complete panorama of the Eternal City.

The Atrium

From Courtyard Q we can reach the atrium of the basilica. This is a vast space, 233 feet (71 meters) in length, 44 feet (13.5 meters) in width, and 66 feet (20 meters) in height, a space larger than many modern churches. Recent restorations have brought light again to the stuccowork and painted decoration of the vault that were completely blackened.

At either side of the atrium are two statues. Facing the basilica, on the left, is the *Equestrian Statue of Charlemagnee,* sculpted in 1725 by Agostino Cornacchini. The statue commemorates the first Holy Roman Emperor, crowned in St. Peter's on Christmas Day, 800.

On the right, through large glass doors, is the ★ *Equestrian Statue of Constantine,* sculpted in 1670 by Gian Lorenzo Bernini. The statue honors the emperor who gave freedom to Christians in 313 and erected the first basilica.

Let us stop in the center of the atrium.

1: DOOR OF THE OLD ST. PETER'S MOSAIC OF THE NAVICELLA COAT OF ARMS OF JOHN XXIII

Before us is the ★ Bronze Door of the old St. Peter's Basilica, by the Florentine artist Filarete in the years 1439–1445.

The door is divided in six panels: Above are the enthroned

figures of Jesus and Mary; in the center panels are standing figures of Saint Paul with his sword and Saint Peter with his keys, and kneeling before Peter is Pope Eugenius IV, the commissioner of the doors; below this are two panels showing the martyrdom of these two apostles.

At left, blindfolded Saint Paul kneels to have his head chopped off; in the upper section of this panel we see Saint Paul on a cloud returning to Plautilla the veil she had given him to cover his eyes. At right, Saint Peter is led to martyrdom by crucifixion upside down. The cruel emperor Nero looks on from his throne.

Above the central door is a bas-relief of *Christ's Charge to Peter,* a work by Gian Lorenzo Bernini and his assistants.

Facing the relief on the wall toward the square is the celebrated Mosaic of the Navicella (little boat), done by Giotto on the occasion of the first Jubilee in the year 1300. Almost completely redone in the seventeenth century, it represents Jesus walking on the waters toward the boat of the apostles on Lake Tiberias (also called the Sea of Galilee). The vessel represents the Church.

On the floor before the central door is the heraldic shield of John XXIII (1958–1963), placed in memory of the Second Vatican Council he convoked (1962).

More than many other documents this coat of arms makes us understand better the goodness of the pontiff whom the world still remembers as "Il Papa Buono" (The Good Pope).

When a pope is elected, he must create for himself a coat of arms. If the cardinal is from a noble family, then the family's coat of arms is used. If he is from more humble origins, he must choose the elements. Angelo Roncalli, of very modest origins, was Patriarch of Venice when he was elected. For this reason he selected the symbol of Venice, the Lion of St. Mark, as one symbol. Usually the Lion of Venice is represented as a powerful animal bearing a sword in defense of the city. Pope John, however, said to the artist preparing the drawing for the coat of arms, "Please, draw a lion with a

Enrico Bruschini

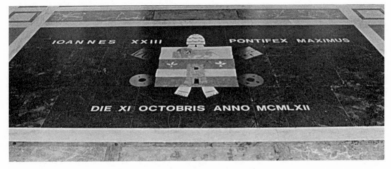

32. HERALDIC SHIELD OF JOHN XXIII

meek expression." Look at the lion here, and you will see that it would be difficult to draw a lion with a more gentle expression.

Before entering we should look at the other bronze doors.

2: THE DOOR OF DEATH

The door to the left, one of the most beautiful, is called ★ *The Door of Death* (1963). This is a work by the sculptor Giacomo Manzoni, very well known as Manzù, on the request of Pope John XXIII. In its panels are scenes on the theme of death. It is remarkable how Manzù succeeded in developing such a sad theme in a way that pleases the eye and the soul. With his profound sensibility the artist transformed the theme from death to "death that engenders life."

In the upper panels Jesus is taken from the cross. The movement of the drapery clearly alludes to the Resurrection. At right the Virgin Mary is assumed into Heaven so that her immaculate body could avoid decay.

The two reliefs show two Eucharistic symbols: vines that have been pruned, for from grape wine the blood of Christ is obtained; and ears of wheat, for from this the bread is obtained for the host, the body of Christ.

In the lower panels, at left, are contrasting scenes: the violent death of Abel and the serene death of Joseph; the cruel

In the Footsteps of Popes

death of Peter, the first pope, and the death in prayer of John XXIII; the stoning of Saint Stephen, the first martyr, and the death in exile of Pope Gregory VII in 1085; the disquieting death in space of the modern astronauts, and the death of a mother who leaves her children in grief.

3: DOOR OF GOOD AND EVIL
The second door is called *The Door of Good and Evil* (1977). This was given to Pope Paul VI by Luciano Minguzzi on the occasion of the pontiff's eightieth birthday. In the right panel we see John XXIII and Paul VI, respectively the popes who opened and closed the Second Vatican Council.

4: DOOR OF THE SACRAMENT
The door to the right of the central door is *The Door of the Sacraments* (1965). Here the sculptor Venanzio Crocetti represented an angel and the seven sacraments of the Catholic Church.

5: HOLY DOOR
The door at the far right is the famous *Holy Door*. The bronze panels are the work of Vico Consorti, sculpted in 1950. In the last panel in the lower right we see Pope Pius XII opening the Holy Door on Christmas Eve, 1949. This door is opened every twenty-five years during the Jubilee. The last time it was opened was in 1999. On Christmas Eve Pope John Paul II, during a touching ceremony, pushed the door and it opened to receive the pilgrims to Rome for the Jubilee.

०—☛ Let us remember that the word *Jubilee* is derived from the Hebrew word *jobel,* a ram's horn, whose call, at fifty-year intervals, signaled a year dedicated to God and to rest. For Catholics it was Pope Boniface VIII, named by Dante in *The Divine Comedy,* who proclaimed the first Holy Year or Jubilee in 1300, to invite pilgrims to Rome for special indulgences. In 1350 Clement VI decreed that the Jubilee year fall every fifty years, and this was reduced to every twenty-five by Paul II (1464–1471).

Enrico Bruschini

In addition to the ordinary Jubilees, there have been extraordinary Jubilees such as that called by Pius XI in 1933 for the nineteenth centenary of the death of Christ, that called by Paul VI in 1966 for the closing of the Second Vatican Council, and that called by Pope John Paul in 1983 for the Special Holy Year of the Redemption (1,950 years after Jesus' death).

To the upper left of the Holy Door is the ★ original inscription of the papal bull of Boniface VIII instituting the first Jubilee in 1300.

Interior of the Basilica

When entering the basilica, the first sensation is certainly one of astonishment, for we are in the largest basilica in the world! The eye moves freely through the vast space, resting here and there on statues and monuments that at first do not seem immense. As soon as a group of people draws near one of these monuments we become aware how large it is. The cherubs who hold the holy water basins would appear "normal" in scale, but when someone stands beside one of them, we see that the cherubs are taller than the person. Everything is enormous but we are not aware of this because everything is in perfect proportion.

When Julius II asked Bramante to design a new basilica, the great architect promised to raise the dome of the Pantheon, the largest dome in the world, on the basilica of Maxentius, the largest building to survive in the Roman Forum.

The enormous church, which required more than a century to construct, appears to us in all its Renaissance classicism and in its entirely Baroque splendor. The coffering of the enormous vault, an almost perfect reproduction of the vault of an ancient Imperial basilica, is in the pure Renaissance style of the sixteenth century, whereas the splendid decoration in colored marble, the enormous angels in stucco, and the gilding that creates golden warmth in the basilica are all spectacular Baroque of the seventeenth century.

For those enamored of numbers, let us give the impressive

dimensions of the basilica: the internal length is 614 feet (187 meters)—633 feet (193 meters) with the walls included, and 715 feet (218 meters) with the atrium included. The transept, the largest part of the basilica, is 459 feet (140 meters). The height of the central nave is 148 feet (45 meters). A fifteen-storied building, including the ground floor, can rise inside the nave.

After having admired the general view, let us now discover and savor some of the innumerable details.

Just in front of the central entrance is a large marble disk in red porphyry. Until the fifteenth century, this disk sat before the high altar of the old Constantinian basilica. On it Charlemagne kneeled before Leo III on Christmas Day, 800, to receive the crown and be invested as the first Holy Roman Emperor!

6: THE PIETÀ

Looking to the right we recognize in the first chapel one of the most famous statues in the world, Michelangelo's ★ *Pietà*. In 1498 the young artist was only twenty-three years old when he was called by the French cardinal Jean Bilhères de Lagraulas, the ambassador of King Charles VIII of France, to Alexander VI, to sculpt a statue in honor of the Virgin Mary.

The work is admirable for the sweetness which Michelangelo has expressed in the sad face of the Madonna and for the perfect technique that makes the single block of Carrara marble appear almost soft. Standing before such an exquisite statue we can think of when Michelangelo uttered with great simplicity, "Sculpting in the end is not difficult, the statue in all its beauty is already within the block, it is only necessary to remove what is superfluous."

We can only marvel at the tender face of the Virgin Mary, too youthful in view of the fact that Jesus was thirty-three when he was crucified.

☞ There have been several explanations for this youthfulness. It has been said, for example, that Michelangelo lost his own mother at the age of six, and that he therefore wanted to see in

Enrico Bruschini

33. THE PIETÀ
Michelangelo

the face of the Virgin the features of his own mother. This seems an acceptable explanation.

There is a recent fascinating hypothesis, perhaps conceived by the great art critic and historian Giulio Carlo Argan, who died in 1992, that would explain the youth of the Madonna. Michelangelo has shown Mary at a particular moment. She holds on her lap the Baby Jesus, and in that moment she has a terrible vision: Jesus will die in the cruelest way possible, nailed to a cross. With sorrow the Virgin accepts God's will.

I have found several details that compel me to accept this

terrible and remarkable hypothesis. Look, for example, at the left hand of the Virgin, which is held in a gesture that could possibly mean, "What can I do? Let the will of God be done!" Look now at how the Virgin gazes downward on the Child, and note how her right arm delicately supports the head of the dead Jesus just as one supports a baby's head.

But the greatest proof of this hypothesis is the scale of the Virgin Mary. Look at how large she is in comparison to the body of Christ, and try to imagine her standing. She is much taller than he, she is almost a giant! No, I do not think this error in proportion could be unintentional in the young Michelangelo's work. It must surely mean something: the vision of the dead Christ.

This new idea is at once tragic and sublime. The face of the Virgin shows at once sadness and acceptance, love and resignation. Michelangelo will never cease to amaze us!

From this distance we cannot read the signature of the great artist incised on the sash that runs across the torso of the Virgin. The signature and work of the young Michelangelo, only twenty-three when he began this statue, were mentioned at the entrance of the Pinacoteca in discussing the copy of the Pietà there.

In 1962 the Pietà was sent as a messenger of Faith and Art to New York on the occasion of the Universal Exhibition. In 1972 a mentally ill man climbed onto the altar—at that time undefended by a sheet of glass—and struck the statue several times with a hammer, breaking a finger of the left hand and an eyelid of the Madonna. The experts in the restoration laboratory of the Vatican did a perfect reinstatement and now it is nearly impossible to view the effects of the vandalism.

Even if every other work of art seems to vanish beside a masterpiece like the Pietà, I think it worthwhile to look at the small dome above the statue. This is the only dome in the basilica decorated in fresco; all the others are covered with beautiful mosaics. This was frescoed by Giovanni Lanfranco

Enrico Bruschini

around 1630 with *The Triumph of the Cross.* Angels carry the cross to Heaven. Lanfranco succeeded in achieving such a surprising effect in perspective that it could almost be compared to the perspective we saw in the *Tapestry of the Resurrection* (H2). If you move completely to the right of the altar rail, you see that the vertical beam of the cross is bent in your part of the dome, while the horizontal beam is completely in the left part of the dome. Walking to the left side of the balustrade, note that the cross moved in the true sense of the word, for on the left you will see the effect is reversed: the vertical section is now in the left side of the cupola and the horizontal section transferred to the right.

On the floor in front of the Pietà is a large coat of arms of Paul VI.

On the right the inner side of the Holy Door is visible. The mosaic over this is from the seventeenth century and shows *Saint Peter with the Keys of the Kingdom,* symbols of his authority, against a gold background.

○━┳ After the Jubilee, the door was closed and sealed with a wall of bricks. Each one of these bricks bears in relief the seal of the pope who reigned when the door was shut and remains in place until the next Jubilee twenty-five years later, unless an extraordinary Jubilee is proclaimed before that, eventually by a new pope. When the door is reopened the bricks that closed it will become a highly valued gift for those fortunate to receive one.

The second chapel has a mosaic altarpiece representing *The Martyrdom of Saint Sebastian.*

To the left of the altar is the *Monument to Pius XII,* by Francesco Messina. To the right is the *Monument to Pius XI.*

Let us go now to the center of the nave. If we look carefully at the floor we can note bronze stars have been inserted at intervals. These indicate the length of almost all the major churches in the world.

In the Footsteps of Popes

The first is the Latin indication LONDINENSE S. PAULI FANUM showing the Cathedral of Saint Paul in London, the largest temple after St. Peter's. You can read the length in meters: 158.10 (519 feet). The external length of this church is measured from the inner wall of the apse of St. Peter's, exactly from the glass window with the Dove that symbolizes the Holy Spirit.

These measurements make clear that St. Peter's Basilica is indeed the largest church in the world, since each of the large churches of the world could be placed within it!

It is interesting to note the measurement in meters and the Latin names of other churches such as the SANCTUARIUM IMMAC-ULATAE CONCEP[TIONS] WASHINGTON showing the National Shrine of the Immaculate Conception in Washington, D.C. (139.14 meters, or 530 feet), the largest Roman Catholic Church in the United States, in addition to Notre Dame in Paris, St. Sophia in Istanbul, etc.

Almost in the center of the basilica, on the border of the octagonal design just before the bronze statue of Saint Peter (which we will see in a moment), there is a star with the inscription ECCLESIA METROPOL[ITANA] S. PATRITII—NEO EBORACEN[SIS]. This is one of the most noted Roman Catholic churches in North America and in the entire world. And yet no one stops to look at the star given it and to observe its measurements in comparison to the Roman basilica. The fact is, no one recognizes it with its Latin name!

It refers to the well-known St. Patrick's Cathedral in New York. But where is the name of the great city? Why "Neo Eboracensis"?

In 1625 the Dutch West India Company founded a trading post on the southern point of the island of Manhattan called New Amsterdam. In 1664, as an effect of the commercial rivalry between the Dutch and the English in Europe, the English seized New Amsterdam almost without a fight and they renamed the city New York after the English city of York, the capital of Yorkshire. This name remained after 1783, when the city became American at the end of the War of Independence.

Enrico Bruschini

In England the city of York was founded by the ancient Romans. On the bank of the river Ouse, toward the year 72 B.C., a commander established a military camp for Roman legionaries and he called it "Eboracum." This camp grew and became historically important. It was destroyed and rebuilt several times. Two Roman emperors died there, Septimius Severus in A.D. 211 and Constantius Chlorus in A.D. 306. The name York did not appear until the twelfth century. For this reason "New York" in Latin becomes "Neo Eboracum" (*Eboracensis* is the adjective).

With this small revelation we can draw nearer to the bronze star and consider the length (101.19 meters or 332 feet) of one of the largest and most beautiful churches in the United States.

7: CHAPEL OF THE HOLY SACRAMENT

Let us now enter the right nave to admire the Chapel of the Holy Sacrament. The beautiful wrought iron gate is an early work of the Baroque sculptor and architect Francesco Borromini, who contributed so much to the beauty of St. Peter's and the city of Rome. Within the chapel the Holy Sacrament, the consecrated Host in which Jesus is present under the appearance of bread, is exhibited for adoration by the faithful. For this reason the chapel is not open to all tourists, but only to those who wish to pray.

Above the altar is the precious ★ Tabernacle in gilded bronze, a work of Gian Lorenzo Bernini, clearly inspired by the magnificent "Tempietto" (little temple) built by Donato Bramante in the cloister of the church of St. Peter in Montorio in Rome. Also by Bernini are the two gilded bronze angels that kneel in adoration at the sides of the tabernacle as well as the small but marvelous ★ crucifix in gilded bronze and lapis lazuli at the center of the altar.

Behind the altar is an altarpiece by Pietro da Cortona painted in 1669, *The Trinity*. This is the only painted altarpiece remaining in the basilica; all the others have been substituted with large mosaics.

The gilded stucco decoration on the white ground helps to render this sacred chapel at once solemn and mystical.

In the Footsteps of Popes

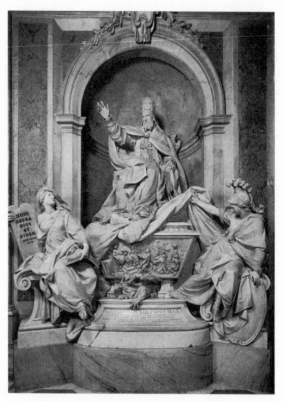

34. MONUMENT TO GREGORY XIII

Camillo Rusconi

8: MONUMENT TO GREGORY XIII

In the small corridor to the left of the chapel is the ★ Monument to Gregory XIII, by Camillo Rusconi. The pope is represented majestically seated on a throne above a large urn. The statues of *Faith* (to the left) and of *Wisdom,* in the semblance of the goddess Minerva, are by Camillo Rusconi (1720–1723).

It was Gregory XIII Boncompagni who, in 1582, reformed the Julian Calendar that had been introduced by Julius Caesar in 46 B.C. and adopted throughout the empire. Although very advanced, Caesar's calendar was not perfect, and after 1,628 years of use it had caused an advancement of ten days with

Enrico Bruschini

regard to real solar time. Gregory XIII cut those ten days away in 1582 by making October 15 immediately follow October 4. With this simple alteration the beginning of spring, the Vernal Equinox, returned to March 21. Modifying too the computation of leap years, he established the calendar that still carries his name, the Gregorian Calendar, adopted in almost the entire world.

On the sides of the urn we see on the left the statue of *Faith* and on the right the statue of *Wisdom* in the guise of Minerva, with helmet and shield, as she raises a curtain to reveal the bas-relief of the encounter between astronomers and mathematicians who have gathered to solve the problem of the calendar. The pope is shown with a hand on a globe. The scientist who most helped the pope on this occasion was Egnazio Danti, the same man who provided the drawings for the magnificent Gallery of Maps we visited in the Vatican museums.

Below the urn is a dragon, the heraldic animal of the Boncompagni family.

Continuing, we find ourselves in the large ambulatory by Michelangelo that leads around the four enormous piers built by Bramante to support the dome.

9: BRONZE STATUE OF SAINT PETER

Let us return now to the central nave to see, at right, the ★ *Bronze Statue of Saint Peter,* almost certainly a thirteenth-century work by Arnolfo di Cambio. The Prince of the Apostles, whose pontificate in Rome according to tradition lasted twenty-five years, is represented enthroned with his keys in his left hand and in the act of blessing.

For centuries pilgrims who visit St. Peter's have touched or kissed the feet of this statue. As you can see, the millions of kisses given with devotion over the centuries have worn down the hard bronze and rendered the right foot of Saint Peter, the first pope, almost flat.

On June 29, the Feast of Saint Peter, this statue is dressed in pontifical vestments including the Fisherman's Ring and the Papal Tiara.

Behind the statue is a magnificent embroidered hanging. Only a very close look allows us to discover that it is not made of silk but composed of very fine mosaic tesserae.

Above the statue of St. Peter is a mosaic portrait of Pius IX, who reigned for thirty-two years, from 1846 to 1878. For many centuries there was no portrait above the statue, out of respect for Saint Peter. In 1871, when Pius IX surpassed the twenty-five years Peter reigned, his portrait was placed above that of the apostle. The niche above the mosaic of Pius IX holds a statue of Saint John Bosco, the great educator who in the previous century helped so many needy children.

With a few steps we find ourselves beneath the enormous cupola, and our gaze does not know where to stop.

10: PAPAL ALTAR

Before us is the Papal Altar, so called because only the pope may say mass there, usually with a large number of other celebrants. The altar is made from an enormous block of ancient marble from the Forum of Nerva, one of the Imperial Forums. It is placed directly above the Tomb of Saint Peter and looks over the Confessio. With this word the first Christians indicated the tomb of a martyr who had "confessed" his faith in Christ and then in his name accepted martyrdom. The Confessio, the burial place of Saint Peter, was decorated with colored marble in 1615 by Carlo Maderno. Ninety-nine oil lamps burn always in honor of the first pope.

The Confessio, and the Tomb of Saint Peter, will be better seen and described later, during the visit to the Holy Grottoes.

11: BRONZE BALDACHIN

Almost in protection of the altar and the Confessio, the majestic ★ *Bronze Baldachin* rises above them.

Enrico Bruschini

This is a sublime work by Gian Lorenzo Bernini, who began the Baldachin in 1624, when he was only twenty-six years old, and finished nine years later. Francesco Borromini, who was only a year younger than Bernini, also contributed enormously. The entire upper part of the Baldachin, the elegant peak that lightens Bernini's design, is by Borromini, as is the decorative carving on the marble bases, and, more important, the technical calculations for the heavy monument. In view of this, it seems time to call this Baroque masterpiece the Baldachin of Bernini and Borromini. Without a doubt the design both in general and in decoration belong to Bernini, but to Borromini belong the attentive calculations and the meticulous execution of figurative details. The two artists worked together as well on the building of the Barberini Palace, and here too the credit for the work was given entirely to Bernini. In the end this created a great rivalry between the two artists. See the *Bronze Baldachin* in the color insert.

o—⚓ Personally I maintain that Bernini was certainly superior to Borromini in his sense of architectural drama. Saint Peter's Square and the Four River Fountain in Piazza Navona are striking examples. Borromini, however, was superior to Bernini in his architectural inventions. No church will surpass the perfection of the small church of San Carlo alle Quattro Fontane or the stupefying energy and purity of the lines of the church of Sant'Ivo alla Sapienza, a masterpiece of the Baroque in Rome.

The collaboration between the two great artists resolved a great problem: the need for the Baldachin to appear majestic in order not to disappear in the immense space of the basilica (in fact this is the largest bronze monument in the world and also the heaviest). At the same time, the Baldachin could not appear heavy visually. Incredibly the enormous Baldachin appears almost transparent!

It was Bernini's idea to adopt Solomonic spiral columns whose twisting movement makes the object lighter. The columns do not impede the view of the apse; on the contrary,

they appear to frame it. The resulting lightness and framing effect are also due to the crown of the Baldachin, conceived by Borromini, whose elegant empty spaces render the enormous structure lighter.

The tall bronze columns are gilded and decorated with laurel and olive branches and playful putti. From above hang bronze banners with three bees, the heraldic emblem of the Barberini, the noble family of Pope Urban VIII. Above the columns are four enormous angels who hold garlands of flowers, and two smaller angels who display the papal tiara and the papal keys. Above these figures are four elegant volutes, the work of Borromini, united to hold a cross. The Baldachin is 95 feet (29 meters) high, almost as tall as a ten-story building including the ground floor.

Solomonic columns like those of the Baldachin were seen in the old St. Peter's Basilica. These marble columns were placed before the old altar. According to an ancient tradition, they came from the Temple of Solomon in Jerusalem. We can still admire these antique columns because they had been preserved, and Bernini placed them in the four balconies that are seen above, on the four great piers that support the dome.

0━╼ To cast the Baldachin many tons of bronze were necessary. To obtain this bronze, Urban VIII Barberini ordered the melting down of the magnificent bronze ceiling in the portico of the Pantheon that until then had remained perfectly intact. The Romans of the seventeenth century considered this an act of vandalism, and for this coined a new Latin proverb, *Quod non fecerunt Barbari, fecerunt Barberini,* or "What the barbarians didn't do, the Barberini did."

There is another curiosity concerning the Baldachin. A few years ago it was discovered that the marble reliefs of the bases that support the columns were hiding a story. To look at them superficially they appear only to show the coat of arms of the Barberini with the three bees. But more attentive observation

Enrico Bruschini

makes us aware that these heraldic shields gradually swell, like the womb of a pregnant woman. In fact, above the shields we see the face of a suffering woman. The birth proceeds without complication, as we see on the last base, where the suffering face of the woman has become a smiling face of a baby, and the heraldic shield is again flat!

Writers have become overwrought in trying to find an explanation for such an uncommon work in a church, particularly in the center of Christianity. One writer suggested that a niece of Urban VIII had carried a difficult pregnancy to a happy end. Other suggestions were malicious. A more recent hypothesis, and I think the most plausible one, is that this motif was invented by Borromini, who at that moment was in the course of spiritual regeneration. The pains of birth symbolize the pain the Church is ready to suffer to give birth to new Christians.

The Dome

The large ★ Dome of Michelangelo is upheld by powerful arches that in turn rest on pentagonal segmented piers built by Bramante. Everything is gigantic and perfect. Each pier has a perimeter of 233 feet (71 meters), within which one could easily place the little but beautiful church of Borromini, San Carlo alle Quattro Fontane.

The arches are 148 feet (45 meters) in height and these too were completed by Bramante in 1511. In 1513 Julius II, the pope who commissioned the new basilica, died, and in the following year Bramante also passed away. The work on the basilica remained nearly suspended until 1547, when Paul III commissioned Michelangelo, who was then seventy-two, to continue the building. Michelangelo constructed the apse and the transept, that is, all the part surrounding the piers. The great genius also completed the drawings and calculations for the dome, and he constructed the high drum which he made lighter by inserting sixteen windows. For this work Michelangelo asked no money. He worked only to render "honor to Saint

In the Footsteps of Popes

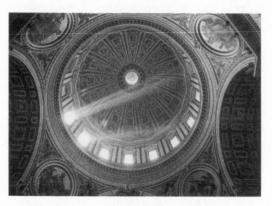

35. THE DOME, ST. PETER'S BASILICA

Peter, glory to God, and for the salvation of his soul." He worked until the age of eighty-nine. At his death in 1564, the work was again suspended. In 1588 Sixtus V, a very determined pope, ordered the architects Giacomo Della Porta and Domenico Fontana to complete the dome, and the work was finished in only twenty-two months. In another seven months the lantern was added.

The inside dimensions of the dome are also enormous, 140 feet (42.56 meters) in diameter, 348 feet (106 meters) in height, plus an additional 46 feet (14 meters) to the small dome of the lantern where there is a beautiful mosaic of the blessing of the Creator on the design of Pietro da Cortona.

○—⚷ It is impressive to think that a 40-story building could stand inside the dome! The dome could also be an elegant shelter for the impressive Statue of Liberty whose height, with the pedestal and torch, is as we know 305 feet (93 meters).

The decoration of the rest of the dome was done by Pietro da Cortona in the seventeenth century.

Enrico Bruschini

Over the sixteen windows of the drum are the figures of Christ, the Virgin Mary, Saint John the Baptist, Saint Paul, and the Twelve Apostles.

On the base of the drum there is an inscription in blue letters on a gold ground that duplicates the words of Jesus to Peter: TU ES PETRUS . . . or "Thou art Peter, and upon this rock I will build my church. And I will give unto thee the keys of the Kingdom of Heaven."

12: THE COLOSSAL PIERS WITH THE RELICS

Bernini carved out four large niches in Bramante's colossal piers, each niche measuring 33 feet (10 meters) in height, and also four balconies to honor and conserve the relics associated with the Passion of Christ.

In the niche to the left of the papal altar is the beautiful statue of ★ *Veronica,* a noteworthy work by Francesco Mochi, carved in 1632. It represents the pious woman who wiped the face of Jesus with a white cloth as he carried the cross toward Calvary. Almost as an act of gratitude and blessing the appearance of the Sacred Face remained on the cloth. A late Byzantine icon with the face of Christ was held in the church during the Middle Ages (Dante described it in *The Divine Comedy*) and in the Baroque period this was placed within the small chapel that one sees behind the balcony above the statue.

A few years ago the relic was stolen, and notwithstanding immediate and continued searching it has not been found.

In the large niche to the right there is the statue of Saint Helen, the mother of the emperor Constantine. According to tradition Helen found the Cross of Christ while on pilgrimage to the Holy Land in 326. The Cross had been buried by the early Christians near the Holy Sepulcher. She brought the Cross to Rome. Since 1626 the relics of the True Cross are preserved in a gold shrine in the form of a cross. The statue itself, five meters in height like the other statues in the niches, is the work of Andrea Bolgi (1646).

In the next large niche to the right is the beautiful statue of ★ Saint Longinus by Gian Lorenzo Bernini (1639). According

to ancient tradition, Longinus was the Roman centurion who pierced the side of Christ with his lance to determine if he was dead. The tradition relates that Longinus converted and preserved this lance. Its point was given to the Crusaders who liberated Jerusalem, but then it was retaken by the Saracens. In 1492 the Turkish sultan Bayezid II, the son of Mohamed the Conqueror, gave this relic to Innocent VIII and it is still preserved at St. Peter's.

In the last niche is the statue of Saint Andrew by the Flemish sculptor François Duquesnoy (1640), the son of Jerome Duquesnoy, the sculptor of the famous statuette *Manneken-Pis* in Brussels.

Andrew, the brother of Peter, was also a fisherman from Capernaum. He brought the Gospel to Greece and was martyred at Patras by the Romans, who fastened him on an X-shaped cross. Andrew is the patron saint of Russia and Scotland. In the fifteenth century the Christians of Greece sent the head to Rome, so that the remains of the apostle could be near the remains of his brother Peter. In 1966 Pope Paul VI returned the relic to the church of St. Andrew of Patras as an ecumenical present.

The two remaining relics of the Passion, the fragments of the True Cross and the lance head, are now preserved in the chapel above the niche of Saint Veronica. During Holy Week these relics are shown to the faithful and used in blessing.

Entry to the Holy Grottoes

The entrance for descending to the Sacred Grottoes, which are beneath the central nave, is usually the small staircase beneath the statue of Saint Andrew, or that beneath the statue of Saint Veronica. At times the entrance is moved to the stairs beneath one of the two other statues.

You can find the entrance by looking for this sign in Italian:
ENTRATA AL SEPOLCRO DI S. PIETRO E ALLE TOMBE DEI PAPI.
L'USCITA E' DAL PORTICO DELLA BASILICA (SENSO UNICO)
This means that, after visiting the grottoes, you will be

Enrico Bruschini

obliged to exit outside the basilica, after which, if you want, you can enter again.

To avoid leaving the basilica and having to enter again, I suggest descending to the Holy Grottoes at the end of your visit.

12A: THE VATICAN GROTTOES

The Sacred Vatican Grottoes extend under the central nave of the basilica and occupy the space between the floor of the old Constantinian basilica and the actual basilica. From one of the four staircases open in the colossal piers of the dome one descends a ring-shaped corridor that links the chapels surrounding the tomb of the first pope. Approximately halfway through this corridor there is an opening to the Chapel of Saint Peter, adorned with stucco and gilding. The rich altar is fronted with a slab of malachite, a stupendous ornamental stone of emerald green, and two small columns of porphyry. Such splendor is understandable in view of the fact that this is the altar closest to the Tomb of the Apostle. The slab of white marble and porphyry seen through the grating over the altar is the back end of the ancient aedicule that the emperor Constantine built in the fourth century over an even more ancient aedicule from the second century that was built directly over Peter's simple tomb.

Let us recall that the excavations that brought to light the tomb of Saint Peter and the necropolis under the Constantinian basilica were carried out in the years 1939–1949 on the orders of Pius XII.

In the small space before the chapel of Saint Peter is the tomb of Pope Pius XII himself. The pontiff expressed the desire to be buried in this space so near to the tomb of the Prince of the Apostles that he had himself contributed in discovering.

Continuing in the circular corridor we reach a space that could be considered the heart of the basilica. Through a glass sheet we can see the holy place: the tomb of Saint Peter. It was

John Paul II, on October 16, 1979, who opened this archway in the foundation of the basilica so that pilgrims and visitors could see from nearby the spiritual center of the basilica. The same pontiff also had the inscription placed which moves one by its terseness: SEPULCRUM SANCTI PETRI APOSTOLI.

Through the arch we can see a richly decorated niche. The niche is the lower part of the second-century aedicule built over the tomb of Saint Peter. This contains a precious silver coffer in which are preserved the *pallia,* the long, narrow white stoles decorated with black woven crosses that the pope gives to newly ordained metropolitans as a pledge of faithfulness to Christ and Peter. These stoles are worn on special ceremonies.

A lamp is always lit on the right side of the aedicule, indicating the place where, in a little rectangular niche, the emperor Constantine put the bones of Saint Peter to prevent their disintegration. The bones found during the excavations that brought to light the tomb of Saint Peter were deposited again in that niche.

Let us continue to visit the papal tombs. There are 147 popes buried in the basilica and grottoes.

To the right of the tomb of Saint Peter, proceeding down the central nave of the grottoes, we see in a niche the tomb of John XXIII, the "Good Pope." This pope was recently beatified, and quite surely his tomb will be moved inside St. Peter's Basilica. Following on the other side of the corridor is the tomb of John Paul I, decorated by two fifteenth-century angels.

We will always remember John Paul I, Albino Luciani, for his gentle smile. He reigned only from August 26 to September 28, 1978.

His very brief pontificate brings to mind the prophecies of Malachi—not the prophet of the Old Testament, but the holy monk Maelmaedhog, the primate of Ireland in the twelfth century. To him was attributed an apocryphal work, probably in the sixteenth century, the *Prophecies on the Popes.* In all there are 111 brief epithets to designate each future pope, from Celestine V to the end of the world, finishing with a more compre-

Enrico Bruschini

hensive and terrifying prophecy. Some of his characterizations have been used almost officially for some pontiffs, such as Pius XII as "Pastor Angelicus" (Angelic Shepherd) and John XXIII as "Pastor et Nauta" (Shepherd and Helmsman). The pope whom all the world knew as the "Good Pope" was without doubt a pastor of souls and a guide, for he was the first pope to leave the Vatican to visit the sick, the imprisoned, the needy. Paul VI was designated as "Flos Florum" (Flower of the Flowers), a cryptic term, but let us remember that on his coat of arms there were three lilies.

We were perplexed when we learned that the epithet for the just elected Pope John Paul I was "De medietate lunae" or "De media aetate lunae" (the average duration of the moon, the length of the moon). Only at the moment of his premature death did we understand, with a shudder, that the length of the reign of John Paul I was one month, the duration of the moon!

For his Holiness John Paul II the motto is "De labore solis" (the labor of the sun). Already one can affirm the meaning of the prophecy when we think of the pastoral work accomplished by this pope every day throughout the world, and also when we think of how he is the "son of the sun," this pope from the East!

Spontaneously we wonder, what are the attributes of the next popes? Only two are left. The 111th is designated as "De gloria olivae" (the glory of the olive). It is easy to think of an olive-complexioned pope, perhaps of Asian or South American origin—or, remembering the olive as the tree of peace, a pope who could finally bring peace to the world.

In his last prophecy Malachi was more precise, even too precise, for he tells us the name of the last pope, "Petrus Secundus vel Petrus Romanus" (Peter II, or Peter the Roman) and he adds that "during the last persecution of the Roman Church he will feed his sheep with many troubles and when the troubles will finish the City of Seven Hills will be destroyed."

With our incurable optimism we would like to think and

In the Footsteps of Popes

hope that such an apparently negative prophecy means instead the end of a uniquely Roman Church and the birth of an Ecumenical or Universal Church in which all of good will unite, as all recent pontiffs have prayed and as all humanity earnestly hopes!

Let us proceed to the end of the Vatican Grottoes, lingering on the side across from the tomb of Pope John Paul I, before the large niche with the simple tomb of Paul VI. Many other tombs of popes and cardinals, some remarkable for their use of precious alabaster, accompany us to the exit from this part of the basilica so rich in testimony.

Continuation of the Visit Inside the Basilica

Let us move into the Right Transept.

This part of the basilica is sometimes reserved for the Sacrament of Confession, and it could be closed to visits by pilgrims or tourists. In this case we must be content with seeing the monuments from a distance.

The large mosaic over the central altar shows the *Martyrdom of Saints Processus and Martinian,* the two jailers of the apostles Peter and Paul during their detention in the Mamertine Prison near the Roman Forum. They were converted and baptized by the apostles. Denounced as Christians and tortured, they were decapitated on the Via Aurelia. Their remains are venerated in the porphyry urn under the altar. Note in the mosaic the angel who brings them the palm of martyrdom.

13: MONUMENT TO CLEMENT XIII

Moving through the small corridor to the left of the principal altar, let us admire the splendid ★ *Monument to Clement XIII,* a neoclassical masterpiece executed by Antonio Canova between 1784 and 1792. The pontiff is shown in prayer. Still quite young, Canova achieved with the drill and chisel incredibly precise effects in the elaboration of the drapery. At left is the figure of Religion, who holds a cross in her right hand and rests her left hand on the sarcophagus. Her face radiates faith.

Enrico Bruschini

On the right is the ★ Genius of Death, admired for the beauty of the body, the splendid wings, and the languor with which it puts down a spent torch, a symbol of the extinguished earthly life of the pontiff. Also famous are the two lions that guard the door of the monument. They seem to be alternating the duty of keeping watch: As one keeps vigil, the other rests.

Continuing a little further we find ourselves before a magnificent altarpiece, one of the most beautiful in the basilica, *The Burial of Saint Petronilla,* a mosaic after a painting by Guercino now in the Capitoline Museum. Above we see the soul of Saint Petronilla received by Jesus, and below, the body of the young martyr is being lowered to its grave. Note the care the two gravediggers use in lowering the body. A third gravedigger is in the grave to help the others, we see only his two enormous hands that come out of the grave.

One legend narrates that Saint Petronilla was the daughter of Saint Peter. The apostle was certainly married (the Gospel mentions a miracle concerning his mother-in-law), but there is no proof of the existence of a daughter. According to Christian tradition Petronilla was a young Roman woman who was converted by Saint Peter. She became Christian and was martyred in the first century. Thus, at the very least, we can say that Petronilla was a "spiritual daughter" of Peter.

14: ALTAR OF THE CATHEDRA

Continuing to the left we reach the great central apse of the basilica. This is dominated by the impressive ★ *Altar of the Cathedra,* or *Altar of the Throne,* a triumphant Baroque design of Bernini fashioned between 1658 and 1666 during the pontificate of Alexander VII.

Four powerful gilded bronze statues depict four "Doctors of the Church" who are touching the Throne of Saint Peter, a symbol of papal authority. The statues before the throne depict Saint Ambrose and Augustine of the Latin Church, and behind are Saints Athanasius and John Chrysostom of the Greek Church. According to tradition, within this bronze throne is contained the ancient throne, or *cathedra,* on which

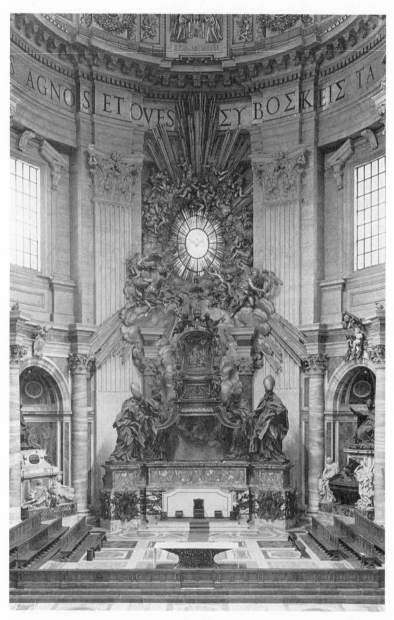

36. ALTAR OF THE CATHEDRA

Bernini

Saint Peter sat as he instructed the Christians of Rome. In real-
ity, there is an ancient chair of wood and ivory within the
bronze reliquary. But it has been proven that this is the throne

Enrico Bruschini

37. MONUMENT TO PAUL III

Guglielmo Della Porta

which Charles the Bald gave to Pope John VIII in 875 when he was crowned by the pope as Holy Roman Emperor in the Old St. Peter's Basilica.

Above the throne, in an extraordinary window made of transparent alabaster, we see the Dove of the Holy Spirit surrounded by golden clouds and angels.

This altar is particularly beautiful in the late afternoon, when the light of the sun at dusk passes through the alabaster making it glow while at the same time it passes through the upper windows, creating a highly suggestive, almost magical moment.

Two large monuments are at the sides of the altar. On the left is the ★ *Monument to Paul III,* a beautiful work by Guglielmo Della Porta finished in 1575.

At the top we see the bronze statue of the pope who commissioned Michelangelo to paint *The Last Judgment*. At his feet are figures of Justice and Prudence. In the figure of Justice we see a portrait of Giulia Farnese, the young sister of Paul III, called in Rome "Giulia Bella" for her breathtaking beauty. In the figure of Prudence, on the other hand, we see the features of the mother of the pope, Giovannella Gaetani, old and sullen, very similar to the Cumean Sibyl painted by Michelangelo in the Sistine Chapel.

☞ The statue of Justice was originally nude, because Justice, like Truth, should not be hidden or covered.

Unfortunately for the sculpture, at the beginning of this century, it was covered by a mantle of metal of the same color as the marble.

At right is the ★ *Monument to Urban VIII*. Finished in 1647, it was executed by Bernini with great gratitude to the pope who had commissioned him to erect the Baldachin and many other works in Rome. The majestic figure of the pontiff, in gilded bronze, is seated on a throne clothed in solemn papal regalia. At his feet are the figures of Charity, with a child in her arms, and Justice. At center a skeleton, Death, writes in a book the name of the deceased pontiff. Note the bees, the heraldic symbol of the Barberini, on the monument. They are no longer arranged in the shield but appear to be upset by the death of their patron and are ready to take flight.

15: MARBLE RELIEF WITH SAINT LEO THE GREAT

Let us quickly pass through the small passage left of the altar and stop before the large ★ marble relief with Saint Leo the Great. This is a remarkable altarpiece sculpted in high relief by Alessandro Algardi (1595–1654), and it represents an historical event we saw in the Rooms of Raphael. In 452 Attila, the ferocious king of the Huns known as the "scourge of God," invaded Italy and laid it waste. His destination was Rome, but the great pontiff met him near Mantua, on the

Enrico Bruschini

river Mincio. He confronted him without soldiers and convinced him to return north. Attila revealed to his soldiers that he was frightened by the sudden apparition in the sky of the apostles Peter and Paul with unsheathed swords, an image we see in the magnificent relief. This is the only marble altarpiece in the basilica.

The remains of the great pope are beneath the altar. The acanthus mosaic decoration on the front of the altar, seen on many altars in the basilica, was designed by Bernini. This is the same plant seen on Corinthian capitals.

16: MADONNA OF THE COLUMN

To the left of the relief, above the altar, we see a portrait of the Virgin Mary painted on a curved support. In the Constantinian basilica there was a column on which was painted an image of the Madonna. This image, called ★ *Madonna of the Column,* was beloved by the Romans and the clergy, and when the old basilica was demolished the column was cut away and then placed in this elegant space designed by Giacomo Della Porta.

17: MONUMENT TO ALEXANDER VII

Further to the left is the last great work of Bernini, the incredible ★ *Monument to Alexander VII,* executed by the artist for the pope who had commissioned the monumental Altar of the Cathedra, which we just admired, and the remarkable colonnade in the square before the basilica. Bernini was eighty years old when he finished this enormous work with the collaboration of his assistants.

This niche for the work was not ideal for Bernini, for a door occupied the entire lower part of the space. But this difficulty did not frighten Bernini, who is the Genius of the Baroque as Michelangelo is the Genius of the Renaissance. Let us see how Bernini resolved this problem. See the *Monument to Alexander VII* in the color insert.

The pontiff is shown kneeling; a gilded bronze skeleton, the Angel of Death, raises a heavy drape (in this way allowing

the door to function unobstructed) and displays an hourglass to the pope to show that the time available to him has run out. The head of Death is covered to show that he does not look at whom he strikes—before him all are equal, the powerful and poor.

On some old engravings it is possible to notice that at one time two little wings in bronze were attached to the hourglass. A clear warning that Time flies!

The drape is formed by a very elegant and hard stone, Sicilian jasper, rendered almost soft and pliable by the able hands of Bernini and his collaborators. At the feet of the pope are four female figures who symbolize the virtues that characterized his life. Justice and Prudence are behind, and in front Charity is on the left and Truth on the right. Let us draw closer to this last virtue and recall how Alexander VII sought hard to resolve the problems that involved the Anglican Church and how the situation troubled the last years of the pope.

⚬—📌 In a strong and elegant manner that nearly escapes notice, Bernini succeeded in recording the events that saddened the pope who had appreciated him so much.

If you look with attention, you will see that Truth rests her left foot on the world, and has a very sad expression because something is making her suffer. A long thorn that juts up from the world wounds her big toe, tormenting the figure. If we look closely, where does this thorn come from? From England!

The message is now abundantly clear: England wounds the Truth!

The curiosities have not ended. Artists always represent Truth completely nude. The Truth does not hide or cover itself, everyone must see it. Bernini himself, in his famous work at the Borghese Gallery, *Truth Unveiled by Time*, represents it nude, and even places in the right hand of this figure a sun because the Truth must be illuminated to be seen best.

This Truth too has the sun in its right hand, and it too was represented nude. Only later did someone think to cover Bernini's work with a mantle of metal painted white. If you

Enrico Bruschini

38. MONUMENT OT ALEXANDER VII

Bernini

look closely, you see how, near the borders of the mantle and over the knee of Truth, this cover is losing color. Time once more is "uncovering" Truth! The statue of Charity at left has received the same treatment in the upper part.

A few paces more to the left, and we are in the Left Transept. The Chapel of the transept to the left is also reserved for prayer. It is not normally open to tourists. This is a corner of great devotion and of particular fascination because it is the only part of the entire basilica that rests on the ancient Circus of Nero, the place where the Prince of the Apostles was crucified.

Out of respect for the faithful who pray and for the sacredness of the place, we advise observing the chapel without entering or entering only for prayer. Here there are masses celebrated every day, and one can receive the sacraments of Communion and Penance. On Holy Friday, the day that com-

memorates that Passion of Jesus, the pope himself hears confessions of the faithful with the other priests.

Above the altar on the left is a mosaic that shows *The Crucifixion of Saint Peter,* an event that happened, according to ancient tradition, on this very site. The mosaic is a perfect reproduction of the beautiful painting by Guido Reni which we saw in the Pinacoteca. In 1963 Pope John XXIII dedicated the central altar to Saint Joseph, who is represented in the modern mosaic above the altar.

Over the altar at right is a beautiful mosaic of *The Incredulity of Saint Thomas* designed by Vincenzo Camuccini (1771–1844). The Gospel of Saint John records how Thomas, not believing the other apostles who said they had seen Jesus resurrected, declared that he would be convinced only if he could touch the body of Christ. Jesus appeared to him and requested him to place a finger in the wound of his side.

18: VIEW OF THE MOSAIC WITH SAINT MARK

Let us move now to a point halfway between the altar of Saint Joseph and the Baldachin, a point indicated on the map of the basilica by an asterisk (No. 18). From here we can better understand and savor the incredible dimensions of the dome and of the basilica. Everything is enormous, but in such perfectly balanced proportion that we are not aware of the scale of individual elements.

I would like to show you a classic example. From the point where we are now, we can well see the pendentives, the triangular transitions between the piers and the vault. Within these are mosaics of the Four Evangelists. Look at the right pendentive, where the crouching lion tells us this is Saint Mark. He is writing his gospel with a quill pen. How large do you think that quill is? It is not easy to estimate the measurement, but we can gain assistance by looking at the people passing along the balcony of the base of the dome, just above the large blue mosaic letters on a gold ground, the inscription recording the words

Enrico Bruschini

of Jesus to Peter. You will become aware that the blue letters of the inscription and the pen of Saint Mark are perhaps taller than the people walking above us!

19: MONUMENT TO PIUS VIII—ENTRANCE TO THE TREASURY

Continuing toward the left nave we come to the entrance of the Treasury of Saint Peter.

Above the entrance to the Treasury is the *Monument to Pius VIII* sculpted by the neoclassical sculptor Pietro Tenerani in 1857 (Note: A remarkable and quite unknown bronze bas-relief by this very good artist entitled *Roman Charity* is preserved in the inner courtyard of the Embassy of the United States in Rome).

19A: THE TREASURY

The Treasury—or better, the Historical Artistic Museum—has suffered numerous serious depredations over the centuries. The Saracens, that is, the Arab pirates, looted it in 846; the Lansquenets, the German mercenaries of Charles V, sacked it in 1527; and Napoleon's troops seized its contents in 1797. Unfortunately not much has remained, including the most ancient sacred objects, but there are nonetheless many works of artistic and religious value.

Room I contains one of the twelve spiral columns from the ancient Constantinian basilica. It is carved in fine marble of the Greek Island of Paros and decorated with vine leaves. We saw eight other similar columns used as ornaments of the Reliquary balconies in the four enormous piers that support the Dome of Michelangelo.

In the glass case in front of the entrance to Room II is a "Dalmatic" (a kind of liturgical vestment) said to be from the time of Charlemagne (ninth century), but in reality is a late Byzantine work of the eleventh century or later. It is made of blue fabric with gold, silver, and silk embroidery. Also noteworthy is the "Vatican Cross," a reliquary of the wood of the

Holy Cross, donated in the sixth century by the Byzantine emperor Justin II.

To the right is a Greek-Byzantine Cross embossed in gold containing the "Sacred Wood of the Cross."

If you move on to Room III (the chapel to the right), you will see, on the left wall, *The Tabernacle,* by Donatello and his pupils, dating from the first half of the fifteenth century (the exquisite bas-relief of the entombment, in the center, was quite surely carved by Donatello himself).

To the right of the Donatello is a copy (1934) of Michelangelo's *Pietà.* The original *Pietà* stayed here from 1506 to 1578. Thanks to this plaster cast the original *Pietà* was perfectly restored after being damaged in May 1972.

Note in Room IV, the ★ *Funerary bronze monument of Sixtus IV,* the builder of the Sistine Chapel, a masterpiece of Antonio del Pollaiolo. It was cast in 1493 on the commission of the nephew of Sixtus IV, cardinal Giuliano Della Rovere, the future Pope Julius II.

In Room V, in the glass case on the right, is the "Fisher's Ring" of Sixtus IV. This is the official ring of the pope as the successor of the fisherman Saint Peter.

To the right as you enter Room VI are candlesticks and a crucifix presented to the St. Peter's Basilica by Pope Gregory XIII Boncompagni. To the left are candlesticks and crucifix presented by Cardinal Alessandro Farnese.

At the end of Room VII is an angel modeled in clay by Bernini. It served as the model for one of the angels we saw on the sides of the altar in the Chapel of the Holy Sacrament (No. 7).

In the first glass case on the left side of the Gallery (Room VIII) there is an object that is especially interesting from the point of view of the history of metallurgy. It is a chalice donated by Charles III of Spain to Pope Pius VI, who reigned from 1775 to 1799. This chalice was the first object in the world made in platinum. Let us recall that this most precious metal was discovered only in 1735 in the gold-bearing sands

Enrico Bruschini

of Colombia, at this time a territory ruled by a Spanish viceroy.

○─✦ The chalice in the glass case is a perfect copy, in platinum, of the original, which was recently donated as an ecumenical gift to the Catholic Cathedral of Philadelphia (Pennsylvania).

In the same glass case, to the right, are the hammer and trowel used by Pope Paul VI for the opening and closing of the Holy Door in the Jubilee of 1975. On both the tools is the cast of the palm of the hand of the pope.

In the upper part of the case is a magnificent ★ York chalice of chiseled gold studded with 130 diamonds. It is a gift of Cardinal Henry Stuart, Duke of York (end of the eighteenth century) whose monument is inside the basilica (No. 26). It is a splendid work by the Roman goldsmith Luigi Valadier.

In the next glass case is preserved the large Triple Papal Tiara, in silver with gems and pearls, which on June 29, the feast of Saint Peter, is placed on the head of the bronze statue of Saint Peter that we saw in the basilica.

Room IX holds the sarcophagus of Junius Bassus. He was a Prefect of Rome (an extremely important public office) who became Christian in the fourth century A.D.

20: ALTAR OF THE TRANSFIGURATION

Continuing further and looking behind the pier that supports the dome, we will find over the altar an incredible mosaic copy of the masterpiece by Raphael that can be admired in the Pinacoteca, *The Transfiguration.*

○─✦ If you did not have the time to admire the original in the Pinacoteca, it is worthwhile to linger before this copy that is truly well done and read the description of the original from the Pinacoteca. It recalls that Raphael died while painting *The Transfiguration.* This copy is so well executed that to realize that it is a mosaic we must come very close to the altar to discover how

the glass tesserae that compose it reflect the light. This colored glass is still produced by the glassworkers of Murano in Venice. To obtain the chiaroscuro of the mosaic that we are admiring, more than several hundred tonalities of color are necessary.

In the small corridor before the altar is the excellent ★ *Monument to Leo XI Medici* by Alessandro Algardi and his assistants, finished in 1652.

21: CHAPEL OF THE CHOIR

Through an elaborate bronze gate of Baroque style we see the seventeenth-century Chapel of the Choir, normally closed to the public. This chapel is so called because the canons of St. Peter's Basilica gather here on Sundays and religious feasts to chant the Divine Office. Planned by Giacomo Della Porta, it was consecrated by Urban VIII in 1627 and is richly decorated with colored marble and gilded stucco. The choir stalls are finely done in intarsia.

22: MONUMENT TO INNOCENT VIII

In the small corridor on the left, there is the highly interesting *Monument to Innocent VIII*. This is a sublime work by Pollaiolo, in partially gilded bronze, finished in 1498. This is the only monument from the old basilica transferred to the new basilica. Seated on a throne, the pope blesses with his right hand and in his left holds a reproduction of the lance head of Longinus (12), a gift the pope received from Sultan Bayezid II in 1492.

○━━ If you look closely, you will see a curiosity. When Sultan Bayezid II fell in disgrace his title was changed. On the eighth line of the bronze plaque below the monument it is possible to see above the title of the sultan the word *Tyranno* (tyrant) reincised in a more crude way.

It was not as easy to correct an historical error that is still visible on the fourth line of the plaque. It is erroneously stated that America (Novi Orbis, or "of the New World") was discovered in the reign of Innocent VIII. We know, instead, that

Enrico Bruschini

when Christopher Columbus touched the new continent on October 12, 1492, Innocent VIII was already dead and Alexander VI Borgia had been elected.

23: COAT OF ARMS OF JOHN PAUL II

The next chapel shows a gathering of memories—religious, historical, and artistic. The first, on the floor, is the coat of arms of John Paul II, inaugurated in 1999.

The profound devotion of the pope to the Virgin Mary is evident in the heraldic shield. The letter M is a devout homage to the Queen of Heaven and the motto is directed to her, Totus Tuus (completely yours).

On the altar is a mosaic altarpiece, a copy of a work by Romanelli, *The Presentation of Mary in the Temple,* whose original is preserved in the church of St. Mary of the Angels in Rome. The figure of the child Mary is very touching. She ascends the stairs accompanied by her parents Joachim and Anne. The future mother of God will be raised and educated in the temple until she reaches the age of matrimony.

24: BRONZE RELIEF TO JOHN XXIII

To the right of the altar is a modern bronze relief dedicated to the sweet figure of John XXIII, the "Good Pope," who reigned from 1958 to 1963.

The large relief, a work of the sculptor Emilio Greco, records the first visits of the pope after his election to the imprisoned, the sick, and children. Smiling angels are present in the scene. The face of the pontiff, however, usually illuminated by a sweet smile, is here saddened by the human suffering that torments the world.

25: URN OF SAINT PIUS X

Below the altar the body of Saint Pius X is displayed for the veneration of the faithful. Born Giuseppe Sarto and reigning as Pius X from 1903–1914, he was the last pontiff sanctified by the Church. He is dressed in pontifical vestments and his face and hands are protected by a metal leaf. To the left is the *Mon-*

In the Footsteps of Popes

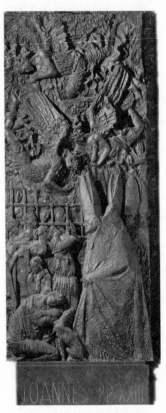

39. BRONZE RELIEF
DEDICATED TO JOHN XXIII

Emilio Greco

ument to Benedict XV, finished by Pietro Canonica in 1928. The olive branches that cover the monument make us recall how much this pope tried to convince governments to avoid the First World War, which he termed a "pointless slaughter."

26: MONUMENT TO THE STUARTS

At the end of the small corridor we find a Neoclassical masterpiece by Antonio Canova, the *Monument to the Stuarts,* the royal family of England, Scotland, and Ireland. The elegant monument finds inspiration in Greek, Etruscan, and Roman models. Above we see the coat of arms of the Stuarts, with a rearing lion and a rearing horse at the sides. Beneath there are profiles of James III, the "Old Pretender," and of his sons Henry,

the Duke of York, Cardinal, and Archpriest of St. Peter's Basilica, and Charles Edward. Beneath these portraits, almost as guards, are two beautiful ★ winged genii who are setting down extinguished torches, symbols of the end of human life.

27: BAPTISTERY CHAPEL

The last chapel is the Baptistery. The large altarpiece shows the *Baptism of Christ,* a stupendous copy of the painting by Carlo Maratta in the church of Saint Mary of the Angels in Rome. Note the incredible transparency of the water obtained in mosaic!

The baptismal font is an enormous overturned cover to a Roman sarcophagus. The scale of the cover, the use of porphyry (the imperial marble), and the location of its discovery, which almost surely was the ancient Mausoleum of Hadrian, are elements that allow us to conclude that almost certainly this is an extraordinary historical artifact, the only cover nearly intact from an imperial sarcophagus, the sarcophagus of Hadrian!

The gilded bronze cover, on which the Lamb of God rests, is a Baroque work by Carlo Fontana (1695).

Saint Peter's Square

Leaving through the atrium of the basilica, the vision of ★ Saint Peter's Square leaves us without words. It is a harmonious and solemn sight, considered one of the most astonishing squares in the world. It owes its existence to the genius of Gian Lorenzo Bernini, who succeeded in harmonizing in a most exquisite manner stateliness, theatricality, and proportion, while taking into account the preexisting elements.

The unity of this square is owed to diverse heterogeneous elements that are perfectly integrated. Let us enjoy observing them.

FAÇADE

The ★ façade of the basilica was erected by Carlo Maderno between 1607 and 1614 on the order of Paul V Borghese. Its tall and wide mass partially covers the view of the large dome

In the Footsteps of Popes

40. ST. PETER'S SQUARE
Carlo Maderno

of Michelangelo. When the basilica was partially completed, Paul V ordered the architect to modify the plans. Bramante and Michelangelo had envisioned a Greek Cross plan (its four arms are at equal length, like a mathematical "plus" sign). The church became longer both for ideological motives—it had to cover at least the space of the ancient basilica—and for practical motives: more space was needed to welcome pilgrims and to use for solemn celebrations, such as Ecumenical Councils in which bishops from all over the world participate.

The façade is formed by a single order of columns and pilasters, called the "Gigantic Order" because the columns are higher than one story and reach to the top of the façade.

If we compare the columns of the façade with those of the atrium, which are also enormous, we become aware that the term "gigantic" is not exaggerated.

The façade ends with an attic on which open elegant windows. Crowning the façade is a balustrade on which there are thirteen huge statues almost 19 feet (5.70 meters) in height.

Enrico Bruschini

Jesus is in the center. Beside Him are, on the right, Saint Andrew and, on the left, Saint John the Baptist, Jesus' cousin (he replaces Peter, whose statue is on the square). Beside these are the other apostles. The second statue from the left is Mattia, chosen by the apostles to replace Judas Iscariot.

On the sides are the two clocks added by the architect Giuseppe Valadier.

Paul V Borghese, with little modesty, had his own name engraved under the central pediment: PAVLUS V BVRGHESIVS ROMANVS.

The balcony beneath this is the Benediction Loggia. Immediately after the election of a new pontiff, his name is announced from this balcony and from here he gives his first solemn blessing "Urbi et Orbi," "To the city of Rome and to the World."

Beneath the loggia is a seventeenth-century bas-relief that shows the the *Donation of the Keys to Saint Peter.*

At the extreme left of the façade is the Arch of the Bells, so called because it is placed immediately beneath the bell tower. It is very enjoyable to hear, every fifteen minutes, the sound of the bells that solemnly measure the passing of time. Especially the full and deep sound of the big bell that the Romans have always called "il Campanone" succeeds in making something resound within us.

Before the Arch of the Bells, one of the entrances to Vatican City, the Swiss Guard stands watch, wearing the characteristic uniform of vivid yellow, blue, and red that, according to tradition, was conceived by Michelangelo using the colors of the Medici family's coat of arms.

The large stairs, divided in three flights, is the work of Gian Lorenzo Bernini.

At the bottom of the stairs are the big statues of Saint Peter (left) and Saint Paul (right), carved in the middle of the nineteenth century. These statues are 20 feet (6 meters) high, two true giants; but think how the thirteen statues above the façade are six feet (nearly two meters) taller than these!

BRONZE DOOR

Let us move to the beginning of the colonnade at right to see the official entry to the Vatican Palaces, the Bronze Door. Here too the Swiss Guard in uniform is on watch; note that they give a military salute to any religious who visit the palace.

⊶ The use of the Swiss Guard is an old tradition in the Vatican. The Swiss Guard sacrificed themselves during the Sack of Rome in 1527 to save the life of Pope Clement VII. Today the Swiss Guard is formed by Swiss Catholics who act as an Honor Guard for the Pope. They take their oath on the sixth of May, the same day so many sacrificed themselves to save the pontiff in 1527.

ROYAL STAIRWAY

Through this large door it is possible to see a long corridor at the end of which is a Bernini masterpiece, ★ *The Scala Regia* (the Royal Stairway). This powerful staircase, which appears to be at least 400 feet (about 120 meters) in length, is an incredible invention, as Bernini played a trick with perspective. The height and diameter of the columns decrease as we ascend. The human mind is tricked and sees the staircase as longer than it is in reality. As a matter of fact it is only 135 feet (41 meters) long! We can discover the trick if we have the fortune to see someone stand at the far end of the stairs, because this person appears to be as tall as a giant. We must mention that Bernini took this marvelous idea from Borromini, who had constructed another gallery in perspective, smaller but also more impressive, in the Spada Palace here in Rome.

OBELISK

Let us now draw near to the center of the square to admire the mighty ★ *Obelisk*. It is monolithic, that is, formed of one block of red Egyptian granite, and was made to decorate the Forum of Julius Caesar in Alexandria almost two thousand years ago. Caligula had it transported to Rome in A.D. 37 to adorn his new circus (completed later by Nero) that rose to the

Enrico Bruschini

left of the actual basilica. Given the size and weight of the obelisk, no merchant or military ship was fit to transport it. Therefore an enormous boat was built specially for this cargo. It is without hieroglyphs because in Egypt the Romans had a dedicatory inscription to Gaius Giulius Caesar Germanicus incised on it, an inscription that still can be seen. The Romans called this emperor "Caligula," because as a child he always wore a kind of military sandal called *caliga* in Latin.

The obelisk was the mute witness to the crucifixion of Saint Peter and to the sacrifice of a great number of martyrs.

When the Constantinian basilica was built, it was still standing to the left of the basilica, and it was still in that location when the new Renaissance basilica was built. Only in 1586 did Pope Sixtus V give the commission to Domenico Fontana to transfer the Obelisk to its present position in front of the basilica. It was not an easy undertaking, and to accomplish the task 900 workers, 140 horses, 44 winches, and more than four months of labor were necessary.

The monolith is 84 feet (25.50 meters) in height, and with the cross it touches a height of 135 feet (41 meters).

○━☞ It was a majestic idea of this pope, Felice Peretti, to raise or move the ancient obelisks in Rome, using them as ornaments before churches. He also had a cross placed on top of almost all the obelisks to transform them from a pagan symbol to a Christian symbol (his coat of arms, three hills and a star, are at the top, just under the cross, and the other part of his coats of arms, the lions, are supporting the obelisk.)

In the year 1740, to give more importance to the cross in the center of Saint Peter's Square, a piece of the cross found according to the ancient tradition by Saint Helen, the mother of Emperor Constantine, was placed inside the cross in bronze. It is still there!

COLONNADE

From the point where we are now, near the obelisk, we can observe in all its stateliness the ★ colonnade. Commissioned by

In the Footsteps of Popes

Pope Alexander VII Chigi (1655–1667), it was designed and constructed by Bernini. The religious and architectural idea of the great architect was to create "two large arms embracing humanity." Standing within the square we must recognize that Bernini's intention was completely realized!

The colonnade is formed by 284 columns and 88 pilasters and is surmounted by 140 statues of saints as well as large heraldic shields of Alexander VII; all are works of Bernini's workshop.

From our viewpoint we can note other interesting details. To the right of the façade we can see the left half of the roof of the Sistine Chapel. The halfway point of this roof is where the chimney is located from which the white or black smoke issues giving the results of the balloting during a papal election (we described already this ceremony, which takes place in the Sistine Chapel).

○━┭ Like the good Roman that I am, I have from youth always followed the actual progress of the votes from Saint Peter's Square, the only place in Rome where the small chimney is visible. It is a tradition and I well remember the long waits until the emotional instant the smoke issued. At the beginning it always seemed to be a neutral gray color. Only after several, endless, minutes does this darken to black. Then, anticipation mounted as the black smoke issued again and again, until the joy when the white smoke appeared.

Looking now further to the right, we note that on a narrow façade of one of the palaces closest to the square there is a walled-up window and in its frame there is a mosaic of the Virgin Mary.

After the assassination attempt that took place on May 13, 1981, as Pope John Paul II entered the piazza for a public audience, the pontiff wanted the image of Mary to protect the square, the city, and the world. He requested that the ancient image of the Madonna of the Column, whose original we saw in the basilica (16), be reproduced in mosaic on a larger scale.

Enrico Bruschini

This is the only image of the Madonna in the entire square and it is the only work of art placed in the piazza during the past century.

PAPAL PALACE

Further to the right is the principal façade of the ★ Papal Palace, erected by Domenico Fontana between 1585 and 1590 for Sixtus V. The last floor is the pontifical apartment. Every Sunday at 12:00 thousands of people look up at the next to last window on the right to see the white figure of the pope who comes out to impart words of faith and give his benediction to the crowd.

Two fountains adorn the square and give joy with the natural sound of water. Facing the façade of the basilica, the fountain at right was erected by Carlo Maderno in 1613 for Pope Paul V Borghese. The fountain at the left was erected by Carlo Fontana in 1667 under Bernini's direction but was not inaugurated until 1677 because of a water shortage.

Moving now to the right or to the left, almost to the halfway point between a fountain and the obelisk, you will note a circular stone of gray granite. Around this is written "Centro del colonnato," or "Center of the Colonnade." These two stones (one on each side) are the focal points of the ellipse of the colonnade. Standing on one of these points, one sees only the first of the four columns that compose the colonnade. This is only a geometric curiosity, but it is so enjoyable to experience, as millions of people do every year, how three rows of columns vanish behind the first row.

Another curiosity that is less known is given by the elliptically shaped white stones that are near the gray stone. These form part of the great sundial of which the obelisk functions as the gnomon. In 1817 a priest named L. F. Gili, who was an astronomer, designed this sundial. Around the obelisk there are small pieces of marble that indicate the compass card.

From the square we can see in one view the entire ★ dome projected by Michelangelo. It is 449 feet (137 meters) high till the top of the cross. Michelangelo's plan was followed in the construction of the drum with its windows, double Corinthian columns, and elegant garlands. At this point (1564), unfortunately, the great artist died.

The architects Della Porta and Fontana, as we know, completed the dome in 1591. The curvature of the dome did not follow perfectly the design of Michelangelo, for he had in mind a lower and more round dome.

One cannot deny that Della Porta's modifications obtained a most pleasing result, giving the dome that perfect and most elegant silhouette that has made it famous throughout the world.

The Necropolis

Beneath St. Peter's Basilica, as we have indicated, there is an ancient cemetery that was used from the end of the first to the fourth centuries. It is in the western portion of this cemetery that Saint Peter was buried. The necropolis was excavated between 1939 and 1949. The majority of tombs belong to pagan Romans from the second and third centuries. Many have well-preserved stucco and mosaic decorations. This is one of the best preserved Roman cemeteries and is very interesting to see. In the western portion, among the most ancient tombs, there is the aedicule that, according to scholars, is the monument of Saint Peter described by the priest Gaius. It was already present on the Vatican hill around the year 200. The aedicule is from the years 160–170. It now consists of niches, one over the other. The central niche is the famous niche of the pallia, over which the papal altar and the Baldachin rise.

To visit the excavations you need to present a written request to the Ufficio Scavi della Fabbrica di San Pietro, 00120 Vatican City, some days in advance, specifying name and number of visitors, language, desired date of visit, and your address and telephone number. The request may be sent by mail or by

Enrico Bruschini

fax (at the moment 06.6988.5518), or you may fill in the form at the Office, inside the Vatican, entering through the Arch of the Bells.

The Excavation Office will confirm by phone the day and the time of the visit.

You can try to make a reservation for your visit at the excavations by calling the same office at the following number: 06.6988.5318.

Office opening hours: 9:00 A.M.–5:00 P.M. Closed on holidays (Info: 06.6988.4866).

Ticket: Lire 15,000 with specialized guide (the duration of the guided tour is about seventy-five minutes).

Visiting the Papal Gardens

The Papal gardens occupy one third of the Vatican's territory and are formed from huge Mediterranean trees, lawns, and small woods through which are promenades, artificial grottoes, statues, and fountains. To visit the gardens you need to book a guided tour some days in advance. The Guided Tours counter is located at the entrance of the Vatican museums (the first counter on the left), Tel: 06.6988.4466 and 06.6988.4587; Fax: 06.6988.5100.

Tours are normally permitted from March to October at 10:00 A.M. on Monday, Tuesday, Thursday, Friday, and Saturday. The duration of the tour is about two hours.

You can try to obtain a last-minute reservation by calling the office on the morning between 8:00 and 9:00 A.M. of the same day you wish to take the tour.

Papal Audiences

It is possible to participate in the public audience the Holy Father holds every Wednesday and normally starts at 10:00 A.M. In the summer months the audience takes place in Saint Peter's Square. In winter it takes place in the Hall of Paul VI in the Vatican. The Pontifical Audience Hall is one of the last works of Pier Luigi Nervi (1964–71).

To participate in a Papal Audience one must write to the Prefect of the Pontifical Household, 00120 Vatican City (Tel: 06.6988.3273 and 06.6988.3114; Fax: 06.6988.5863) at least several days in advance for an invitation.

For the large public audiences any decent dress is allowed.

If you are invited to a Private Audience, it is appropriate to wear black. Women may wear white, but the dress must be long, cover the shoulders, and have sleeves to the wrists. A veil is fitting.

You can try to obtain a last-minute invitation on Tuesday evening or on Wednesday morning (between 8:00 and 9:00 A.M.) by making a request at the Bronze Gate entrance, located at the beginning of the right side of Bernini's Colonnade in Saint Peter's Square.

If invitations are still available at that time, the Swiss Guards at the Bronze Gate entrance will be more than happy to give one of them to you.

The Eternal City is looking forward to seeing you!

Useful Information for the Vatican

HOURS:

Monday through Friday.
Entrance: 8:45–3:30
Exit: 4:45

Last Sunday and every Saturday
Entrance: 8:45–12:30
Exit: 1:45

ENTRANCE FEE

Regular Lire. 18,000. Reduced Lire. 12,000 for minors to age 14 and for students to age 26 with a valid student card.

The museums normally remain closed on Sundays except for the last Sunday of the month when they are open and free to all visitors.

Enrico Bruschini

The museums are closed on the following Vatican Holidays: January 1 and 6, February 11, March 19, Easter Sunday and Easter Monday, May 1, Ascension Day, Corpus Christi Day, June 29, August 15 and 16, November 1, and December 8, 25, and 26.

Since the entrance hours and the closing days are subject to change, it is suggested that you check the actual schedule by calling: 06.6988.4947 or 06.6988.3333.

Wheelchairs are available on request.

Still and video cameras are allowed inside the museums but a flash cannot be used in certain marked areas. However, the use of cameras and video equipment *with or without flash* is strictly forbidden in the Sistine Chapel. Small binoculars can be useful to see the details of the chapel ceiling.

Note: If you wish to visit St. Peter's Basilica after visiting the Sistine Chapel, *remember that entrance to the basilica is allowed only to those with covered shoulders and legs!* It is also suggested that you wear clothes that are not too short or revealing for a visit to the Sistine Chapel.

AVOIDING THE LONG TICKET LINES

The Vatican museums and the Sistine Chapel are the most visited places in Rome, with more than 3 million visitors a year. For this reason, the lines at the entrance can be very long.

To avoid a tiresome wait and, overall, a too crowded museum, the advice provided below is the fruit of extensive personal experience.

If you are part of an organized group and accompanied by an Official Guide authorized by the museums, you may enter at 8 o'clock in the morning (even in this case there could be a long line).

If you are an individual visitor remember that at 8:45 A.M. when the museums open, the line is already normally very long.

A way to avoid this is by arriving at the entrance during the late morning hours, 11:00–11:30, when the line has become much shorter or almost nonexistent.

In the Footsteps of Popes

As all other Roman museums are closed on Mondays, it is therefore advisable to arrive at the entrance of the Vatican Museums long after 12:00 P.M. on that day because lines are usually much longer.

Saturday is also one of the most crowded days, mainly due to local visitors. It is suggested to arrive at the entrance long after 11:00 (remembering, however, that on Saturdays the exit is moved to 1:45).

Finally, the last Sunday of the month, when entrance to the museums is free, is the preferred day for schoolchildren from all over the world. The line outside is usually so long, and the crowd inside so concentrated, that it is almost impossible to enjoy the beauty of the various collections. If possible, choose another day to visit the museums.

Enrico Bruschini

INDEX

index

index

index